**Publisher's Acknowledgements**
We would like to thank the follow-
ing authors and publishers for
their kind permission to reprint
texts: **Centre National des Arts
Plastiques**, Paris; **Centro per
l'Arte Contemporanea**, Prato; **T.J.
Clark**, Berkeley; **Jean-François
Chevrier**, Paris; **Ludion Press**,
Ghent; *Galeries*, Paris; **Dan
Graham**, New York; **Serge
Guilbaut**, Vancouver; **Kunsthalle
Basel; Kunsthalle Nurnberg;
Kunstmuseum, Luzern; Musée
communal d'Ixelles**, Brussels;
*Parachute*, Montreal; *Parkett*,
Zurich; **Portikus**, Frankfurt;
**Schocken Books, Pantheon
Books**, a division of **Random
House, Inc.**, New York; **Martin
Schwander**, Luzern; **Städtisches
Kunsthalle**, Dusseldorf; and
**Anne Wagner**, Berkeley. We are
grateful to the following for
lending reproductions: **British
Film Institute**, London; **Louvre**,
Paris; **Musée des Beaux-Arts et
de la Ceramique**, Rouen; and
**Galerie Roger Pailhas**, Marseilles,
Paris. We are grateful to the
**Marian Goodman Gallery**, New
York, and **Galerie Johnen &
Schöttle**, Cologne, for their
assistance. Photographers:
**G. Amsellem, Fred Aubert, Cathy
Carver, Max Wechsler** and
**Vladimir Goralcik.**

**Artist's Acknowledgements**
Thanks to my assistants in
Vancouver, Daniel Congdon and
Stephen Waddell, for help in
preparing material for the book.
Thanks also to Iwona Blazwick,
commissioning editor, and to
Clare Stent, Gilda Williams, John
Stack, Stuart Smith, Ben Dale,
Gary Hayes, Catherine Pearce and
Charlotte Beauchamp at Phaidon,
for making the book.

All works are in private collections
unless otherwise stated.

Phaidon Press Limited
Regent's Wharf
All Saints Street
London N1 9PA

Phaidon Press Inc.
180 Varick Street
New York, NY 10014

www.phaidon.com

First published 1996
Reprinted 1998
Second edition, revised and
expanded, 2002
© 1996, 2002 Phaidon Press
Limited
All works of Jeff Wall are © Jeff
Wall.

ISBN 0 7148 33495

A CIP catalogue record of this
book
is available from the British
Library.

Designed by SMITH and Ben Dale
Printed in Hong Kong

*cover,* **Morning Cleaning, Mies van
der Rohe Foundation, Barcelona**
1999
Transparency in lightbox
187 × 351 cm

*page 4,* **Untangling** (detail)
1994
Transparency in lightbox
189 × 223 cm

*page 6,* **Jeff Wall** installing
**The Destroyed Room**
1979

*page 24,* **Dead Troops Talk (A
Vision After an Ambush of a Red
Army Patrol Near Moqor,
Afghanistan, Winter 1986)**
1992
Production still

*page 56,* **Coastal Motifs** (detail)
1989
Transparency in lightbox
119 × 147 cm

*page 70,* **Odradek, Taboritska 8,
Prague, 18 July 1994** (detail)
1994
Transparency in lightbox
229 × 289 cm

*page 162,* **The Flooded Grave**
(detail)
1998-2000
Transparency in lightbox
229 × 282 cm

*page 192,* **Restoration**
1993
Production still

Thierry de Duve  Arielle Pelenc  Boris Groys  Jean-François Chevrier

# Jeff
# Wall

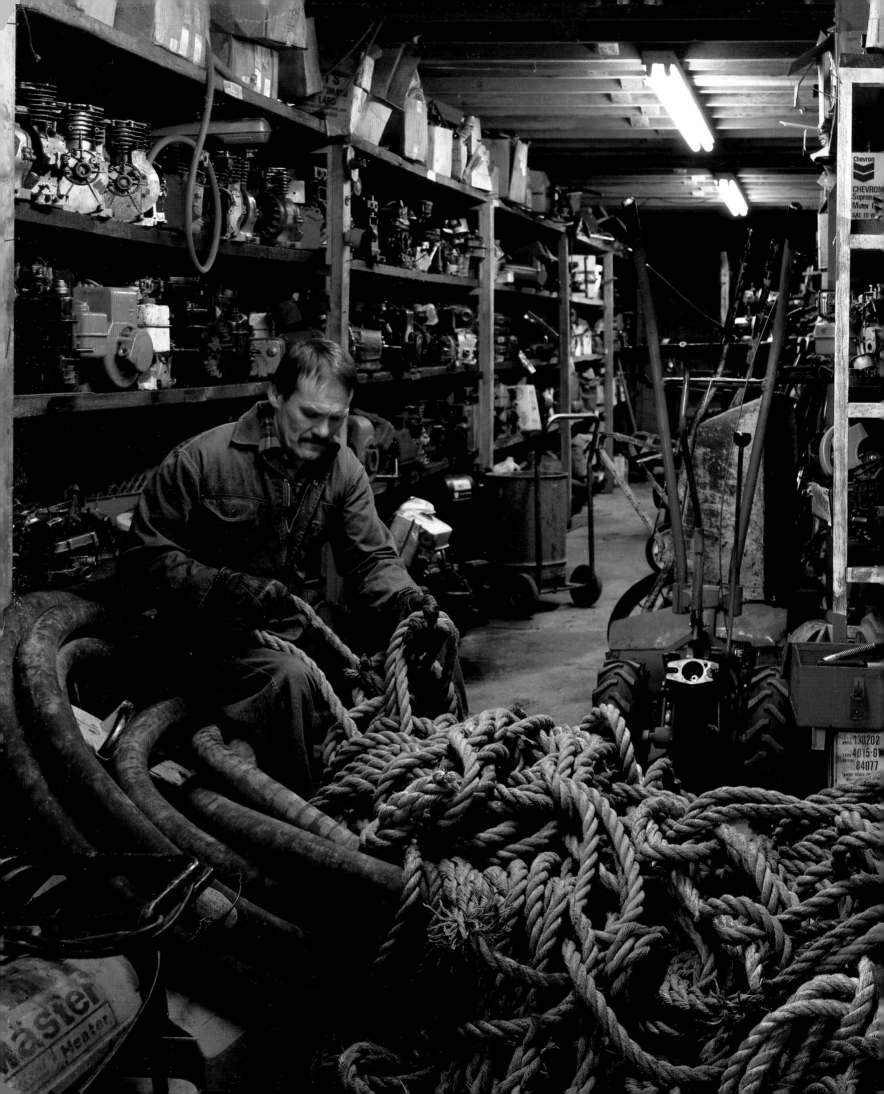

# Contents

**Interview** Arielle Pelenc in correspondence with **Jeff Wall**, page 6. **Survey** Thierry de Duve The Mainstream and the Crooked Path, **page 24**. **Focus** Boris Groys Life without Shadows, **page 56**. **Artist's Choice** Blaise Pascal Pensées, 1658 (extract), **page 72**. **Franz Kafka** Troubles of a Householder, 1919, **page 72**. **Artist's Writings** Jeff Wall Gestus, 1984, **page 76**. Unity and Fragmentation in Manet, 1984, **page 78**. Photography and Liquid Intelligence, 1989, **page 90**. An Outline for a Context for Stephan Balkenhol's Work, 1988, **page 94**. A Guide to the Children's Pavilion (a collaborative project with Dan Graham, extract), 1989, **page 102**. The Interiorized Academy, 1990, **page 104**. Representation, Suspicions and Critical Transparency, 1990, **page 112**. Restoration, 1994, **page 126**. About Making Landscapes, 1995, **page 140**. Boris Groys in Conversation with Jeff Wall,1998, **page 148**. After *Invisible Man* by Ralph Ellison, the Preface, 2001, **page 161**. **Update** Jean-François Chevrier The Spectres of the Everyday, **page 162**. **Chronology** page 192 & Bibliography, List of Illustrations, **page 210**.

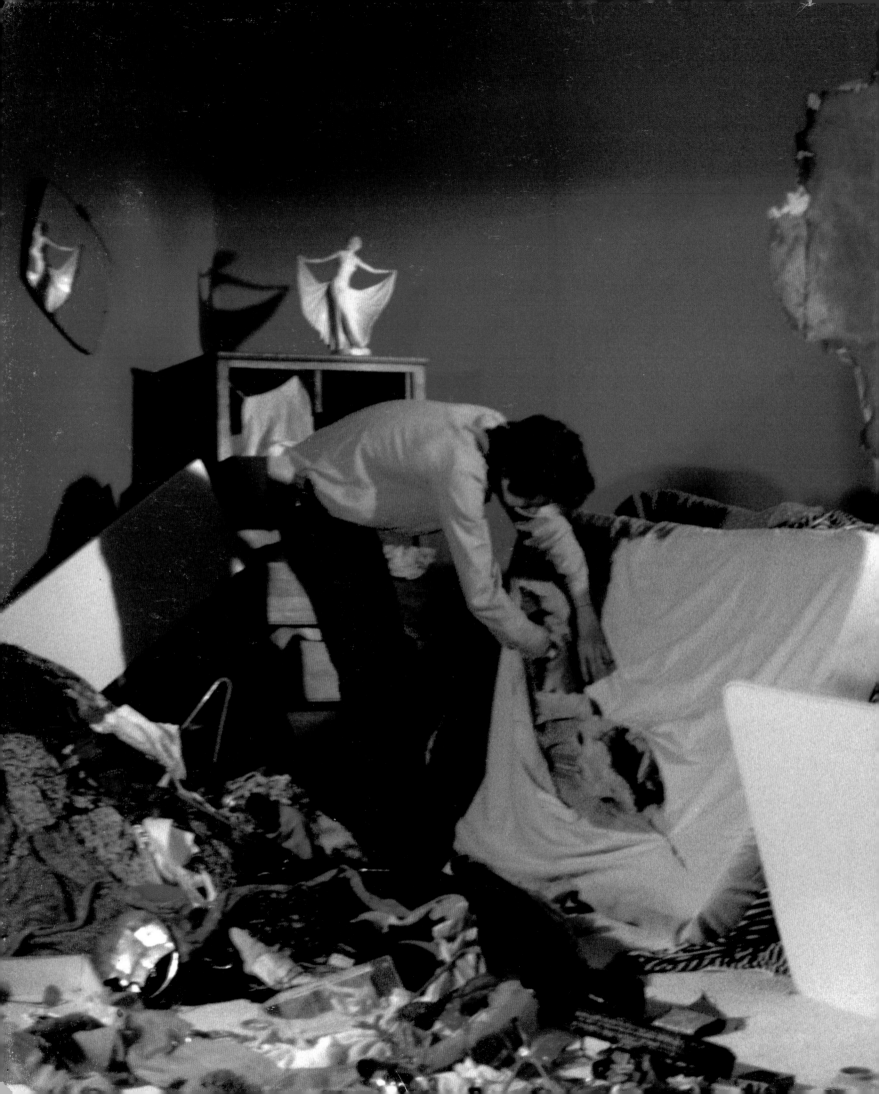

# Contents

**Interview** Arielle Pelenc in correspondence with **Jeff Wall, page 6**.  Survey Thierry de Duve

The Mainstream and the Crooked Path, page 24.  Focus Boris Groys Life without Shadows, page 56.

Artist's Choice Blaise Pascal Pensées, 1658 (extract), page 72.  Franz Kafka Troubles of a

Householder, 1919, page 72.  Artist's Writings Jeff Wall Gestus, 1984, page 76.  Unity

and Fragmentation in Manet, 1984, page 78.  Photography and Liquid Intelligence, 1989, page 90.  An Outline for a Context for

Stephan Balkenhol's Work, 1988, page 94.  A Guide to the Children's Pavilion (a collaborative project with Dan Graham, extract),

1989, page 102.  The Interiorized Academy, 1990, page 104.  Representation, Suspicions and Critical Transparency, 1990,

page 112.  Restoration, 1994, page 126.  About Making Landscapes, 1995, page 140.  On Colour or Black and White

Boris Groys in Conversation with Jeff Wall, 1998, page 148.  Update Jean-François Chevrier The Spectres of

the Everyday, page 160.  Chronology page 192  & Bibliography, List of Illustrations, page 210.

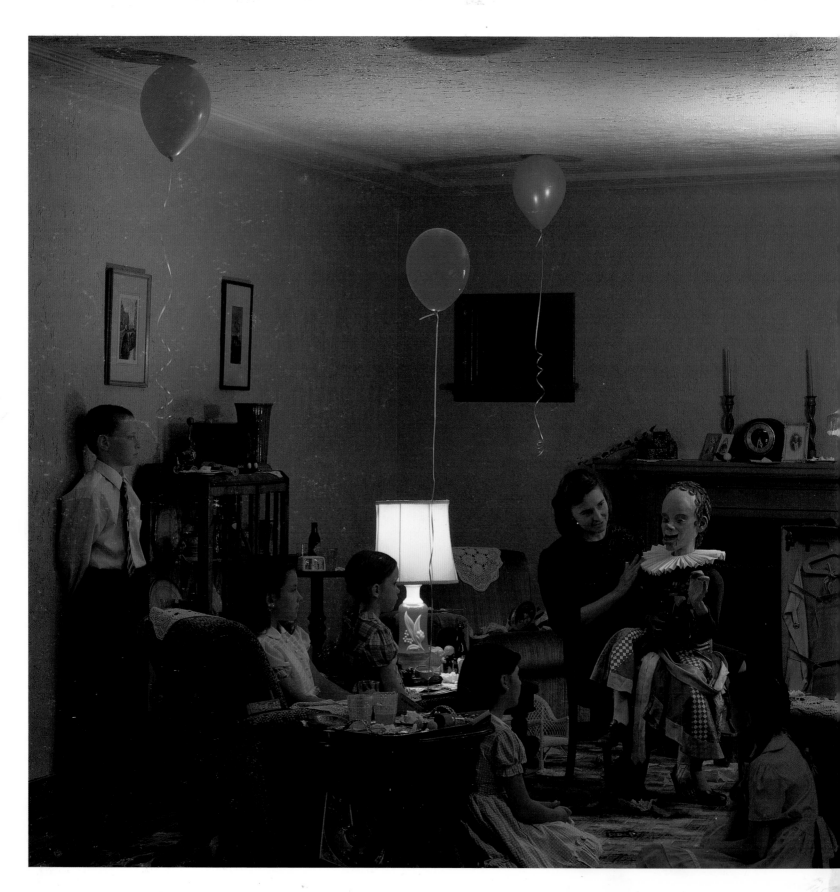

A Ventriloquist at a Birthday
Party in October, 1947
1990
Transparency in lightbox
229 × 352 cm

**Arielle Pelenc**  I thought we could start with the idea of conversation and talk.
A lot of your pictures involve verbal communication: *Diatribe, The Storyteller,*
*Pleading, Dead Troops Talk.* You once told me that the film *La Maman et La Putain*
by Jean Eustache was very influential, and this film is mostly based on talking.
How does talking, or voice, participate in the construction of your pictures?

Jeff Wall  One of the problems I have with my pictures is that, since they are
constructed, since they are what I call 'cinematographic', you can get the
feeling that the construction contains everything, that there is no 'outside'
to it the way there is with photography in general. In the aesthetic of art
photography as it was inspired by photojournalism, the image is clearly a
fragment of a greater whole which itself can never be experienced directly.
The fragment then, somehow, makes that whole visible or comprehensible,
maybe through a complex typology of gestures, objects, moods and so on.
But, there is an 'outside' to the picture, and that outside weighs down on
the picture, demanding significance from it. The rest of the world remains
unseen, but present, with its demand to be expressed or signified in, or as, a
fragment of itself. With cinematography or construction, we have the illusion
that the picture is complete in itself, a symbolic microcosm which does not
depict the world in the photographic way, but more in the way of symbolic
images, or allegories. For example, Giotto's paintings, although often part
of narrative cycles, seem to evoke a whole universe just by the nature of the
depiction and composition. Italian Catholic art as a whole has this totalizing
quality, in which the design of the picture implies a complete and profound
statement about the subject, and we do not have the feeling that there is
anything left outside the frame. This condition is always at odds with the
nature of pictorial construction based on perspective and the rectangle,
which necessarily implies a boundary to the picture and not to the subject.
This conflict is one of the essential sources of energy for Western pictorial art.
It reached its first absolutely decisive formulation in the 'naturalistic Baroque'
of Caravaggio and Velázquez, in which meanings seem to be totalized while
the pictorial form is recognized as being inherently bounded. In their work,
there is simultaneously no outside and an outside, and I think we've been in
this borderland ever since.

Making pictures of people talking was for me a way to recognize this
condition. I have always been interested in the nature of the pictorial, its
indwelling structure, its transcendental conditions, if you like. Journalistic
photography developed by emphasizing the fragmentary nature of the
image, and in doing so reflected on the special new conditions created by
the advent of the camera. So, this kind of photography emphasized and
even exaggerated the sense of the 'outside' through its insistence on itself
as fragment. I accept the fact that a photographic image must be a fragment
in a way that a painting by Raphael never is, but at the same time I don't
think that therefore photography's aesthetic identity is simply rooted in this
fragmentary quality. In the history of photography itself there has obviously
been a continuous treatment of the picture as a whole construction. This
has often been criticized as the influence of painting on photography, an
influence that photography has to throw off in order to realize its own
unique properties. But in my view, photography's unique properties are
contradictory. Imitation of the problematic completeness of the 'naturalistic
Baroque' is one of them.

A picture of someone talking is to me an elemental example of the problem of the outside and the threshold. I can construct the gestures and appearance of the speaker and listener, and so can suggest that I also control the words being spoken and heard. But, at the same time, it is obvious that I cannot, and that every viewer of the picture can 'hear' something different. Talking escapes, and so it is itself an image of what is both included and never included in a picture, especially in a picture which seems to wish to imitate the 'naturalistic Baroque' invented by painting.

**Pelenc**  The child in *In the Public Garden* looks like an automaton – in the garden but cut off from the outside world. There is a lot of automatic gesturing in your pictures, maybe because of their 'cinematographic' character. This automatism of the image is different from the distancing produced by theatre or painting. In classical cinema, the *hors-champs*, the outside, is open and endless. But with modern cinema the *hors-champs* is transformed by the jump cut (*faux raccord*). It becomes like an irrational number not belonging to one or the other class or group it is separating. Your work presents these irrational cuts where the rupture with the outside world is visible inside the image, like in *Dead Troops Talk*, for example.

Wall  **My work has been criticized for lacking interruption, for not displaying the fragmentation and 'suturing' which had become *de rigueur* for serious**

*above*, **Robert Bresson**
Mouchette
1966
90 mins., black and white
Film still

*above, right*, **Jean Eustache**
La Maman et La Putain
1973
219 mins., black and white
Film still

**In the Public Garden**
1993
Transparency in lightbox
119 × 188 cm

art, critical art since the 1960s. In your terms, it didn't seem to have any jump cuts which let in the outside, and break up the seamlessness of the illusionism. But, already by the middle of the 1970s, I felt that the 'Godardian' look of this art had become so formulaic and institutionalized that it had completed its revolution, the plus was becoming a minus, and something new was emerging. I preferred *Mouchette* to *Weekend*, and was interested in the preservation of the classical codes of cinema as was being done by Buñuel, Rohmer, Pasolini, Bergman, Fassbinder and Eustache, all of whom achieved very new things in what I would call a non-Godardian or even counter-Godardian way. Eustache's *La Maman et La Putain* had a tremendous effect on me. I wish he hadn't died.

What I think these people were doing was transferring the energy of radical thinking away from any direct interrogation of the medium and towards increasing the pressure or intensity they could bring to bear on the more or less normative, existing forms which seemed to epitomize the medium. They accepted, but in a radical way, what the art form had become during its history. They accepted technique, generic structure, narrative codes, problematics of performance and so on, but they broke away from the decorum of the dominant institutions, like the production companies or, in Europe, the state filming agencies. In that process, they brought new stories and therefore new characters into the picture. Think of the couple in Fassbinder's *Ali: Fear Eats the Soul*, or Mouchette herself, or the people in *Persona* or *Winter Light*.

There's a lot that could be said about a kind of internalized radicalism in the work of these filmmakers and others working between, say, 1955 and about 1980, an almost 'invisibilized' intensity as far as any disruption of the classical codes is concerned. What happened was that the 'outside', as you call it, did get inside, but in doing so it refused to appear directly as an outside, disruptive element. It dissembled. It appeared to be conventional, appeared to be the same as (or almost) the conventionalized 'signs for the real' that make up ordinary cinema. Buñuel was of course a master at this. So, the new form of the threshold was not a drastically broken-up surface like in Godard, but a self-consciously, even ironically, even manneristically normalized surface. This is – or seems to be – a more ambivalent approach to the idea of critique and auto-critique than an openly contestatory one. This apparent ambivalence, this technique of mimesis and dissembling, this 'inhabitation' didn't satisfy anyone who demanded avant-gardist criteria of overt, antagonistic confrontation. I agree that there are these 'jump cuts' or irrational cuts in my work. But they appear as their opposites, as adherence to a norm, the unity of the image or picture. I accept the picture in that sense, and want it to make visible the discontinuities and continuities – the contradictions – of my subject matter. The picture is a relation of unlike things, montage is hidden, masked, but present, essentially. I feel that my digital montages make this explicit, but that they're not essentially different from my 'integral' photographs.

**Pelenc** Representation of the human body, depending on the construction of micro-gestures, is kind of programmatic in your work. Recently some unrealistic, improbable bodies have appeared such as those in *The Vampires' Picnic*, *The Stumbling Block*, *The Giant* and the zombies in *Dead Troops Talk*. What are these bodies?

Wall  I feel that there has always been a grain of the 'improbable' in my pictures and in my characters. For example, I thought of the woman in *Woman and Her Doctor* as a sort of porcelain figurine, and tried to make her look a bit like one, very glossy, so that the 'clinical gaze' of the doctor would have something to work on. I made a 'double' in 1979 (*Double Self-Portrait*). The man in *No* seems to have only one leg – how is he moving along the street? The woman in *Abundance* always seemed sort of hallucinatory to me. *The Thinker* is an impossible being, too. I have always thought of my 'realistic' work as populated with spectral characters whose state of being was not that fixed. That, too, is an inherent aspect, or effect, of what I call 'cinematography': things don't have to really exist, or to have existed, to appear in the picture. So, I see my more recent 'fantasy' pictures as just extensions of elements that have always been present. Being able to use computer technology released certain possibilities, certain energies, and made new approaches viable. But a recent work like *Restoration*, for example, used the computer and the process of digital montage to create a very realistic, very everyday, very 'probable' scene; so this technique does not just imply overtly fantastic images. It makes a spectrum of things possible, and helps to soften the boundary line between the probable and the improbable. But it did not create that threshold – that was already there, both in my own proclivities, and in the nature of cinematography. 'What are these bodies?' – that question requires an interpretation of the picture in which they appear, and I'm not the best person to do that.

**Pelenc** In an interview with T.J. Clark you emphasized the notion of the representative generic constructions of your pictures. By using generic constructions, figures, stories or gestures, your work seems to underline the inadequacy of representation to its referent. Would your 'spectral characters' be an indication that the world and its representation do not match?

Wall  The claim that there is a necessary relationship (a relationship of 'adequacy') between a depiction and its referent implies that the referent has precedence over the depiction. This 'adequacy' is what is presumed in any imputed legitimation of what you're referring to as Representation. A critique of Representation claims that Representation happens when some- one believes that a depiction is adequate to its referent, but is deceived in that belief, or deceives others about it, or both. Representation occurs in that process of self-deception, and so it becomes the object of a deconstruction. I don't think depictions, or images, can be judged that way, and I don't think they're made in those terms, or at least not primarily. Depiction is an act of construction; it brings the referent into being. All the fine arts share this characteristic, regardless of their other differences. Depictions are generic because, over time, themes, motifs and forms bear repetition and re-working, and new aspects of them emerge in that process. Genres are forms of practice moulded slowly over time, like boulders shaped by water, except that these formations are partially deliberate, reflexive and self-conscious. 'Generic' con- structions are old by nature, maybe that is why they play such an important part in the expression of the 'new' and the 'modern', as Baudelaire observed.

In that sense, there is always something spectral – ghostly – in the generic, since any new version or variant has in it all the past variants, somehow. This quality is a sort of resonance, or shimmering feeling, which to me is an essential aspect of beauty and aesthetic pleasure. But none of this is concerned with the adequacy of the depiction to its referent. This notion of such a relation is not artistic; it seems to have more to do with other ways of thinking, other images, other depictions. The 'match' between the world and depictions is organized or regulated differently in different practices. Art might refer to, borrow from or even imitate other things, the way many artist-photographers have imitated photojournalists, for example. But it does not accept the total- ity of regulations covering or defining that from which it borrows – the principle or condition of the autonomy of art ensures that. I think our awareness of this is the outcome of the years – or even decades – of deconstruction.

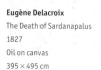

**Eugène Delacroix**
The Death of Sardanapalus
1827
Oil on canvas
395 × 495 cm

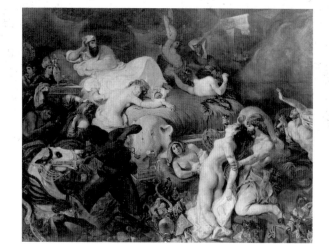

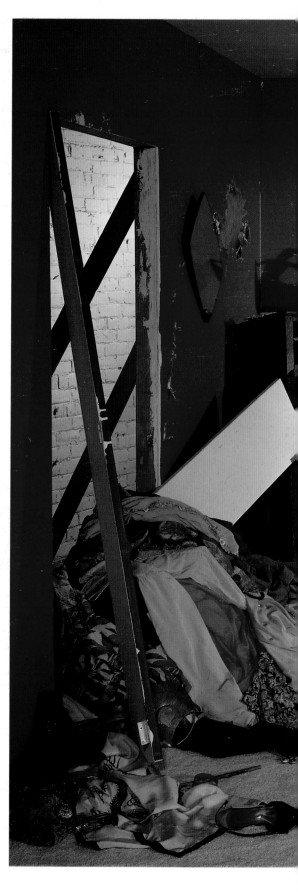

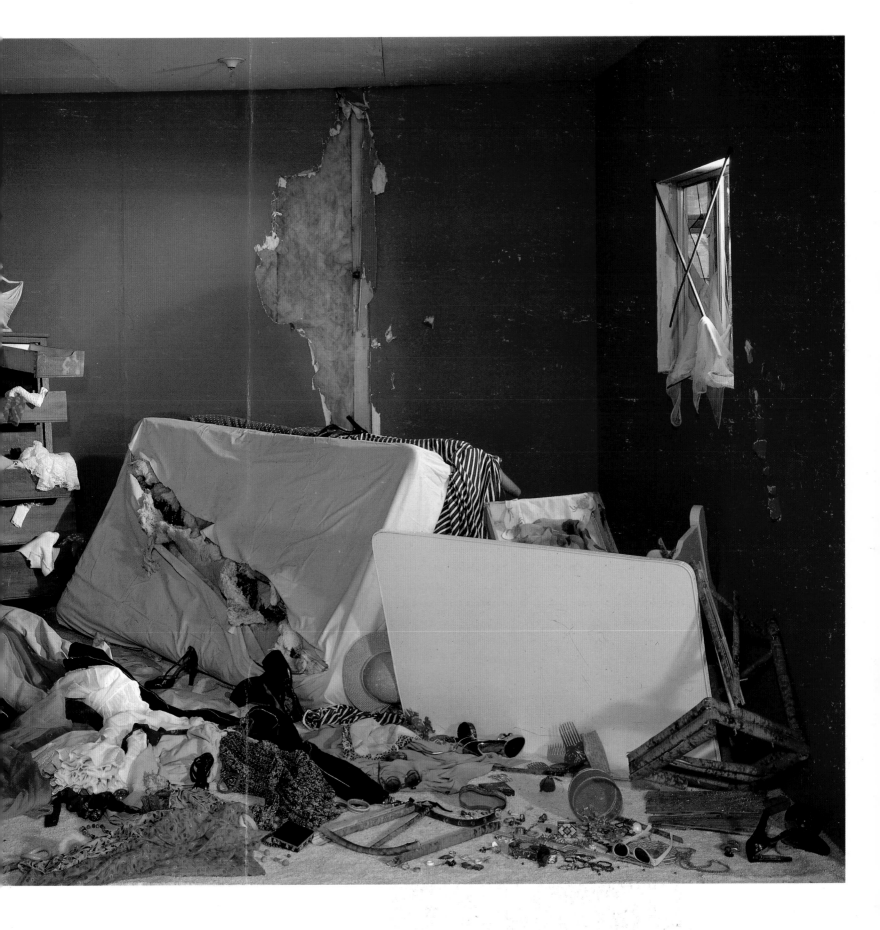

**The Destroyed Room**
1978
Transparency in lightbox
159 × 234 cm

Interview

**Pelenc** In his essay about 'Analytic Iconology', the art historian Hubert Damisch looks into the question of beauty in relation to the Freudian theory of desire, revisiting the myth of Paris through European painting from Raphael to Seurat. It is clear that the female nude from the Renaissance to Manet and Picasso has been the site for aesthetic and libidinal gaming with tradition, a site of transgression of its rules and laws. *The Destroyed Room* is a kind of allegory of the nude, and you have made male nudes – *Stereo* and *The Vampires' Picnic*. *The Giant* is your first female nude. What importance do you give to this subject?

**Wall  I'm not convinced that the nude is such a 'site' on which such transgression is acted out. That's not to deny the historical and even psychological truth of this acting out, but only to place oneself in relation to it. Being 'in relation to it' is not to be outside it or free of it, but not to be simply subjected to it as an inevitable and necessary condition. I don't think it is any longer necessary to make nudes, which might be a way of saying it is no longer necessary to enact transgressions in order to make significant works of art, even modernist art. This is, again, not to suggest that the cultural and social antagonisms which provoke the whole process of art as transgression, from Romanticism on, have been cured or calmed. But the 'culture of transgressions' involves a sort of romantic binarism. Law exists, and the soul is crushed by it. To obey the law is to live in bad faith. Transgression is the beginning of authentic existence, the origin of art's truth and freedom. But modern societies are constitutional; they have written, deliberately, their own foundations, and are continually rewriting them. Maybe it is a sense that it is the writing of laws, and not the breaking of them, that is the most significant and characteristic artistic act in modernity. Avant-garde art certainly operated this way, writing new laws as quickly as it broke any old ones, thereby imitating the constitutional state. The maturation and aging of modernist art maybe brings this aspect more into focus. In any case, the gesture, or act, of transgression seems far more ambiguous in form and content than it has seemed in concepts of art simply based upon it. I feel that art develops through experimentally positing possible laws or law-like forms of behaviour, and then attempting to obey them. I admit this is a completely reversed view, but it interests me more than any other. So I guess the nudes I've done are not intended to be sites for any such gaming with authority. I see them as 'mild' statements, marking a distance from any Philosophy of Desire. Except for the vampires, of course.**

**Pelenc** I think you're dismissing the idea too easily. I was thinking about transgression in a more symbolic sense, not simply in terms of 'shocking the bourgeoisie'. If you say that modern society is constitutional, are you saying that it is like *all* societies in the sense that they are constructed in terms of the main law – the interdiction against incest, which allows language as the symbolic function? Any significant work of art touches on or crosses that interdiction, that borderline, which is also the border between nature and culture. When that border is not approached you have academic art, art made by the application of laws. The production of meaning in poetic language, because it reactivates what Julia Kristeva called the 'archaic body', is equivalent to incest. That is, by means of rhythm, intonation, everything that introduces the heterogeneous law is challenged. It seems to me that the economy of meaning in your work acknowledges this territory.

Wall  OK, I agree that in that sense, my work must involve what you want to call transgression. When I talk about law-making, I see that in the light of the origins of constitutional states, that is, regicide. So there is no question of the application of laws, of academic conformism, except in the sense that we can never simply oppose conformism without in some way internalizing it, participating in it, becoming part of it. The image of pure law-breaking activity, pure violation, pure incestuousness (if you want to call it that), seems to me to be a rhetorical construction, a kind of romantic fiction of the radical avant-garde.

To my mind, the violator is hypothesizing a new or antithetical code, to which he or she conforms often very strictly. I recognize what Kristeva is referring to – the heterogeneity and productivity of the poetic. I identify that with the pleasure created over and over again by the picture itself. But I don't think of it as essential, or as more productive than the 'linear' or impulses towards institutionalization, reiteration, enforcement and mimesis. This is part of not accepting that art is primarily or directly a gesture of liberation, as all avant-garde concepts insist it is.

They are still quarrelling with their own 'Ancients'. In my opinion, the triumph of the avant-garde is so complete that it has liberated what previously had to be seen as the anti-liberating elements in art, or in the process of making art. There are transgressions against the institution of transgression. I think the pictorial has come to occupy this position to a certain extent.

Pelenc  I can follow you on that, but to be a little more specific, your pictures are full of 'micro-transgressions', many of which are involved with themes of violence, particularly male violence. I think of *No, Milk, Dead Troops Talk* or *The Vampires' Picnic*. If we think of representation in terms of a symbolic function equivalent to the Name of the Father, it seems your work has something to say about it but not in terms of 'deconstruction' or 'seduction'.

Wall  The problem is that the rhetorics of critique have had to make an 'other' out of the pictorial. This is the form the history of art has taken, from the beginning of Modernism. This is our 'Quarrel of the Ancients and Moderns'. The pictorial itself is identified with the Name of the Father, with control and domination, and, finally with violence. I think I understand why this has happened, but, as I said, I see that as a necessity imposed by the polemical character of artistic discourse, by the 'quarrel'. So there is truth in the identification. But, rhetorically, this truth has been totalized, and transformed into what Adorno called 'identity'. I'm struggling with this identity.

The violence you see in my pictures is social violence. *Milk* or *No* derived from things I had seen on the street. My practice has been to reject the role of witness or journalist, of 'photographer', which in my view objectifies the subject of the picture by masking the impulses and feelings of the picture-maker. The poetics or the 'productivity' of my work has been in the stagecraft and pictorial composition – what I call the 'cinematography'. This I hope makes it evident that the theme has been subjectivized, has been depicted, reconfigured according to my feelings and my literacy. That is why I think there is no 'referent' for these images, as such. They do not refer to a condition or moment that needs to have existed historically or socially; they make visible something peculiar to me. That is why I refer to my pictures as prose poems.

**The Vampires' Picnic**

1991

Transparency in lightbox

229 × 335 cm

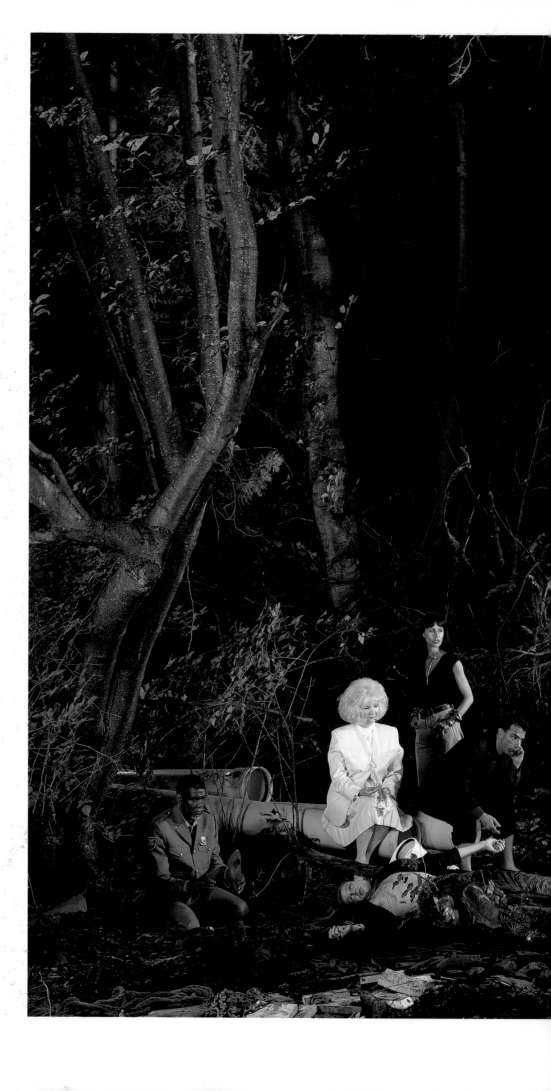

**Pelenc** *The Vampires' Picnic* is certainly a prose poem. I saw it as a kind of
reversed and dark version of the Paris myth, a kind of disintegration of the
aesthetic judgement, and this interiorized violence, this emotional and
pictorial discord seems to have something to do with the symbolic function.

Wall  The feelings of violence in my pictures should be identified with me
personally, not with the pictorial form. These images seem necessary to me;
the violence is not idiosyncratic but systemic. It is repetitive and institution-
alized. For that reason I feel it can become the subject of something so stable
and enduring as a picture. The symbolic function we call the Name of the
Father appears in a process of masking and unmasking, and perhaps of re-
masking. The work of art is a site for this process, and so the work potentially
is involved in masking. But, from that it is difficult to move to an essential
identification of any artistic form with masking alone. This would be to single
out that form as so different that it would have to have a category all of its
own. Any image of a male has to include in some way the identity with the
Father, and so all the problems involved with that are evoked just in the

The Stumbling Block
1991
Transparency in lightbox
229 × 337 cm

process of depiction. Rather than dominating and organizing that experience, the picture sets it in motion in an experimental universe, in a 'play', including a play with tropes of depiction, a play of styles. For example, I think that the nude in *The Vampires' Picnic* signifies the Father function. I wanted to make a complicated, intricate composition, full of sharp details, highlights and shadows in the style of German or Flemish mannerist painting. This style, with its hard lighting and dissonant colour, is also typical of horror films. I thought of the picture as a depiction of a large, troubled family. Vampires don't procreate sexually; they create new vampires by a peculiar act of vampirism. It's a process of pure selection, rather like adoption; it's based in desire alone. A vampire creates another vampire directly, in a moment of intense emotion, a combination of attraction and repulsion, or of rivalry. Pure eroticism. So a 'family' of vampires is a phantasmagoric construction of various and intersecting, competing, desires. It's a mimesis of a family, an enactment of one. I thought of my vampire family as a grotesque parody of the group photos of the creepy and glamorous families on TV shows like 'Dynasty'. The patriarch of this family is the nude who is behaving oddly. In this behaviour he occupies the position of Father, and the discordancy implies something about the vacancy of the symbolic position itself, which can be occupied adequately by a figure who does not perform in a conventional or law-governed way. I wanted to get a lawless feeling, a feeling that things are amiss and at the same time normal – that 'father feeling'.

**Pelenc** In your *Galeries* interview with Jean-François Chevrier(see pp. 104-111) you discussed the 'black humour' and suppressed laughter you thought were in your work. But I see, or hear, another laughter, softer, gentler and maybe more humanistic. This is maybe most evident in *The Stumbling Block*, maybe in *The Giant*, where I sense it to be a nourishing, maternal feeling.

Wall  When I started to work with the computer, I had the idea that I could use the otherworldly 'special effects' to develop a kind of philosophical comedy. *The Giant, The Stumbling Block* as well as *The Vampires' Picnic* and *Dead Troops Talk* are in this genre, as are older pictures like *The Thinker* or *Abundance*. This makes me think of Diderot, of the idea that a certain light shone on behaviour, costume and discourse creates an amusement which helps to detach you from the immediate surroundings and project you into a field of reflection in which humanity appears as infinitely imperfectible. This imperfection implies gentleness and forgiveness, and the artistic challenge is to express that without sentimentality. I guess the key metaphor in these works is 'learning'. We learn; we never complete the process of learning, and so learning is a kind of image of incompletion and limitation but a hopeful image as well. I've tried to express this feeling, and this love of learning, in pictures on the subject of discourse and talk, like *The Storyteller* or *A Ventriloquist at a Birthday Party in October, 1947*. In *The Stumbling Block*, I thought I could imagine a further extrapolation of society in which therapy had evolved to a new, maybe higher stage than it has up to now. In my fantasy, *The Stumbling Block* helps people change. He is there so that ambivalent people can express their ambivalence by interrupting themselves in their habitual activities. He is an employee of the city, as you can tell from the badges on his uniform. Maybe there are many Stumbling Blocks deployed on the streets of the city, wherever surveys have shown the need for one. He

is passive, gentle and indifferent: that was my image of the perfect 'bureaucrat of therapy'. He does not give lessons or make demands; he is simply available for anyone who somehow feels the need to demonstrate – either to themselves or to the public at large – the fact that they are not sure they want to go where they seem to be headed. The interruption is a curative, maybe cathartic gesture, the beginning, the inauguration of change, healing, improvement, resolution, wholeness or wellness. It's my version of New Age; it's home-opathic. The ills of bureaucratic society are cured by the installation of a new bureaucracy, one which recognizes itself as the problem, the obstacle. I think there's a sort of comedy there. It's not really black comedy, though; there's still a little black in it. It's a sort of 'green comedy' maybe – dark green.

I had a phone call from a critic yesterday; she was preparing a talk involving *The Giant* and had connected it to the figure of the 'Alma Mater', a monumental symbol of learning which personifies the university. I hadn't though of that, although I had heard the term 'Alma Mater' ever since I had been a student. *The Giant* is a sort of imaginary monument, and that genre itself is connected with various branches of humour or comedy, for example, the Surrealists' proposals for reconfiguring some of the familiar monuments of Paris. Theirs were usually done in a spirit of *humour noir*. Mine is maybe post-*humour noir*. I associate *The Giant* with two other pictures: *Abundance*, in which the older women personify something intangible – freedom – and *The Thinker*, which was also a sort of hypothesis for a monument after the model of Dürer's *Peasant's Column*. I think both of those works involve some *humour noir*, but *The Giant* is different.

**Pelenc** Earlier, when you were discussing the role of 'talk', of 'voice' in your pictures, you concentrated on speech in terms of the characters in the picture, that is in terms of the narrative. There is another kind of voice in your pictures that signifies but not in terms of the narrative. There is something 'ventriloquial' in the pictures.

Wall  That sounds like what I would call 'style', keeping to the old-fashioned way of describing things. Maybe it has something to do with the elemental illusion of photography; the illusion that something was there in the world and the photograph is a trace of it. In photography, the unattributed, anony-mous poetry of the world itself appears, probably for the first time. The beauty of photography is rooted in the great collage which everyday life is, a combination of absolutely concrete and specific things created by no-one and everyone, all of which becomes available once it is unified into a picture. There is a 'voice' there, but it cannot be attributed to an author or a speaker, not even to the photographer. Cinematography takes this over from photography, but makes it a question of authorship again. Someone is now responsible for the *mise en scène*, and that someone is pretending to be everyone, or to be anonymous, in so far as the scene is 'lifelike', and in so far as the picture resembles a photograph. Cinematography is something very like ventriloquism.

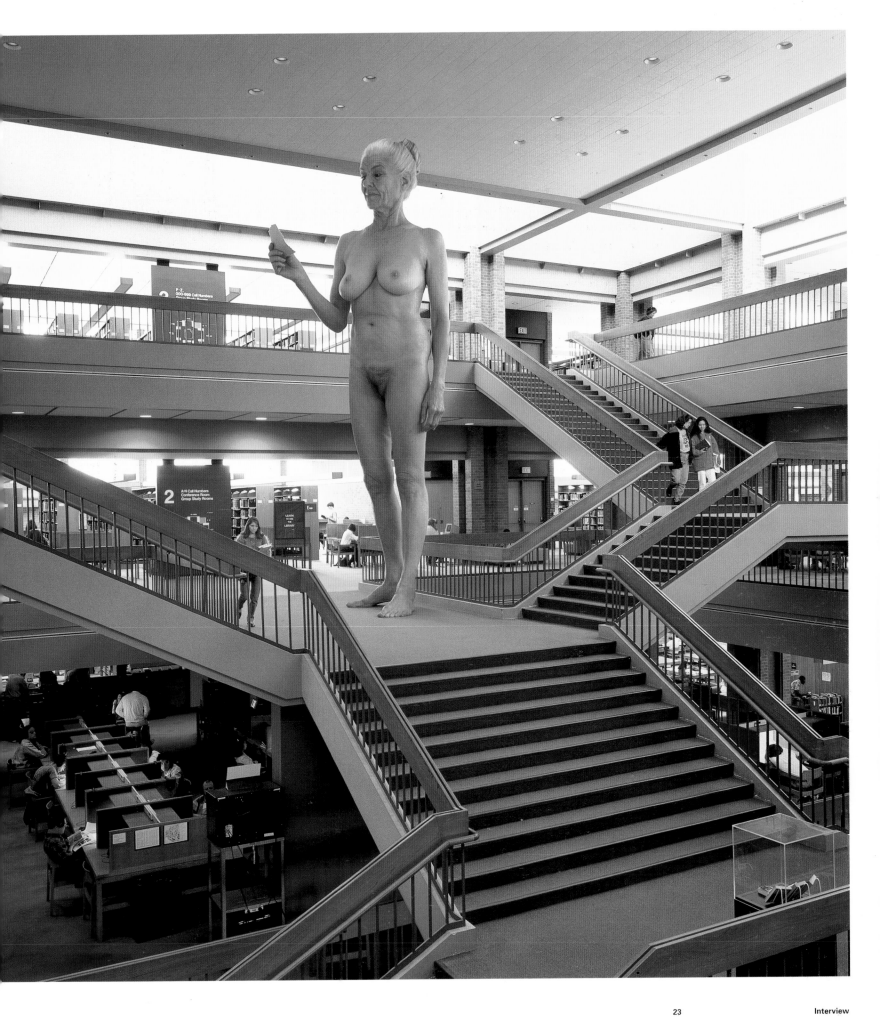

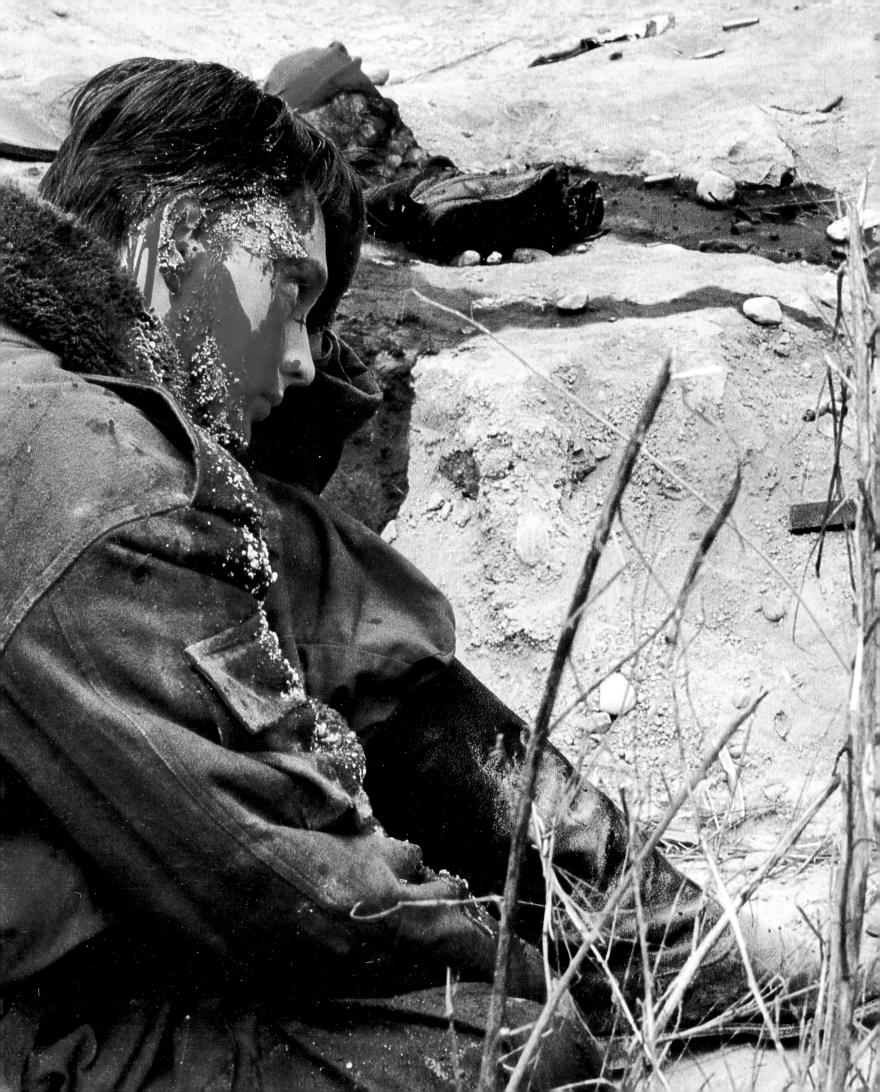

# Contents

Interview Arielle Pelenc in correspondence with Jeff Wall, page 6.  Survey Thierry de Duve

The Mainstream and the Crooked Path, page 24.  Focus Boris Groys Life without Shadows, page 56.

Artist's Choice Blaise Pascal Pensées, 1658 (extract), page 72.  Franz Kafka Troubles of a

Householder, 1919, page 72.  Artist's Writings Jeff Wall Gestus, 1984, page 76.  Unity

and Fragmentation in Manet, 1984, page 78.  Photography and Liquid Intelligence, 1989, page 90.  An Outline for a Context for

Stephan Balkenhol's Work, 1988, page 94.  A Guide to the Children's Pavilion (a collaborative project with Dan Graham, extract),

1989, page 102.  The Interiorized Academy, 1990, page 104.  Representation, Suspicions and Critical Transparency, 1990,

page 112.  Restoration, 1994, page 126.  About Making Landscapes, 1995, page 140.  On Colour or Black and White

Boris Groys in Conversation with Jeff Wall, 1998, page 148.  Update Jean-François Chevrier The Spectres of

the Everyday, page 160.  Chronology page 192 & Bibliography, List of Illustrations, page 210.

How many pairs of quotes within quotes would we need to put around Stendhal's famous phrase, 'beauty is but the promise of happiness', so as to have done with it? And what would having done with it mean? Fulfilling the promise? Perpetuating it as a promise, in other words as deferred fulfilment? Pronouncing it to be done with, protected by the quote marks that quote it? Done with a hope as naive as a promise of fulfilled happiness? Or done with a project as hopeless as fulfilment indefinitely deferred? An early article by Jeff Wall shows that he is perfectly aware of the problem.[1] He knows that if art makes do with positing some idealized beauty as imaginary substitute and compensation for the ugliness and violence of the world, it is giving place to an idea of happiness that is fraudulent and ultimately totalitarian.

Instead of adding to them, the thing to do would be to remove the quotes within quotes, in full knowledge of why we do so. The fact is that Stendhal's forceful dictum might not have reached us had it not been by way of Baudelaire in the opening pages of *Le peintre de la vie moderne*. The fact is that Baudelaire's *modernity* might not have reached us except beneath a layer of dust had Walter Benjamin not passionately exposed its profound ambivalence; and Benjamin's reading of Baudelaire might not have reached us with such an *aura* of critical contemporaneity had it not itself assumed a dialectical relation to the work of Adorno. Now Adorno was not the last to box in Stendhal's phrase with extra quote marks (clearly, I myself have trouble avoiding this little game of quoting quotations), but when he does it, it's with a cutting finality which is hard to get over: 'Art is the promise

of happiness, a promise that is constantly being broken'.[2] This is the conclusion of an interview with Wall by Els Barents:

*Jeff Wall:  The counter-tradition I'm interested in is not just an art movement, it is a whole political culture. And because its politics are based on the material possibility of change, art plays a prominent role in it. It does so because it provides this complicated glimpse of something better that I mentioned before. This glimpse of something 'other' which you experience in art is always a glimpse of something better because experiencing art, is, as Stendhal said, the experience of a* promesse de bonheur, *a promise of happiness.*

*Els Barents:  And how do you think your pictures, which are attentive to the unfreedom and unhappiness of the present, give a promise of happiness?*

*Jeff Wall:  I always try to make beautiful pictures.*[3]

How provocative, quoting Stendhal only to strip away all the quotation marks wrapping him up! However, I would not say that Wall has done away with the weight of historical unhappiness which Stendhal's quotation is bowed down with when Adorno writes it off. When it comes to the representation of poverty (*Abundance*), racism (*Mimic*), exclusion (*Trân Dúc Ván*), gangsterism (*The Agreement*) and all forms of social violence — that of landlords (*Eviction Struggle*), the police (*The Arrest*), young kids (*The Goat*) or between those who are exploited (*Outburst*) — the making of beautiful images does not protect the artist from accusations of 'aestheticizing politics', even if all those images contain an ambivalence of feeling which allows them to be seen as 'politicizing art'.[4] As it is for Benjamin, to whom I allude, in Wall's

images beauty is certainly always 'problematic' or 'aporetic'; but it still remains to be seen very concretely and plastically what kind of beauty we mean. I would feel embarrassed to have to settle for the utopian dimension of his art as a justification for his recourse to the beautiful; as if his saying, not naively, that beauty is the promise of happiness, had enabled him to remake *differently* the history which separates us from Stendhal.

From the numerous interviews Wall has given, I shall draw four themes. The first of these is his insistence on the continuity and legislative action of the avant-garde. Wall simply does not adhere to the idea that the history of modernity is built on escalating rifts; he thinks the avant-garde has written as many new laws as it has broken old ones, thereby imitating the constitutional State.[5] The second is his rejection of quotation. Admittedly, there are few artists with a more sophisticated practice of redeploying and subverting original sources, and of direct or oblique allusion. But these procedures are poles apart from the practice of quotation which prevails among the artists with whom he shares a background in conceptual art; poles apart from quotation conceived as *objet trouvé* or readymade, from appropriation, from re-photographing, from the art of quotation marks. Third is his insistence on the concept of the *tableau*. Although technically he is a practitioner of photography and although the large-format transparency explicitly evokes the cinema screen, it is the pictorial concept of the *tableau* which structures his work, a concept derived from the Renaissance and which, by means of a dialectic of repeated negations and denials, is maintained

throughout the history of modernist painting up to the very last monochrome. Fourth is his rejection of the fragmented aesthetic of collage and photomontage to which the majority of his colleagues in 'photographic conceptualism' have recourse in order to justify their allegiance to the historical avant-garde. His pictures are composed like classical paintings, in a unitary, seamless space. His aesthetic is premodern; the fact that it cloaks a social critique of contemporary life may not suffice to protect him from a rather brutal dilemma: either Adorno's despair, or academicism.

Reading *Le peintre de la vie moderne* today, everybody acts as if Baudelaire was talking about Manet instead of Constantin Guys. And a lot of people talk as if Wall had simply taken upon himself an iconographic project inherited from Manet. From an aesthetic point of view, it is convenient to forgive the poet his error of judgement, but from an ideological point of view, and specifically in relation to the issue of beauty as a promise of happiness, one must agree that Manet does not do the trick. There is no utopia in this bourgeois with his sights (successfully) set on the Legion of Honour, no promise of happiness, but rather real instantaneous and immediate aesthetic delights; so long as the viewer, even the viewer of his day, is open to that beauty of the *shock* which Benjamin loved in Baudelaire and which he rightly attributed to the impact of photographic instantaneity. It is likewise convenient, from a political point of view, to reiterate what has virtually become a cliché in the critical corpus on Wall's work (including his own writings), which is that he has given himself what amounts to the task of being *today's* 'painter of

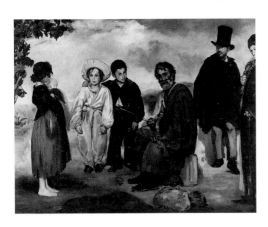

**Edouard Manet**
The Old Musician
1862
Oil on canvas
187 × 248 cm

modern life', just as Manet was in his day. Since painting can no longer assume this function *today*, the painter would become a photographer. The explanation is correct; anyone familiar with contemporary art grasps it intuitively — but it falls a little short. Does this mean that he sees photography as a way of *naturalizing* history and absolving it, of giving the painting of modern life, upon its passage through the medium of photography, a *redeeming* transparency?

Whenever they talk about photography, the majority of Wall's commentators discuss the transparency and its light box installation, to make the point that this has been borrowed from the society of the spectacle and in a reflexive and critical manner turned back against it. Few commentators have veered from the scholarly, interpretative use of the artist's numerous allusions to classical compositions drawn from the history of painting, and have little to say about why the fact that he works in photography should allow him to maintain the same relation to his sources in Manet or Caillebotte as Manet did towards his sources in Watteau, Le Nain or Velázquez. Admittedly, Wall's art prompts scholarly, iconological readings of this kind, which in turn yield a wealth of meanings, including and particularly social ones. This is what has attracted commentators with a background in the social history of art to his work; they find, in a contemporary artist, a mirror of their own attempts at a sophisticated reading, both scholarly and politically aware, of the 'painting of modern life' in the second half of the nineteenth century. This was very honestly confessed by Thomas Crow in an excellent article on Wall.[6] The artist would confirm

the revenge of the social history of art (and of Panofsky) over modernist-formalist history (and over Wölfflin) by producing the painting of modern life which history has not produced. Now, what strikes me about Thomas Crow's article is that nowhere does he take into serious account the fact that Wall has produced this *painting* in *photography*. No doubt this blindness has the unintentional effect, though to my mind one weighted with aesthetic and political consequences, of implying, as I suggested above, that for Wall photography is a way of *naturalizing* history and absolving it, of giving to the painting of modern life a *redeeming* transparency.

There we are, photography *is* transparent. Who says so, and who says so in the first sentence of an article on Edward Weston and Walker Evans written in 1946, is the man who has probably done most to popularize the mainstream of abstract painting, to obscure the importance of the social referent in modern painting or relegate it to the 'literary', to confine iconology *à la* Panofsky to the study of Old Master painting, to promote formalist attention to the treatment of the medium, and to insist on the tropism towards the medium's specificity as the motor of what he calls modernist painting — rather than the painting of modern life. This man, of course, was Clement Greenberg. The article in question begins, 'Photography is the most transparent of the art mediums devised or discovered by man', and ends, 'The final moral is: let photography be "literary".'[7] Wall has admitted to me that this article is of great interest to him, and it is easy to see why. In particular, Greenberg has this to say:

'Photography is the only art that can still afford to be naturalistic and that, in fact, achieves its maximum effect through naturalism. Unlike painting and poetry, it can put all emphasis on an explicit subject, anecdote or message; the artist is permitted, in what is still so relatively mechanical and neutral a medium, to identify the "human interest" of his subject as he cannot in any of the other arts without falling into banality. Therefore it would seem that photography today could take over the field that used to belong to genre and historical painting, and that it does not have to follow painting into the areas into which the latter has been driven by the force of historical development'. [8]

There is nothing to stop us thinking that by relying on this article, Wall is absolving himself, perhaps somewhat perversely, of 'forgetting' the difference between painting and photography. He would not forget the respective specificities of the two media, but would give himself leave to overlook them deliberately. [9] Not only does photography have the right to be naturalistic, but it is urged that it be so, and beyond the right to 'human interest' — in other words to the 'social' — this is the right to a natural relation to representation and beauty which is being rehabilitated. It is above all the right to reclaim the field of genre and history painting. Photography being transparent, it is so in both senses: ideologically as well as materially. It absolves the artist; but of what? I suggested above that the photographer would be allowed to naturalize history, which is problematic. But in Greenberg's mind, what the photographer would be absolved of is more precise: it would be the *historical* necessity of reflecting on the *nature* of the medium. Photography is released from any obligation to be modernist. It is exempted from having to be reflexive, self-critical or self-referential, from having to make the conventions of its practice opaque, in the way that painting has been 'driven by the force of historical development'. But everything changes if in Wall's works, painting is the referent of his photographic practice. One must be perverse enough to push Greenberg's observation to its thorough conclusion. If Wall copes with the paradox of being the painter of modern life by being a photographer, then the paradox closes in on him as a double bind, and he does not escape the 'force of historical development' which has compelled painting to take the route to Modernism. I want to show that this is the case, and that the beautiful, in his work, testifies to this. Knowingly, deliberately, in an explicitly self-critical or self-referential manner, the double bind is taken on. Wall only really copes with being the *painter of modern life* by being at the same time a *modernist photographer*. In his use of the medium, he reflects the medium's immanent features. He does not presume the conventions of his practice to be transparent, natural or innocent; he makes them opaque.

How does he do this? Wall has thought a lot about Greenberg's observation on the transparency of photography, and he knows that if the double bind of his relation to photography as a painter is to be taken on, it will be over this technical question of transparency, because the transparency of the picture plane is *the* convention common to both painting and photography. Common, at least, to the pictorial tradition inherited from the

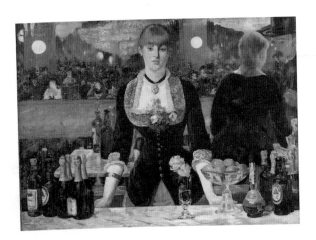

**Edouard Manet**
A Bar at the Folies-Bergère
1882
Oil on canvas
96 × 130 cm

Renaissance and regulated by monocular perspective, and to photography in as much as it mechanizes this tradition and automatically produces images in perspective, that is, *tableaux.* Technically, in perspective theory the picture plane corresponds to the material surface of the picture, a physically opaque surface which, however, is assimilated by convention into an imaginary transparent pane of glass which slices the visual pyramid perpendicular to the gaze of the painter or the viewer. Throughout the history of modernist painting — that history which Greenberg describes as the adventure of flatness, and which runs broadly from Manet to the white monochrome canvas — painters have progressively given way to the physical opaqueness of their support and thereby made opaque, denaturalized or 'disabsolved' the convention of transparency required by perspective. If photographers want to do the same, they have to render opaque this same convention of transparency by giving way to the physical characteristic of their own support, which is that very transparency. In a painted picture, even Old Master painting, the physical presence of the pigment, the brushstrokes, the grain of the canvas, etc., testify to the materiality of the picture plane, whereas the picture plane is invisible in the photograph. How can it nonetheless be made visible? This is the problem which Wall has set himself and has solved with *Picture for Women,* made in 1979. The problem is very simple, the clear-cut solution likewise, but putting it into words is fiendishly complicated. *Picture for Women* is more than a remake of Manet's *A Bar at the Folies-Bergère,* more than a speculation on the 'male gaze', more than a

lesson, taking place in a classroom, on the desiring nature of the dialectic of looking and of addressing the viewer, even if it is all that too. It is the work with which Wall has once and for all made visible the invisibility of the picture plane in photography, while also respecting it. His solution is literally to have made a mirror capable of holding the image, a mirror which is never opaque (something photography cannot be), but is simultaneously transparent and reflective. He has taken literally the comment of a contemporary of *A Bar at the Folies-Bergère*: *'mais ce diable de reflet nous donne à réfléchir'.*[10]

Let us describe *Picture for Women* from the point of view of the photographer-painter, a point of view which we can infer from ours in front of the cibachrome. Wall is positioned in front of the mirror which he is photographing. We know this because we can see him in the mirror-picture. We can grasp that he is outside it because we can see him holding the shutter release mechanism of a camera, and when we see the camera we realize that the photo was taken in a mirror. It is hard to tell which way Wall is looking, and it is only by imagining a bird's-eye view of the whole scene that we can be sure he is seeing the woman facing him in the mirror and is not looking at her back in the real space of the studio. We know that the young woman is in fact on the same side of the picture plane as the photographer. She is, therefore, a viewer and no longer a figure; hence, *Picture for Women*, a picture addressed to women.

The direction of her gaze provokes a disturbance which has much to do with the fascination we experience. Hers has not the veiled melancholia of the barmaid's gaze in *A Bar at the Folies-Bergère,*

but, as in Manet's picture, and moreover as in most of the Manets, her eyes are fixed just past the viewer's gaze. The viewer is not represented in the picture, but the position of his or her eye is: this is the vanishing point. Here, the vanishing point has a 'body' but it is not our body, it is the camera; we know this because we can see it and we understand that it has photographed itself in a mirror. Let us imagine *Picture for Women* bereft of the outer sections of the triptych (a triptych is actually marked out by the two vertical rods supporting the spotlights), so that all that is left in the image is the camera. There would be no way of knowing whether this is a camera photographing itself in a mirror or one camera photographed by another. The camera is an 'unknowing' eye. It is in fact the only player in this game that does not 'know' whether it is looking into a mirror or through a pane of glass. It does 'know', however, that it is looked at, since it is looking at the woman looking at it. We, on the other hand, have trouble working this out, and it is not the least intriguing aspect of this work that, despite its intuitive immediacy, it jolts us into such strange blindness vis à vis this camera which represents us without seeing us; the camera is both our eye and our blind spot.

It seems to me that the beauty of the image derives from this difficulty — a beauty which has as much or as little to do with the depiction of relations between the sexes in modern life today as the beauty of *A Bar at the Folies-Bergère* has to do with the dealings between the clientele of the famous café-concert and the '*marchande de consolation*' behind the bar. Not that the reading of the socio-logical referent in either case lacks pertinence to a formal reading, and vice versa. T.J. Clark, to whom we are indebted for an acute reading of the sociological referent in the *Bar* (although a touch forced when it comes to the '*marchande de consolation*'), has also shown how Manet's shorthand suits his subject, how the insistent flattened space of the picture demonstrates its resistance to interpretation, how the 'errors' of perspective are used to build up uncertainties of vision which are also uncertainties about the identity of the seer and the seen. And though he says nothing about the beauty of the picture, his impassioned description of it is no less a sign of how he has been affected by it.[11] The *social* historian of art in T.J. Clark does not propose the painting of modern life as an alternative to modernist painting, he releases the latter from its formalist straitjacket so as to rediscover the social meaning of the former. When making *Picture for Women*, Wall took this two-way movement for granted. Rather than being a classical kind of beauty, the aesthetic functioning of *Picture for Women* is modernist and it is pictorial, while being at the same time specifically photo-graphic. I can think of no photographic image that has rendered the invisibility of the picture plane better than this one. Everything is explicit in this image, its entire procedure is avowed, nothing is concealed and its total visibility is blinding. It is the evidence that a modernist step can be taken in photography, one that is not an imitation of pictorial Modernism like that of so many pictorialists, but equivalent to it. That this modernist step is also necessary is a logical outcome of the task which Wall has set himself: when it is up to photography to paint, then photography is 'driven by the force

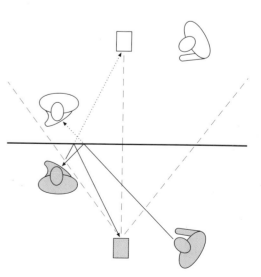

**Picture for Women**, diagram by the author

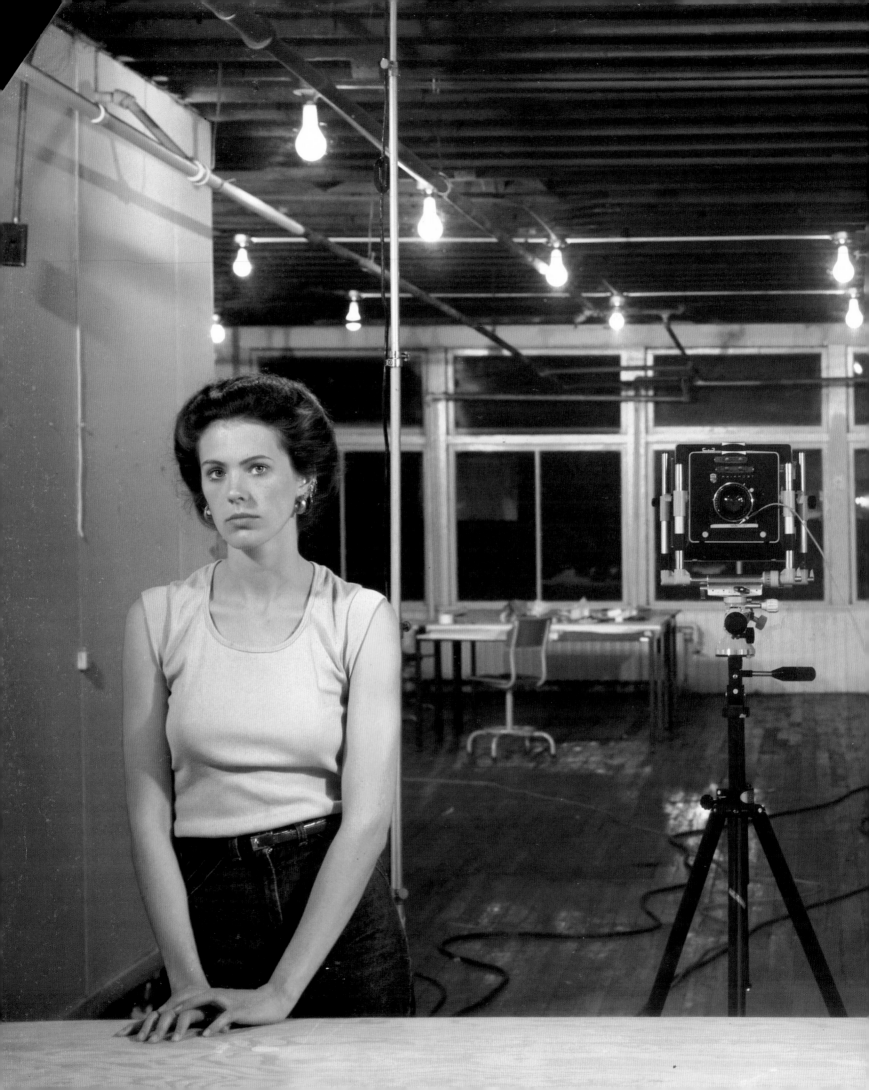

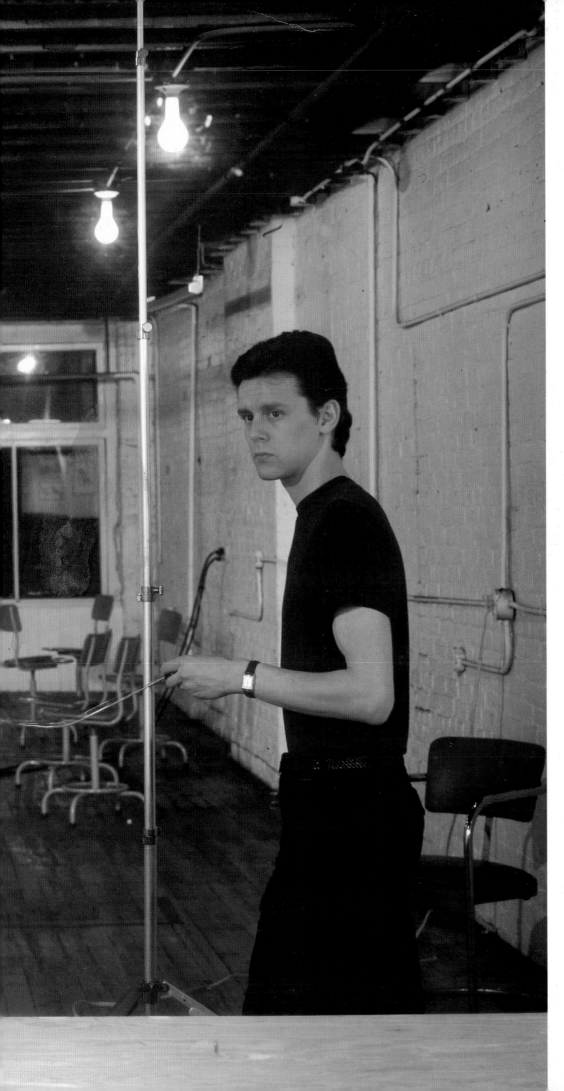

of historical development' to reflect within itself its own relation to painting.

It is quite possible to take over Greenberg's general schema of explanation for the history of modernist painting while at the same time displacing certain value judgements. It is a matter of the individual aesthetic appreciations one makes or has learned to make. Greenberg long maintained that Cubism furnished all subsequent painting with the idiom vis à vis it absolutely had to locate itself if it wanted to live up to the ambition of the masters. He saw Cubism as spelling the triumph of illusionism turned against itself, the victorious struggle of the optical with an explicitly tactile sense, and a new principle of the picture's unity which more than ever stresses the integrity of the picture plane. For me, the watershed point which took modern painting towards abstraction was not Cubism but Cézanne. I have tended to see in Cubism a manner of dealing formally with a problem which in Cézanne was spatial, tackled by him head-on and resolved by the Cubists with a compromise solution. How, when the scaffolding of perspective can no longer be trusted, to demonstrate that there is, as Cézanne said, 'air between objects in order to paint well'? How to locate figures in their space without recourse to perspectival convention or without settling for a decorative flatness which dispenses with space, in the manner of Maurice Denis or Gauguin? Cézanne's solution is an effectively sustained perceptual contradiction, a tension between the hollowing out of the canvas towards the vanishing point inferred from the habit of natural perception and from the conventions of perspective, and the swelling of the canvas out of the picture

plane, produced by the interplay of the patches of colour. In Cézanne the integrity of the picture plane is a total spatial outcome, whereas in the Cubists it is the result of the summation of fragmented gestalts, of numerous mutually contradictory figure/ground relationships, artificially unified by an orchestrated set of grisaille tonal values.

Take Wall's work, *The Drain*, made in 1989, and forget the iconography. Forget the two young girls with their ambiguous games and their half child-like, half-womanly postures. Forget any storyline the image might suggest and any free associations it might prompt in you. Forget the almost provocative arched stance of the girl in the short skirt and the other one's studied pose of fright. Forget that they are still playing at scaring themselves, like children drawn to explore the unknown, and that perhaps a graver fear assails them, a budding woman's fear as her first period looms. Forget that the black hole of this mysterious aqueduct is perhaps a waste outlet, a drain, and that an outflow of red water — of rust or of blood — stains the clear water on the left of the image. Forget today's adolescents and the painting of modern life. Forget even Manet, forget the resemblance of the young girl on the right to Victorine Meurent; forget the carriage of her head and above all the curve of her cheek and chin which resembles (but reversed left-right) that of Victorine's face in *Le Déjeuner sur l'herbe*. Forget that her gaze, again like Victorine's, is fixed precisely to one side of yours. Don't take Poussin's advice to Chantelou, don't read the story and the picture, read only the picture. Be like Cézanne and 'forget everything that has come before us'. And now, look at Cézanne's

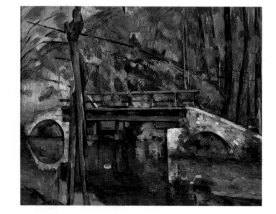

**Paul Cézanne**
The Bridge at Maincy, near Melun
1879-80
Oil on canvas
58 × 72 cm

**Survey**        34

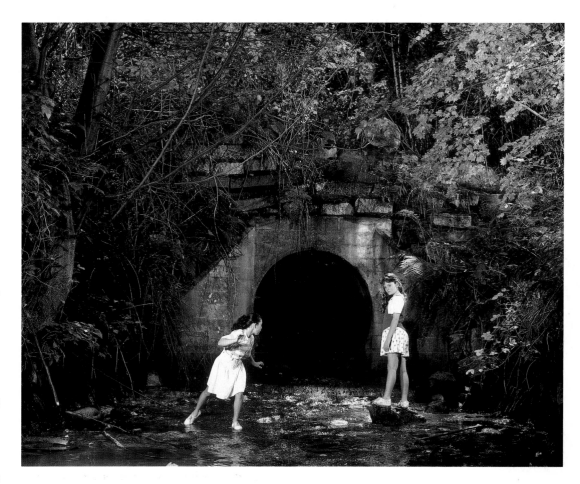

**The Drain**
1989
Transparency in lightbox
229 × 288 cm

*The Bridge of Maincy*.

   Of course, you have to know how to look at a picture the way Freud reads a dream, by bringing condensations and displacements into play. The three arches of *The Bridge of Maincy* are condensed into one in *The Drain*, and the 'bubble' made by the reflection of the left-hand arch in Cézanne's picture, and which seems so oddly convex where it ought to be concave, has shifted to the centre to form that gun-barrel mouth which is coming straight towards us where perspective ought to make it recede. The dry stones which texture Cézanne's right-hand arch have come to take the place of the bridge's roadspan; and the horizontal it forms is virtually at the same height where it meets the tree which, on the left, fans out its foliage in both compositions. The foliage, with its invasive greenery, blocks the whole horizon in the Wall, and in the Cézanne only lets a little patch of sky show through up on the left. Make an extra effort of imagination and don't just put the narrative and sociological themes to one side; physically remove the two figures from Wall's picture and imagine the resulting space. You will then see, to the left of the rock on which the right-hand girl was perched, and on a horizontal line running from the base of this rock to the feet of the left-hand girl, a white, oblong shape reflected in the water. It is in the Cézanne, right under the bridge span. Now take this away from the Cézanne, and you will see something very odd take place. Traditional perspective, 'photographic' perspective, reclaims its rights. The tree moves into the foreground, the picture pulls away towards the vanishing point, and the plane of the water becomes horizontal again. It was not just the left-hand arch and its

reflection which swelled out like a bubble, it was the whole picture which formed a convex space in contradiction with the perspective one would expect.

   The whole point about Cézanne is there, in that white stain which draws forward, away from the picture plane itself, pulling all the space with it, setting the water plane upright without however belying its horizontality, organizing the unity of the picture around a point which is not the furthest from the eye, as in perspective, but the one closest to it. In the last views of the *Montagne Sainte-Victoire* it is the interplay of myriad little planes of colour that produces this convex curving of space charac-teristic of Cézanne's painting. He was perfectly aware of it:

   *'For a long time I found I couldn't, didn't know how to paint the Sainte-Victoire, because, like anyone who doesn't look, I imagined the shadow*

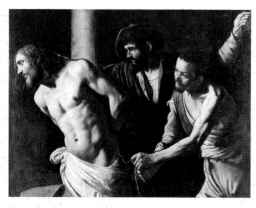

**Caravaggio**
The Flagellation of Christ
1607
Oil on canvas
134 × 174 cm

*as concave, whereas, you see, look, it's convex, it recedes from its centre (…) That's what has to be rendered. That's what you have to know. That's the bath of science, if I might say, where you have to dip your light-sensitive plate'.*[12]

I shall return to that 'light-sensitive plate' and its 'bath of science', but before that I should stress that, though I hope the comparison I have just made is pertinent, Wall is not aware of it. He always has an extremely acute sense of his own iconographic borrowings. He is also fully aware of the 'Freudian' mechanisms whereby he recomposes them — as in *The Arrest* (1989), which condenses several of Caravaggio's pictures, or *Stereo* (1989), which is a displacement of *Olympia*. But here it is not a matter of iconographic borrowing, or hardly at all, and it is certainly not a quotation connecting two themes or two subjects. Here we have a reminiscence which is unacknowledged as such, a secret recall of that *Heimlichkeit* which resides in all *Unheimlichkeit*, an unconscious encounter with something déjà vu. Wall has assured me that he has never in his life made a conscious iconographic reference to Cézanne in any of his works, nor has he really studied him, nor read his biography; this, he says, does not stop him from having the greatest admiration for Cézanne or from having him in mind, plastically, when composing.[13] He says he found the location for *The Drain* by chance. I cannot stop myself from thinking that what triggered his decision to opt for that particular location was that sense of something being strangely familiar which Freud analyzed in his study of Jensen's *Gradiva*.[14] *The Bridge of Maincy* is now in the Louvre and I cannot imagine but that Wall has seen it more than once.

*The Drain* was made, in Cézanne's phrase, *'sur le motif'* — from what was visually present in nature — but in this case the motif is a mnemonic condensation of history and nature, of Louvre and suburbia.

With the figures in *The Drain* imagined to be taken away, the spatial outcome is undeniably Cézanne-like. Replace them for now and there occurs what happened when we took away the white reflection in the water from *The Bridge of Maincy*: the space again becomes scenographic and photographic, and with the direction of their gaze the two girls illustrate Cézanne's contradictory operation of perspective, one of them peering into the black hole of the aqueduct, the other looking out towards the viewer. We can again read the story and the painting, but the story, among other things, narrates the painting. A marriage of Cézanne and Manet, so to speak, a blend of two historically precise beauties, is articulated without the artist's knowing and yet in such a way that in Wall's return to the iconological project of the painting of modern life, one powerful moment in the history of modernist painting resists just beneath the surface.

The somewhat surprising discovery of a Cézanne-like motif and space in Wall's work leads us to look for others which would corroborate them. No other of his cibachromes displays such a striking resemblance to a specific work by Cézanne; but there are several which reactivate, to my mind far beyond any mere coincidence, one theme which was for Cézanne a heuristic motif, crucial to the elaboration of his conception of pictorial space in the years 1870-80: the theme of the winding road. Wall approaches it straightforwardly in *Steve's*

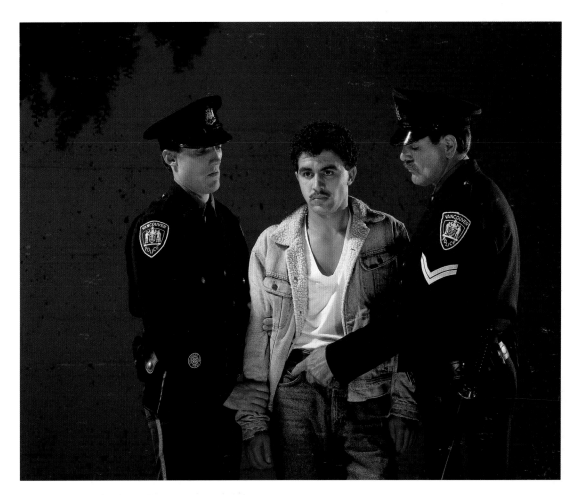

*Farm, Steveston* and *Park Drive*; but we are reminded of it in countless other works — landscapes with or without figures or genre exteriors like *The Bridge* (1980), *The Old Prison* (1987), *The Jewish Cemetery* (1980) or *Eviction Struggle* (1988) — wherever the choice of an oblique point of view sets a fine curve into the environment, frequently a road or a bridge, sometimes a water course or the edge of a lawn, its plastic effect not just that of inscribing a shape, but of curving the whole space. That was indeed the function of the winding road for Cézanne, as a provisional solution which still depended on the picturesque character of the motif. Wall's strictly intuitive adoption of the winding road made him choose a Cézannean motif allowing him to wrongfoot perspective, contradict the automatic illusionism of the *camera obscura* and preserve the integrity of the picture plane. Not as flatness, however (a word which is decidedly ill-suited to Cézanne), but as bulge. 'There has to be a bulge', Cézanne told Gasquet.

If we had to test out a bulging, optically swollen space in one of Wall's works, my choice would be the furthest imaginable from Cézanne: *Dead Troops Talk*. Here again, forget the subject, forget the war in Afghanistan and the gory treatment thereof, forget the tragedy masked as grotesquerie or vice versa, forget the indictment of war, if that's what it is. Forget too the bogusly classical pyramid composition (which is in no way dense enough really to be classical), forget its parody of the *grandes machines* like Baron Gros, Repin or Meissonier. Forget even the scholarly allusions to the *The Raft of the Medusa* and the moral lesson they contain. But remember that the set-up of this scene was totally manufactured in the studio. Wall did not go *'sur le motif'*, he imagined the set, conceived it and constructed it freely, with no constraint other than having to think, simultaneously, like a stage director arranging his actors in a real depth of space; like a painter composing a space from a plane; and like a photographer (or a 'filmmaker of the still image'), lighting the scene and knowing where to place his camera. Then you will be struck by the fact that this image has no horizon, that the eye is drawn from the top of the picture to the middle by a curved pathway; that the central group of soldiers is arranged on a very artificial entablature, like one of Cézanne's fruit bowls sitting on a table; that the ground falls away from this towards the bottom of the picture like a tablecloth, especially towards the right; and that towards the left it rises and dissolves

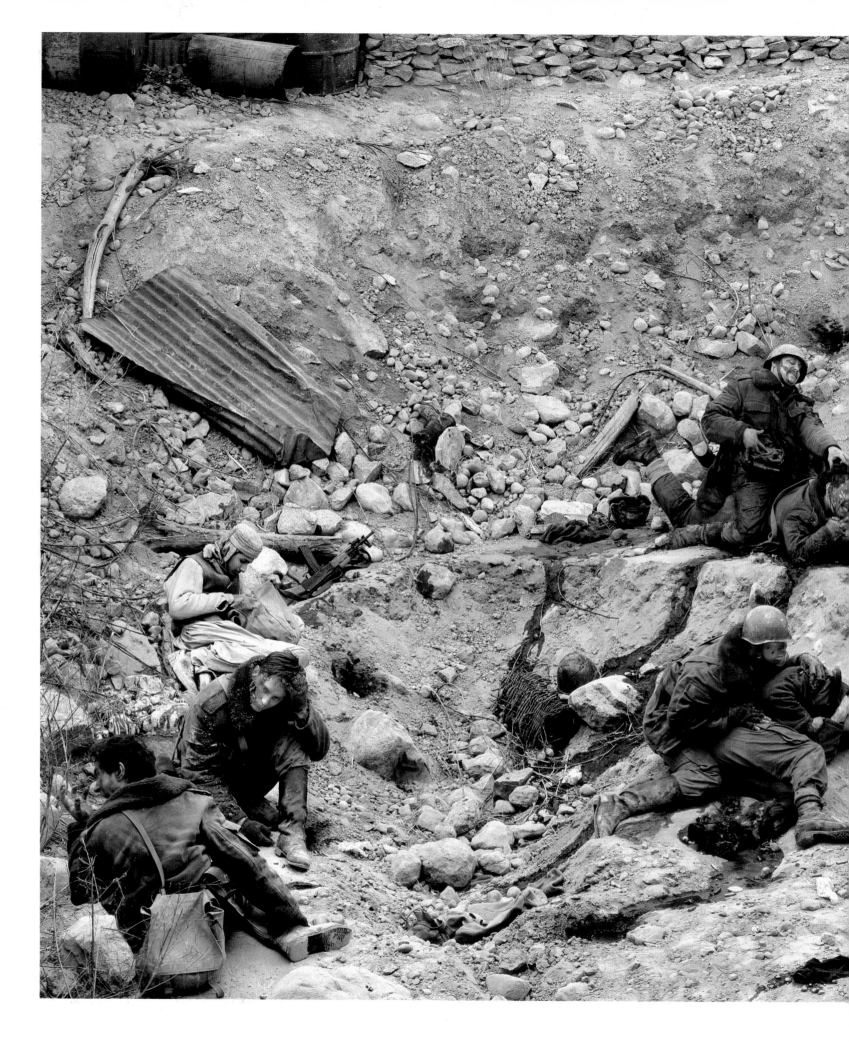

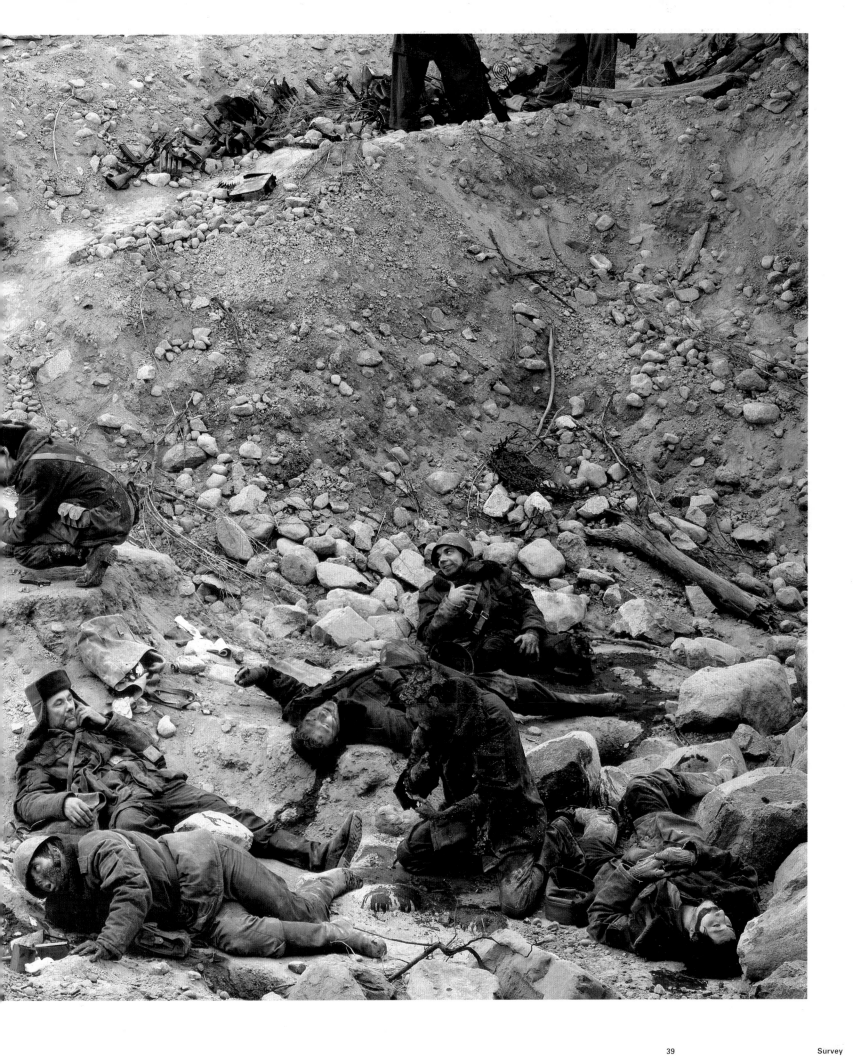

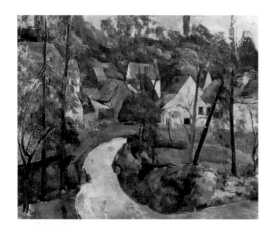

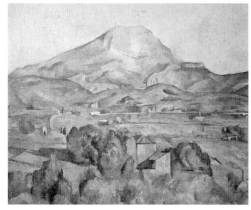

**Paul Cézanne**
Turn in the Road
1879-82
Oil on canvas
60 × 73 cm

**Paul Cézanne**
La Montagne Saint-Victoire
1878- 90
Oil on canvas
73 × 92 cm

into the vertical, as in the still lifes where Cézanne uses a tablecloth, or draperies, to fold back the horizontality of the table, into the verticality of the picture. Then, look carefully at the right hand side of *Dead Troops Talk*, the crater wound about by the line of the curved pathway, which is extended by the back of the soldier hunched down in the middle, then by a fall of loose stones and by the outstretched arms of the soldier lying on the ground. Since it is a crater, a hole made by a bomb or a dugout, it is concave. No, it is convex. Cézanne produced exactly the same thing in the *Turn in the Road* in the Museum of Fine Arts, Boston (Venturi 329).

The location Wall chose for *Diatribe* in 1985, an apposite work for reintroducing issues of social content into the strictly plastic discussion, also echoes the turn in the road. These have been abundantly commented on by the artist, who says he wanted to make visible proletarian motherhood (which is as scandalously invisible as its reverse, proletarian prostitution, is flagrantly visible) by picturing two impoverished young mothers, probably unemployed single parents, engaged in vehement philosophical debate as they walk along.[15] They are turning the bend in a dirt road which cuts across the waste ground at the edge of a complex of prefabricated housing, and where the overgrown vegetation is a patent sign of municipal neglect. Thomas Crow has compared this image of suburban poverty to a small picture by Van Gogh titled *Au confins de Paris*, a picture which T.J. Clark has used a great deal to support his reading of the fringes of Haussmann's Paris.[16] The comparison, which is thematically very apt, has nonetheless struck me as inadequate in plastic terms, as if,

as far as Crow was concerned, it was irrelevant to the work's social meaning whether the road from which the two young women emerge was curved or straight. In the Van Gogh it is indeed perfectly rectilinear and fades away towards the picture's vanishing point. What is interesting, however, is that Wall thought he wanted a straight one; and yet, the fact that it was ultimately curved was, again, by virtue of the artist's chance encounter with the familiar, the déjà vu:

'*For* Diatribe, *I was looking for a straight road at the edge of the city, and I couldn't find one. Then finally I saw this curved lane and thought "this is it". It's like something is in the back of your mind, you don't know it in advance, but you recognize it when you actually experience it (...) When I recognized this space, this lane, I recognized a whole lot of other things that I wanted in the picture which I wasn't aware of before. I realized that this road set up a spatial situation that strongly recalled the classical landscapes of Poussin*'.[17]

Someone whose aesthetic experience of painting has primarily been formed by modern painting cannot but filter Poussin through Cézanne's 'remaking Poussin from nature'. Take for example the *Landscape with Man Pursued by a Serpent* in the Montreal Museum of Fine Arts (a museum which Jeff Wall must have visited). A viewer more familiar with modern painting than with Pliny the Elder, or Virgil, will naturally tend to concentrate attention not on the figures but on the mountainous landscape of the background, and to make the comparison (which is quite astonishing) with some of Cézanne's *Sainte-Victoire*'s (Venturi 454 and 455). With *Diatribe,* Wall evokes Poussin's

*Landscape with Diogenes* in the Louvre. The figure of Diogenes breaking his bowl and discovering the stoic virtues of poverty underlies the logic whereby Wall invests the two women in *Diatribe* with a philosophical moral; and, like them, Diogenes and his companion move forward into the foreground of the picture as they emerge from a winding road, which twists away across the countryside far into the distance. But the way of seeing which prompts Wall to pick out the lower right-hand corner of the *Landscape with Diogenes*, and organize the entire composition of *Diatribe* on it, goes back to the same aesthetic habitus as the one which reveals a *Montagne Sainte-Victoire* in a fragment of *Landscape with Man Pursued by a Serpent*. This zooming in on pictures titled *Landscape with ...* strikes me as rich in implications, foremost among them the idea that the 'something in the back of your mind', which made him choose this curved path rather than the straight road he was seeking, was not just Poussin, but Poussin filtered by Cézanne. Wall goes on to say this about Poussin:

'*He rarely, if ever, uses sharp perspectival recession because it's too dramatic, too irrational. Poussin knew that the vanishing point of the perspective system is the irrational point which permits you to call the whole rational structure into question, and so he usually hides it, as all classicists do*'.[18]

For anyone wanting to confront the vanishing point's basic irrationality, hiding it behind the sinuosities of a winding path is one expedient. Poussin had to make do with it because, as the contemporary of Descartes and heir of Alberti, he belongs to classical culture and it could not even enter his head to question the legitimacy of the

latter's *costruzione legittima*. Wall has to make do with it because, as a photographer, his camera incorporates Alberti's construction and reproduces it ready-made, whether the artist likes it or not. Cézanne made do with it provisionally at the time of the winding roads. But once he realized that he could deploy colour to contradict the rationalist expedient of legitimate construction, he no longer hid the vanishing point, but showed its irrationality by inverting it into the closest point, and by bringing it out to meet the eye of the viewer. There is still a touch of this in *Diatribe,* half-way between Cézanne's solution and Poussin's expedient, on the left side of the image where the convexity of the little mound covered up with branches masks the false vanishing point towards which the bend in the road leads the eye.

*Diatribe* is far from being Wall's most convincing work, perhaps because it is ruled by theoretical intentions that are too complex, too knowing and deliberate, and because it leaves too little room for those surprises that come from the unconscious, whatever the artist might say. We have to compare it to *The Crooked Path*, of 1991, to grasp that, while falling short, its relative failure is a measure of Wall's ambitions in this work. *The Crooked Path* is more modest but distinctly more successful. The winding road has been replaced by a broken, twisted track. The chance meeting with a motif which touches on reminiscences buried in the unconscious has its echo in the motif itself, since the track has been formed by a succession of hundreds of people who have, without thinking, followed in the footsteps of those who went before, beating out the same little detour, the same

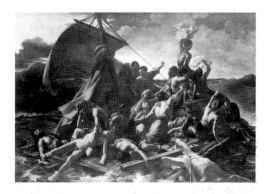

**Théodore Géricault**
The Raft of Medusa
1819
Oil on canvas
491 × 716 cm

sidestep whose original purpose is long gone.[19] The vanishing point is not hidden by a curve in the path, far from it; after some apparent hesitation, the path heads straight for it. Photography does not escape perspective. And yet, the Cézanne-like bulge is there, assisted by a very high horizon and a vast foreground — both extremely rare in classical painters but common in Cézanne. Ultimately, and this is the modesty of this work — but a modernist modesty — this is just a landscape.[20] Which is to say a *motif*, in Cézanne's sense. The term *motif* means that with Cézanne (and already with Monet), landscape was no longer one genre among others. It stood for painting in general, a pure pretext for pure painting. It was here that the way to the mainstream, the way to abstraction, really opened up to become the modernist motorway that it would be, down to the very last monochrome. At the time of Poussin and Lorrain, when landscape began to assert itself autonomously, it was as a *genre* that it did so, and this was a very specific genre: the *landscape with figures*. This conception of landscape is exactly the same as Wall's. Or rather, Wall is aware that it is in this classical conception of landscape, *à la* Poussin, that it crystallizes as a genre:

> '*In making a landscape we must withdraw a certain distance — far enough to detach ourselves from the immediate presence of other people (figures), but not so far as to lose the ability to distinguish them as agents in a social space. Or, more accurately, it is just at the point where we begin to lose sight of the figures as agents, that landscape crystallizes as a genre*'.[21]

Poussin could have said the same thing, only he would have replaced 'social agent' with 'antique

**Nicolas Poussin**
Landscape with Diogenes
1648
Oil on canvas
60 × 221 cm

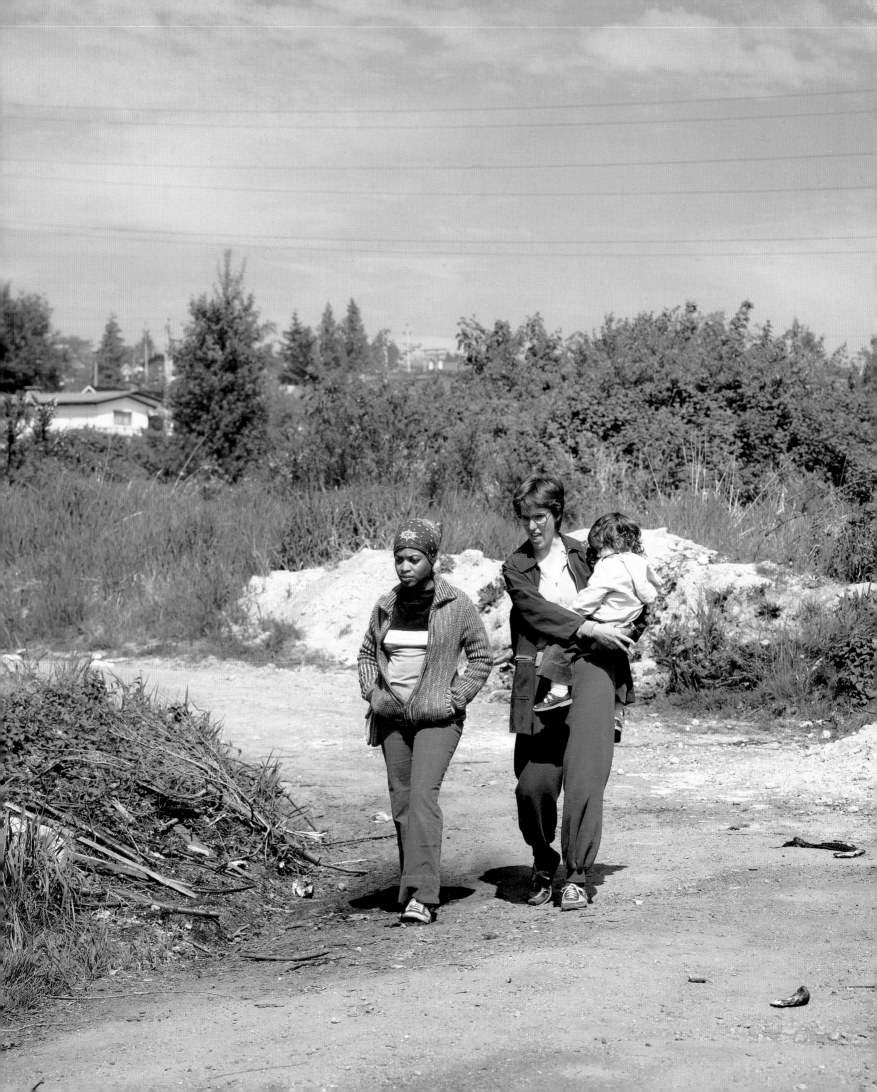

hero'. The scale of the figures in relation to the space in a Poussin landscape is worked out in such a way that the connection between the natural beauty of the landscape, a pretext for pure painting, and the moral lesson embodied in the figures, accessible to the humanist viewer who has mastered his Pliny and his Virgil, is as taut as can be, yet cannot be undone at the expense of one or other pole. *Diatribe* is not a landscape, neither as defined above, nor as common sense would have it. It is a landscape, nonetheless, a *landscape with figures*, if we go by what the artist has said. I'm afraid it fails precisely because we have to go by what the artist has said. By zooming into the lower right corner of Poussin's *Landscape with Diogenes,* Wall magnified the social agents at the cost of the social space, because that was specifically the political intention of *Diatribe*, the lesson of the fable, accessible to those who have not mastered their Pliny and Virgil, but their Walter Benjamin and their T.J. Clark. When read allegorically, the figures are set deliberately too close within the space of the picture in order to compensate for the fact that, as agents in real social space, they are too far away: distant, marginalized and ignored to the point of being, as Wall says, invisible.

We often learn as much from an artist's failures as from his or her successes. *Diatribe* verges on being a politically correct but aesthetically unconvincing work, especially now that we no longer believe, as Benjamin could still pretend to believe in the thirties, that politicizing art is the alternative to aestheticizing politics. But at least this work does pinpoint Wall's aspiration in venturing to lay claim to Stendhal's phrase, 'beauty is but the promise of happiness', while feigning to ignore what became of it when it failed in Adorno's 'art is the promise of happiness, but a promise that is constantly being broken'. At least the ambitious failure of *Diatribe*, when compared with the modest success of *The Crooked Path*, shows the very narrow — and very crooked — path along which Wall is trying to convey the iconographic project of the painting of modern life, so that it might not get lost in the dead end where the modernist motorway of the mainstream has driven it; and therein lies its interest for me. This path is the question of genre.[22] If modernist painting begins when landscape is no longer a genre but a motif, a pretext for painting in general, then it ends at the point when monochrome painting has become a genre, a specific convention. Then the question of its beauty — whose modernist definition is 'the integrity of the picture plane' — has definitively ceased to be the bearer of an interrogation of pictorial space as standing for social space.[23] Greenberg's flatness founders in the decorative, at the point when the promise of happiness is the concern only of those permitted by the art world to enjoy, *hic et nunc*, a little happiness promised by the conventions of the monochrome genre; and when the genre deceives them about the assumed unity of space it allows them to see. When one gets to this point in history (reached in Wall's youth, when various painters of monochromes, himself included, gave up painting for conceptual art), then it is a delusion to reverse the road which runs, in painting, from Manet to monochrome painting; for the memory of the social meaning of pictorial space is already lost. It is as though Wall had gone back to a fork in the roadway

of history, to that very moment when, around Manet, painting was registering the shock of photography; and as though he had then followed the route that had not been taken by modern painting, and had incarnated the painter of modern life as a photographer. This is a fiction, for one cannot remake history. And it would be a revisionist fiction if beauty as the promise of happiness remained still to be conjugated in the future, in keeping with the utopian project of modernity. In this case, Adorno would brutally remind us of the reality of our disenchantment. But in Wall we can discern a conception of the promise which is more Benjamin's than Adorno's: as a promise which history has not kept, and which it is not a matter of fulfilling or deferring any further, but whose brief and flashing memory is to be seen shining out at the moment of peril, in what Benjamin called a 'dialectical image'.[24]

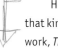 Here, to conclude, is a dialectical image of that kind, in my view Wall's most accomplished work, *The Storyteller*, made in 1986. In it there

shines out that brief moment in the history of modernist painting represented by the Manet of the 1860s, Manet the painter of modern life. Take time to look at it. All it takes is an elbow on a knee, one tiny detail, for *Le Déjeuner sur l'herbe* to come unmistakably to mind, but sufficiently transformed for you to wonder, 'where have I seen that before?' And you only have to have recognized that detail for the dialectical image to trigger all its questions: why has it been transferred from a woman to a man, from a nude to a clothed figure, from the left of the composition to its centre? Why has it been reversed like a mirror image? And why in place of Victorine looking into your eyes is there a young woman disregarding you and talking; and why is she talking to two men who are disregarding you and listening to her? And why does the trio in *The Storyteller* have the same decentred place as the still life in the foreground of the *Déjeuner?* Associations come thick and fast; you tell yourself that if this rather heavyset woman in the white sweater, sitting on

the border of two spaces, seen with her back
three quarters turned and her head in profile, is
somehow reminiscent of the *Nymph Surprised*, then
her companion in the red shirt can easily be seen
as all of Manet's supine women superimposed with
the reclining pipe-smoker in Seurat's *Grande Jatte*,
the only obviously working-class figure in that
other great painting of modern life. Jeff Wall did
not draw these figures, with all their associations,
from his more-or-less unconscious memories this
time, but he has planted them in your mind, so
that you might tell yourself that the memory of *Le
Déjeuner sur l'herbe*, which *The Storyteller* so
magnificently reactivates, is no mere accident.
But is it accidental that *Le Déjeuner sur l'herbe*
was the painting which *par excellence* jostles all
the genres together in a single space — a still life
in the foreground, a nude on the left, a genre
scene in the centre, a landscape in the background,
a contemporary history painting in the manner of
Courbet and even, if I am to take Michael Fried's

word for it, a religious painting?[25] Is it accidental
that, deemed fragmented and excessively flat at
the time, it should have thrust modern painting
onto the self-referential route of painting's critique
by painting? Is it accidental that this painting,
rejected by the Salon of 1863 and the star attrac-
tion of the Salon des refusés, should have required
that the appreciation of its beauty take the form
of the question, 'is this a painting, or isn't it?' and
nothing more?

The answer 'it's a painting' means finding
pictorial unity in it, despite the fragmentation
and, most of all, despite the shock of mixed genres.
With *Le Déjeuner sur l'herbe*, we do indeed find
ourselves at a fork in the road of history, at the very
precise spot where the judgement 'it's a painting,
it's painting *in general*' arises from the sense of a
generalization of all the genres together, unified
by only the extremely fragile sense of the integrity
of the picture plane. And we also find ourselves
(Wall says so) at the precise moment and place

where the tombstone of the Salon was laid down.[26] This moment would not last, and it was in the decline of the Salon, the forgetting of its social stakes and deconstruction of the minor genres that the mainstream would intensify its tropism towards flatness as the paradigm of modernist beauty. A beauty which will not be a promise of happiness, to be realized in social space, but a promise of truth, to be found in pictorial space and self-reflectingly so. Because *Le Déjeuner sur l'herbe*, which is the starting point of modernist painting but also the high point of the painting of modern life, is like an allegory of the Salon's social stakes, the integrity of the picture plane is the only unity which the painter, in his concern to have pictorial space stand for social space, can offer to a public which is itself divided, fragmented into social classes and individual solitudes, all jostling within the same social space. When the history of modernist painting reaches the monochrome, the integrity of the picture plane will be the only aesthetic happiness which painting still considers itself able to offer to anyone. For Manet this happiness was not a promise but an immediate beauty. Nor is it now a promise for Wall, even if he sometimes dreams about it. It is the dazzling memory of this promise, and *The Storyteller* is its dialectical image.

By definition, a dialectical image must articulate two things. In this one, dualisms are multiplied. An electric cable horizontally bisects the whole image. It is not on the picture plane (it's a little behind it), but it emphasizes its invisible presence as firmly as the mirror in *Picture for Women*. It is underlined by a second electric cable, further back, and parallel to it. Perpendicular to these, a motorway burrows towards the vanishing point, which is located visually (though actually a little lower down) at the apex of the upside-down triangle formed by the section of sky between the curtain of trees on the left and the motorway railing on the right, and the upright triangle formed by the hillock of the motorway underside. Hereby is laid down — or hung, rather — Alberti's checkerboard, automatically reproduced by the camera, in a dialectical image of the encounter between the Renaissance and modernity, floating like an oppressive lid over the heads of these British Columbia Indians who have had its rationality imposed upon them. The checkerboard extends laterally beyond the edges of the frame, recalling by metonymy that white modernity covered the whole of America — their America — with its east-west, north-south survey chart. But this is not all: in dialectical counterpoint to the perspectival concavity of the spatial co-ordinates there is the Cézanne-like convexity of the conical mound which both occupies and empties, in scant classical manner, the whole centre of the image. While the former maps out the territory, the latter swells out the landscape, allegorically recalling the time when this pathetic no man's land, squeezed between a flow of cars and a flow of energy, was for the natives the land of their ancestors. The figures are no longer at home there, they are entitled only to the margins. Take a good look at those margins; they are not just edges or borders, they are folds, pockets of concavity between two convex masses which are ready to roll one over the other, as if to laminate those seeking refuge there: on the left the clump of trees threatens to absorb the couple in red and

white, and on the right the bridge span threatens to crush the hunkered Indian. No one ventures to occupy the centre of the composition, that strip of hardy vegetation which splits the mound in three, gratifying the eye with an abstract, pointillist pleasure, and running between the apparent vanishing point at the foot of the background tree, and the wastebin in the foreground, the point closest to the eye. If it takes only one iconographic detail for *The Storyteller* to bring *Le Déjeuner sur l'herbe* to life, its plastic space on the other hand owes a lot more to Cézanne than to Manet. And if Wall has made sacrifice to the modernist imperative of the integrity of the picture plane in this image more than in others, it is done with a sensitivity to the dialectic of the concave and the convex which only his familiarity with Cézanne can have bred.

Wall is not aiming to simulate with photography effects which only painting can produce, but rather to emulate them with the only means available to the photographer: the choice of location, point of view and lighting. *The Storyteller* therefore does not ask to be judged as a painted picture, since it is not painted, but as a photographed picture, and its medium is neither just painting nor just photography, but their historical relations. Among these, the fact that the photographer is at a loss in the face of the motif and bereft of voluntary means of intervention in the image is certainly not foreign to the intrusion of a photographic sensibility into painting itself. It is no longer Manet who is the key moment of this intrusion, it is Monet. Photography is a hybrid technology; it combines the optical science that the theoreticians of Renaissance perspective inherited from the Arabs, with the chemical photosensitivity of silver salts. The first generation of painters, traumatized by the invention of photography (Delaroche, but also Ingres, and even Courbet), reacted towards their adversary with rivalrous optical mimicry; the second (Monet and the Impressionists) with rivalrous chemical mimicry. They fought the appropriation of perspective by chemistry through their imaginary identification of hand and eye, no longer with the *camera obscura*, like the Renaissance painters, but with photochemical emulsion. An impressionist picture — the canonical example being Monet's paintings of Rouen Cathedral — *is* a photograph, not because it imitates the rendering of perspective (since the camera can reproduce it mechanically, this is instead what the painting leaves to its adversary), but because, like the light-sensitive plate, it records light 'unknowingly' and automatically, in ignorance of what the painter sees. It is to the credit of Cézanne, who reproached Monet with 'being only an eye' and as yet without a proper 'science', that he did with full knowledge and awareness what Monet did spontaneously. The solution which Cézanne gave to the problem of the integrity of the picture plane has, I think, everything to do with his systematic mistrust of the optical and mechanical aspect of painting appropriated by photography, and with his no less systematic trust in the chemical aspect of photography reappropriated by painting. I said above, in relation to *Picture for Women*, that the transparency of the picture plane was *the* convention common to (Renaissance) painting and photography. I would now add that it is with Cézanne that this particular convention was problematized and a new pact

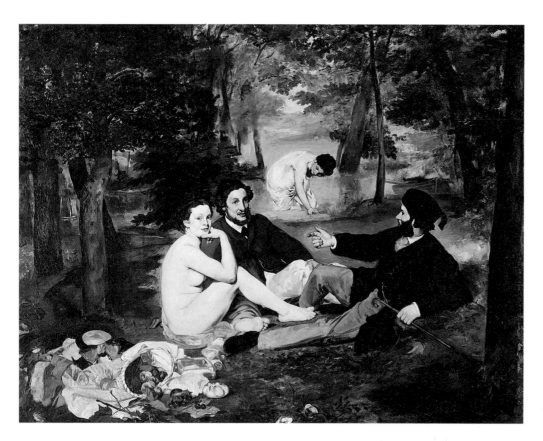

photography and the emblem of the relationship, now lost or becoming lost, between technology and nature. Reflecting on the omnipresence of water in photographic technique — film processing, developing, fixing, rinsing — and everything it recalls of a very ancient *technè*, like the separation of ores in primitive mining, or like the washing, bleaching and dyeing of textiles, he adds:

*'In this sense, the echo of water in photography evokes its prehistory. I think that this "prehistorical" image of photography — a speculative image in which the apparatus itself can be thought of as not yet having emerged from the mineral and vegetable worlds — can help us understand the "dry" part of photography differently. This dry part I identify with optics and mechanics (…) separated to a great extent from the sense of immersion in the incalculable which I associate with "liquid intelligence" (…) Now it is becoming apparent that electronic and digital information systems emanating from video and computers will replace photographic film across a broad range of image-making processes. To me, this is neither good nor bad necessarily, but if this happens there will be a new displacement of water in photography. It will disappear from the immediate production-process, vanishing to the more distant horizon of the generation of electricity, and in that movement, the historical consciousness of the medium is altered'.*[29]

The way in which the historical consciousness of the photographic medium is altered in Wall's more recent work, since he has been using the digitalized image to blend several photographs together, would merit another essay. Since then indeed, the issue of beauty in his work has given way to that of

sought between the painting and its viewer, one founded upon the immersion of the painter's eye — and his canvas — in the light bath emanating from the motif. Perhaps this explains why in Wall's work it is through reminiscences of a Cézanne-like space that the modernist resistance to photographic transparency is made manifest. This is how Cézanne theorizes, so to speak, Monet and his own remove from Monet:

*'I was saying to you a while ago that, while he is at work, the artist's brain, although free, must be like a light-sensitive plate, merely a recording apparatus. But learned baths have brought the light-sensitive plate to the point of receptivity where it can be impregnated with the conscientious image of things'.*[27]

Wall has his own expression for Cézanne's 'learned baths' (*bains savants*): liquid intelligence. In a catalogue essay titled 'Photography and Liquid Intelligence',[28] he says it represents an archaism in

the grotesque. *The Storyteller*, which is in no way grotesque and which I do not hesitate to call Wall's most beautiful work, is the dialectical image of the moment which immediately precedes the triumph of that 'dry' intelligence linked to the optical, the mechanical or the electronic; of the moment of peril when the Cassandras of our day prophesy the death of photography just as a century ago they prophesied the death of painting. Look at it again: the electric cable crosses the image from side to side, expelling out of the frame, very far to the left or right, the hydraulics of dams, turbines and generators which produce electricity. But this motorway which it intersects, this great boat I should say — whose powerful stem stirs up a petrified spray of foam on which there sits, impassive, in other words resisting, a squatted Indian, whose gaze, if we imagine it bouncing off a mirror situated in the picture plane but turned his way, addresses the young *Storyteller* — this ship is the dazzling and 'prehistorical' image of the liquid intelligence of photography. It is, as the artist says, a 'speculative' image in which the apparatus itself can be thought of as not yet having emerged from the mineral and vegetable worlds. It is, I would add, the emblem of a lost relation to nature, probably the same as the one carried in the myths of the Haida, Kwakliut or Tlingit which the young storyteller is perhaps narrating to her two attentive companions; the same, ultimately, as that signified in the modern idiom of Baudelaire by the word 'beauty'. A note in Benjamin's *Charles Baudelaire* defines beauty:

'*in two ways: in its relationship to history and to nature (…) On the basis of its* historical *existence, beauty is an appeal to join those who admired it at an earlier time (…) Beauty in its relationship to nature can be defined as that which "remains true to its essential nature only when veiled". The correspondences* [in the Baudelairean sense] *tell us what is meant by such a veil. We may call it, in a somewhat daring abbreviation, the "reproducing aspect" of the work of art*'.[30]

What Benjamin says here about the 'reproducing aspect' of the work of art echoes everything he says about photography, not only in *Charles Baudelaire*, but also in 'The Work of Art in the Age of Mechanical Reproduction'. Which, by way of another abbreviation, leads back to the starting point of this essay. Not all of Wall's works are beautiful, but when they are they do not convey, whatever the artist might say and notwithstanding Benjamin, any promise of happiness. Stendhal's quotation is too heavily mortgaged, now that it has landed in Adorno. I prefer to think that like that bourgeois Manet, Wall is gratifying us with an immediate and undeferred beauty, and that like that grumbler Cézanne, on occasion he succeeds in making us 'forget everything that has come before us'. Such is the tortuous and risk-taking road — the crooked path — along which proceeds this artist, so abundantly aware of the historical nature of our relation to natural beauty.

Translated from French by Liz Heron

1  Jeff Wall, 'The Site of Culture, Contradictions, Totality and the Avant-garde', *Vanguard*, Vancouver, May 1983

2  Theodor W. Adorno, *Aesthetic Theory*, trans. C. Lenhardt, Routledge & Kegan Paul, London and New York, 1984, p.196

3  Els Barents, 'Typology, Luminescence, Freedom, Selections from a conversation with Jeff Wall', *Jeff Wall, Transparencies*, Schirmer/Mosel, Munich, 1986, p.104

4  Walter Benjamin, 'The Work of Art in the Age of Mechanical Reproduction', *Illuminations*, ed. Hannah Arendt, London, 1973

5  See in this volume the interview with Arielle Pelenc, pp. 8-23

6  Thomas Crow, 'Profane Illuminations, Social History and the Art of Jeff Wall', *Artforum*, New York, February 1993

7  Clement Greenberg, 'The Camera's Glass Eye: Review of an Exhibition of Edward Weston', in *The Collected Essays and Criticism, Volume 2, Arrogant Purpose, 1945- 1949*, ed. John O'Brian, The University of Chicago Press, 1986, pp.60-63

8  Ibid.

9  Greenberg had made the point in the same article: 'It again becomes important to make the differences between the arts clear'.

10  The critic Maurice Du Seigneur, quoted by T.J. Clark, *The Painting of Modern Life*, Thames & Hudson, London, 1984, p.312, note 71

11  T.J. Clark, *The Painting of Modern Life*, ibid., pp.245-255

12  Cézanne to Joachim Gasquet, *Conversations avec Cézanne*, Macula, Paris, 1978, p.112

13  'I have always admired Cézanne, but never really studied him, except to look at his pictures whenever I could. I could not claim ever to have had any of Cézanne's motifs or themes in mind, but I have often thought about him in moments when I'm working on compositions, colours, etc.' Wall in a letter to the author, 20 April 1995

14  The artist acknowledged similar experiences of something sensed as familiar in relation to *Doorpusher, Abundance* and *Diatribe* in the interview with Els Barents, op. cit.

15  'The only impoverished mothers who are spectacularized today are those who disintegrate in violence of some kind, or else the "super-madonnas". For the rest, that is for almost all, it's the opposite, invisibility. They've become almost like pariahs, in terms of the public space anyway (…) The title word, "diatribe", comes from Greek and defines at least two ancient forms of critique — a "vehement denunciation", and a "rhetorical argument with an absent third party".' Jeff Wall, interview with Els Barents, op. cit., p.98. The choice of the word 'diatribe' in this context has Spenglerian connotations which cannot be overlooked. Indeed, Spengler conceived of diatribe as the specifically plebeian form taken by the intellectual production of the masses in those periods of decline when 'culture' yields to 'civilization'. Oswald Spengler, *The Decline of the West*, vol. 1, Albert Knopf, New York, pp.359-61

16  Thomas Crow, op. cit., p.67; T.J. Clark, op. cit., pp.23 ff.

17  Interview with Els Barents, op. cit., p.98

18  Ibid.

19  'And so the casual origin of the curve may be interpreted as a collective slip of the tongue, the significance of which was unintended', Camiel van Winkel, 'Blind Figures', *Archis* No 12, Rotterdam, 1994, p. 65

20  '*The Crooked Path* is just a landscape photograph. I make them from time to time, when I can'. 'Wall Pieces, Wall interviewed by Patricia Bickers', *Art Monthly*, London, September 1994

21  Jeff Wall, 'About Making Landscapes', in this volume pp. 140-47

22  As Michael Newman clearly saw in his catalogue essay, 'The True Appearance of Jeff Wall's Pictures', in *Wall*, De Pont Foundation for Contemporary Art, Tilburg, The Netherlands, 1994

23  It is at this precise historical moment that monochrome painting meets with photography. Wall articulates this in three articles about artists in whose work this meeting-point occurs: 'La mélancolie de la rue: Idyll and Monochrome in the Work of Ian Wallace 1967-82', *Ian Wallace: Selected Works 1970-87*, Vancouver Art Gallery, 1988; 'An Artist and His Models, Roy Arden', *Parachute* No 74, Montreal, April/May/June 1994; 'Monochrome and Photojournalism in On Kawara's Today Paintings', lecture, DIA Center for the Arts, New York, December, 1993

24  'The dialectical image is an image which dazzles. We must therefore preserve the image of the past, in the present case that of Baudelaire, as an image which dazzles in the present moment, in the "now" of the

possibility of knowledge'. Walter Benjamin, *Charles Baudelaire*
(This passage does not appear in the English edition.)

25  Michael Fried, *Manet's Modernism or, the Face of Painting in the 1860s*,
University of Chicago Press, 1996

26  'Manet is the tombstone of the Salon', Jeff Wall, 'Unity and
Fragmentation in Manet', *Parachute* No 35, Montreal, Summer 1984,
p.7, in this volume pp. 78-89

27  Cézanne to Joachim Gasquet, op. cit., p.111

28  Jeff Wall, 'Photography and Liquid Intelligence', in *Une autre
objectivité/Another Objectivity*, Centre National des Arts Plastiques,
Paris, and Centro per l'Arte Contemporanea, Prato, Idea Books, Lyon,
1989; in this volume pp. 90-93

29  Ibid.

30  Walter Benjamin, *Charles Baudelaire: A Lyric Poet in the Era of High
Capitalism*, trans. Harry Zohn, Verso, London, 1983, p.140

# Contents

**Interview** Arielle Pelenc in correspondence with Jeff Wall, page 6. **Survey** Thierry de Duve The Mainstream and the Crooked Path, page 24. **Focus** Boris Groys Life without Shadows, **page 56**. **Artist's Choice** Blaise Pascal Pensées, 1658 (extract), page 72. Franz Kafka Troubles of a Householder, 1919, page 72. **Artist's Writings** Jeff Wall Gestus, 1984, page 76. Unity and Fragmentation in Manet, 1984, **page 78**. Photography and Liquid Intelligence, 1989, **page 90**. An Outline for a Context for Stephan Balkenhol's Work, 1988, **page 94**. A Guide to the Children's Pavilion (a collaborative project with Dan Graham, extract), 1989, **page 102**. The Interiorized Academy, 1990, **page 104**. Representation, Suspicions and Critical Transparency, 1990, **page 112**. Restoration, 1994, **page 126**. About Making Landscapes, 1995, **page 140**. On Colour or Black and White, Boris Groys in Conversation with Jeff Wall, 1998, **page 148**. **Update** Jean-François Chevrier The Spectres of the Everyday, **page 160**. **Chronology** page 192 & Bibliography, List of Illustrations, **page 210**.

It's completely impossible to overlook Jeff Wall's works in an exhibition: they glow. For contemporary viewers this will certainly be taken as a reference to the glowing advertisements of the modern city street scene, but this association is by no means the only one that comes to mind. For all peoples throughout history, the ability to glow, to shine, has been a sign of holiness, of being chosen, of being invested with magical powers. Even those glowing advertisements lend a magical dimension to any landscape, a fact extensively exploited by countless filmmakers.

Glowing produces an aura. After Benjamin, everyone knows that modern art, in so far as it can now be reproduced, has lost its aura. Accordingly, photography above all can have no aura, because of its potential for infinite reproduction: photography has apparently nothing to lose by being reproduced. Works by Wall, however, lose their glowing aura when reproduced in a catalogue or a book, although they are photographs. In reproduction, works by Wall cease to glow. All that remains is their theme, their art-historical or social relevance.

**Jello**
1995
Transparency in lightbox
143 × 180 cm

That's a great deal, but it isn't everything. And in my view it isn't the essential thing.

In Wall's originals the glow is technically produced: it comes from a light box hidden from view behind the picture. The aura is not to be understood in a metaphorical sense, as in Benjamin, but in a literal sense – and this continues a long tradition. In old icons the halos of the saints actually do shine. And the background – in Byzantine icons, for example – shines too, being made of gold or silver. One of the most interesting interpreters of icon painting, Pavel Florenski, describes the icon as a semi-transparent wall which screens the light on the other side from the viewer, protecting the viewer's eyes from the light's intensity – a description astonishingly apposite to Wall's works. As Florenski continues, the figures on this icon wall mark only different intensities of light, and for that reason cast no shadows. The true iconic technique resides in this absence of shadows: the figures in the icon articulate the light, but they do not resist it. There is nothing dark, opaque, purely material about them. For Florenski, this is what distinguishes the icon from post-Renaissance European painting, which stages a play of light and shade within the painting. Where painting in the modern era is concerned, the reality in the world that it seeks to find consists in that the world has a dark, opaque core that can only be lit from without; light cannot pass through it.[1]

But the light that illuminates Wall's transparencies from within is definitely a very modern light. It is distributed very evenly – 'democratically', you might say – behind the picture surface. It does not divide the essential from the inessential, the high from the low, the centre from the periphery – and in this sense too it casts no shadows. This light knows no hierarchies, it ignores no details. It is the light of the modern enlightenment which leaves nothing in the shadows and shines through everything, makes everything visible. It is not by chance that this light flows to us through a photograph, the embodiment of the objective gaze of modern science.

In our century, for this very reason, there is a great tradition in which photography is subject to criticism. The neutral, scientific gaze is accused of failing to capture the dark, opaque core of the world which constitutes its reality, and of striving only for external control and power. Thus, for example, Siegfried Kracauer writes that photography preserves only an outward sign of the past and reality, its empty shell. Photography is a 'general inventory' of these external signs, a sum of everything that must be stripped from people and nature if their true, hidden reality is to be recognized. Man, space and time collapse in

*left, top,* Installation, National Gallery of Canada, Ottawa
1993
**Stereo**, 1980

*left, bottom,* Installation, Documenta 8, Kassel
1987
**The Storyteller**, 1986

*opposite, top left,* Installation, Kunstmuseum Luzern
1993
*l. to r.,* **Stumbling Block**, 1991; **Pleading**, 1988

*opposite, top right,* Installation, Kunstmuseum Luzern
1993
**Dead Troops Talk**, 1992

*opposite, bottom left,* Installation, Palais des Beaux-Arts, Brussels
1992
*l. to r.,* **Eviction Struggle**, 1988; **Coastal Motifs**, 1989

*opposite, bottom right,* Installation, De Pont Foundation, Tilburg, 1994
*l. to r.,* **Odradek, Taboritska 8, Prague, 18 July 1994**, 1994; **Insomnia**, 1994

the photograph, and are abandoned to death.[2] This critique of photography was later pursued in even greater depth by Roland Barthes. For Barthes, photography represents only the semiotics of a purely external social context which denies actual reality – for Barthes, everything that eludes that context.[3]

According to this vision, photography – in contrast with painting – is not a picture of living reality, but merely an arrangement of dead signs. It is writing, presenting itself as a picture. True reality can only be achieved in painting, which emerges out of a hidden and outwardly uncontrollable piece of memory work. Photography, on the other hand, lacks the time it takes a painting to become a picture of the living world. Life is only possible in time, in duration – but photography is momentary. An experience that can only be gathered over time is inaccessible to photography: photography has no memory. Painting necessarily contains something opaque, insoluble, inexplicable. And it is this element of the irrational, which holds within itself an accumulated time, that gives painting its reality, a reality which photography must inevitably lack.

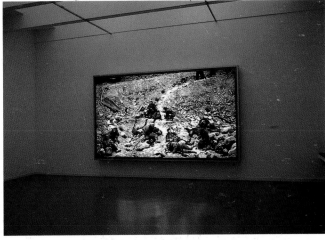
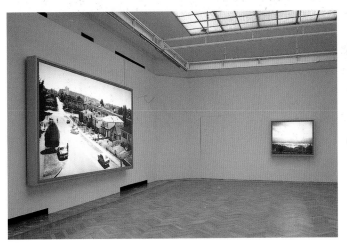
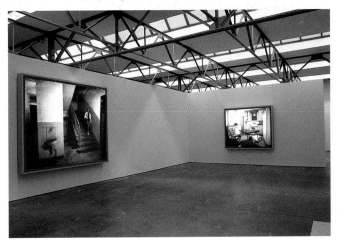

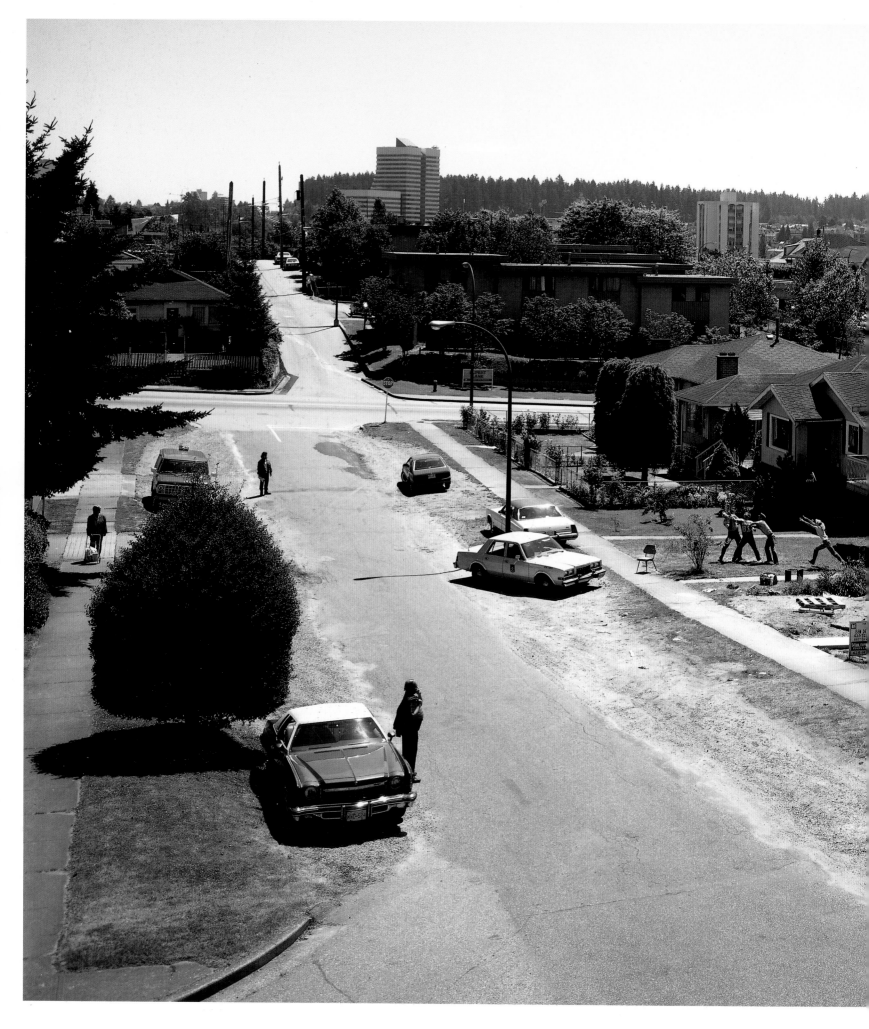

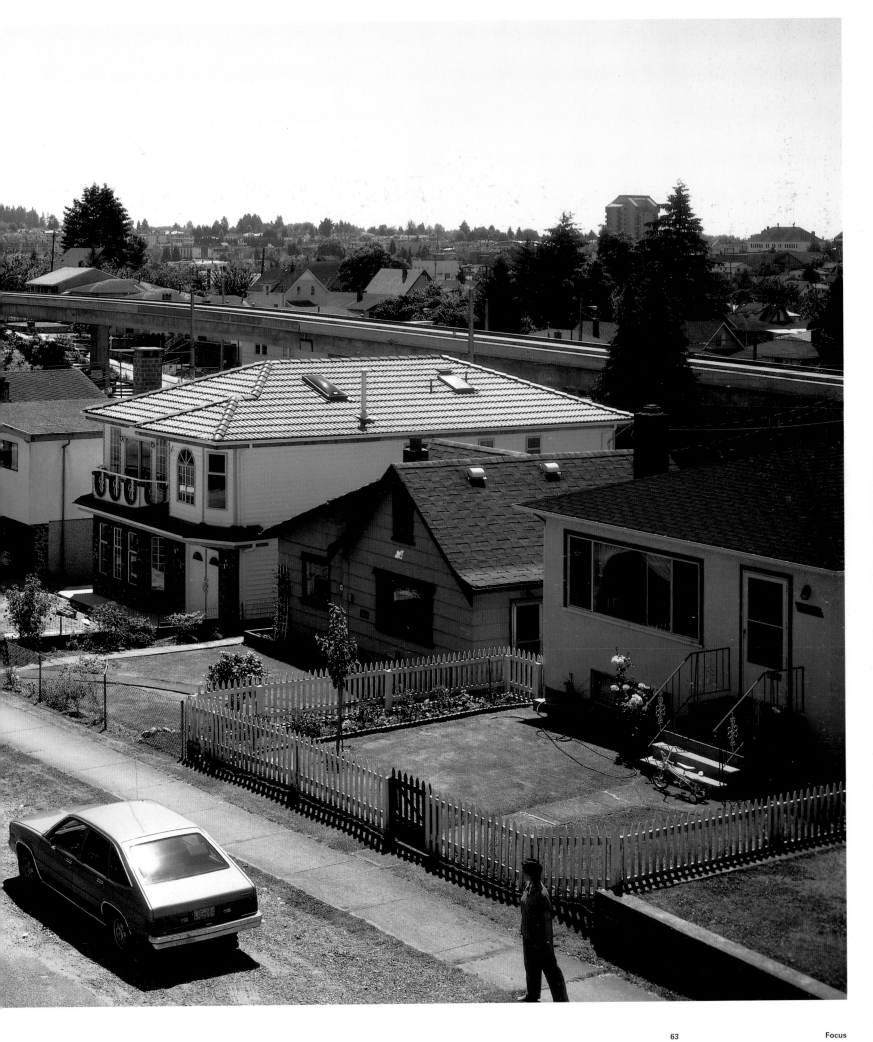

Of course such objections to photography have not gone historically uncontradicted. But it is interesting to note that photography's defenders are constantly searching for the element of the opaque and the irreducible real in photography. This is to be found not in the opacity of lived experience, however, but in the element of chance to which photography is necessarily prone. For Alexander Rodchenko and later for Susan Sontag, the chance and fragmentariness of the world – the lack of the total vision, the presence of dark spots in space and time which cannot be overcome by any amount of memory work – are the reality whose proof only photography can provide.[4]

Against the background of this basic discussion about the relationship between painting and photography, in which each side thinks it can best defend its preferred medium by discovering an irreducible, opaque, 'deconstructing' remnant of reality, it is particularly interesting to note that Wall uses references to the two media with a view to eradicating all remnants of opaque reality, and reaching total illumination. Thus, all elements of chance and fragmentariness are systematically and consistently avoided in the taking of the photographs, and to achieve this Wall chiefly relies upon references to the naturalistic painting of the last century. His photographs are precisely planned and organized so as to avoid any chance disturbance. In this context it is particularly interesting that whenever Wall talks about chance, that chance consists precisely in the elimination of chance. Thus, when considering a landscape he suddenly finds himself being reminded of a painting by Poussin – and for that reason chooses that same landscape.[5] Here, the Poussin painting is working as a materialized Platonic idea: a landscape is recognized as a landscape, because this landscape recalls an art-historical model. Wall is using the tradition of painting to free photography from everything that is not pre-planned and calculated, to leave nothing to uncontrollable chance.

Every detail is thought through, and explained by comparison with the existing store of paintings. Accordingly, history is not thought of as an opaque process in the depths of subjectivity, but as an objectively identifiable difference in representation. Wall also observes that the formal proximity of his own photographs to the paintings of the art-historical tradition gives him the opportunity for a precise measurement of a temporal shift in perception.[6] It is interesting that Kracauer sees this kind of comparison, which photography has made possible, as a crucial threat to historical consciousness.[7]

**Eviction Struggle**
1988
Video installation
9 images
'The video element was made in conjunction with the transparency of *Eviction Struggle* as an experiment in the relation between still and motion pictures. Each of the figures in the picture was filmed in slow motion from two angles, one at approximately the angle at which they are seen in the large photo, and one reverse angle, taken from a position within the picture's space. Each view lasts between 3 and 10 seconds. For each figure, the two views were edited into a loop in alternating patterns, each shot linked to the next with a lap dissolve. The loops, which run continuously when the work is exhibited, are shown on screens set into the reverse side of the wall on which the transparency in its light box is hung. The arrangement of the screens follows, in general, the positions of the figures in the picture'.
Statement by the artist, 1995

*preceding pages,* **Eviction Struggle**
1988
Transparency in lightbox
229 × 414 cm

In using the references to the history of naturalistic painting to reduce the element of chance and fragmentariness in photography, Wall is also, with the photographic process, eliminating the opacity of painting, its purely subjective, lyrical, dark dimension, seen as the free development of technically uncontrollable signs, which refer to the accumulation of time and refuse momentary correspondence with that external, controllable reality. Photography ('writing in light', to translate from the Greek) possesses the transparency and controllability of the technical process that eliminates all darkness.

Thus, according to Kracauer, photography apparently becomes an arrangement of pure signs grouped around the great void. And the photographic image as a whole becomes a purely emblematic, allegorical sign of mourning for a reality that has vanished without trace. Illumination, enlightenment, apparently fails to reach its goal here, being obstructed

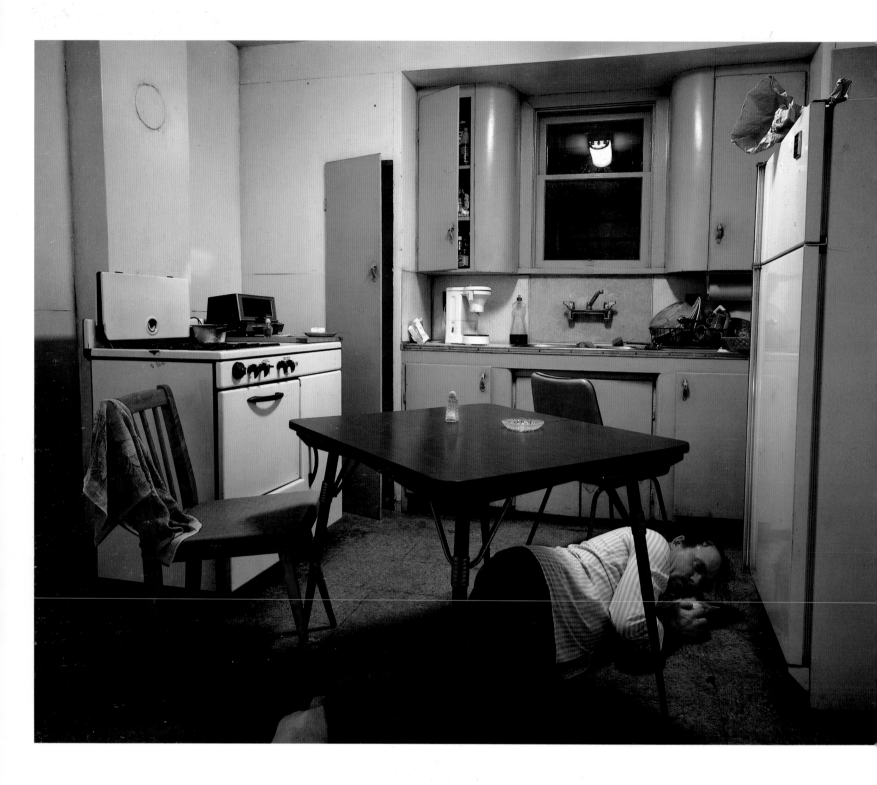

by the surface of things. The revelation of the inner, hidden, unconscious, dark reality of the world, which Wall himself often describes in his texts and statements as a universal economic law, does not occur here. The control to which the figures are subjected is twofold: by the artistic tradition and by the technical, photographic process. There is no room left for any additional determination which could itself be observed and critically opposed in reality.

Nevertheless, Wall's works have a public, liberating effect. The light of enlightenment, passing through what exists, does not encounter an opaque, dark core of reality,

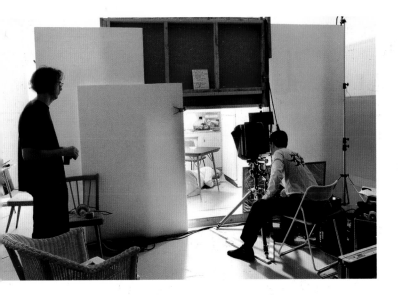

*opposite*
**Insomnia**
1994
Transparency in lightbox
172 × 213 cm

*above*
**Insomnia**
Production still

but another light with which it can mingle. Behind the world, as it is represented in works by Wall, nothing is concealed apart from its visibility as such, an inner light source that flows through the surface of the world. The light of enlightenment proves to be related to the mystical light of apocalyptic illumination.[8] The emblematic nature of photography suddenly refers to the emblematic nature of icons. Both are a form of writing with light, a system of signs that cast no shadow.

The use of the tradition of painting serves to overcome that tradition. It is cleansed of everything dark, subjective and opaque, and is itself transformed into a system of signs. This turns light into a universal principle of visibility that cannot be manipulated. For what is dark and hidden – understood as reality – can always also be invisibly manipulated. While in Wall's work, light becomes a support for reality, that reality becomes irrefutable. We can only see what is shown to us. And if we begin to analyse what we see in the light of enlightenment, we will soon understand that we are merely repeating the original visibility – without penetrating behind that visibility, for behind that visibility there is nothing except the very light that produces it.

And what is hidden behind the light? A light source. Maybe a god, maybe a sort of lamp. But this light source is so publicly inaccessible and opaque that there is certainly no point in wasting any further thought on the matter.

Translated from German by Shaun Whiteside
1   Pavel Florenski, *Die Ikonostase*, Urachhaus, Stuttgart, 1988, p.160ff.
2   Siegfried Kracauer, *Der verbotene Blick*, Leipzig, 1992, pp.185-202
3   Roland Barthes, 'La chambre claire. Note sur la photographie', Paris, 1980
4   Susan Sontag, *On Photography*, Harmondsworth, Middlesex, 1977
5   Interview by Els Barents, *Jeff Wall, Transparencies*, Schirmer/Mosel, Munich, 1986, p. 98
6   Ibid., pp. 96-97
7   Siegfried Kracauer, op. cit., p. 201
8   On the relationship between enlightenment and illumination, Jacques Derrida, 'D'un ton apocalyptique adopté naguère en philosophie', Paris, 1983, p. 64ff.

**Coastal Motifs**
1989
Transparency in lightbox
119 × 147 cm

# Contents

Interview Arielle Pelenc in correspondence with Jeff Wall, page 6. Survey Thierry de Duve

The Mainstream and the Crooked Path, page 24. Focus Boris Groys Life without Shadows, page 56.

Artist's Choice Blaise Pascal Pensées, 1658 (extract), page 72. Franz Kafka Troubles of a

Householder, 1919, page 72. Artist's Writings Jeff Wall Gestus, 1984, page 76. Unity

and Fragmentation in Manet, 1984, page 78. Photography and Liquid Intelligence, 1989, page 90. An Outline for a Context for

Stephan Balkenhol's Work, 1988, page 94. A Guide to the Children's Pavilion (a collaborative project with Dan Graham, extract),

1989, page 102. The Interiorized Academy, 1990, page 104. Representation, Suspicions and Critical Transparency, 1990,

page 112. Restoration, 1994, page 126. About Making Landscapes, 1995, page 140. On Colour or Black and White

Boris Groys in Conversation with Jeff Wall, 1998, page 148. Update Jean-François Chevrier The Spectres of

the Everyday, page 160. Chronology page 192 & Bibliography, List of Illustrations, page 210.

Odradek, Taboritska 8, Prague,
**18 July 1994**
1994
Transparency in lightbox
229 × 289 cm

Description of man:

dependence,

desire for

independence,

needs.

**Pensées**, no. 158

Some say the word Odradek is of Slavonic origin, and try to account for it on that basis. Others again believe it to be of German origin, only influenced by Slavonic. The uncertainty of both interpretations allows one to assume with justice that neither is accurate, especially as neither of them provides an intelligent meaning of the word.

No one, of course, would occupy himself with such studies if there were not a creature called Odradek. At first glance it looks like a flat star-shaped spool for thread, and indeed it does seem to have thread wound upon it; to be sure, only old, broken-off bits of thread are legible, not merely knotted but tangled together, of the most varied sorts and colours. But it is not only a spool, for a small wooden cross-bar sticks out of the middle of the star, and another small rod is joined to that at a right angle. By means of this latter rod on one side and one of the points of the star on the other, the whole thing can stand upright as if on two legs.

One is tempted to believe that the creature once had some sort of intelligible shape and is now only a broken-down remnant. Yet this does not seem to be the case; at least there is no sign of it; nowhere is there an unfinished or unbroken surface to suggest anything of the kind; the whole thing looks senseless enough but in its own way perfectly finished. In any case, closer scrutiny is impossible, since Odradek is extraordinarily nimble and can never be laid hold of.

He lurks by turns in the garret, the stairway, the lobbies, the entrance hall. Often for months on end he is not to be seen; then he has presumably moved into other houses; but he always comes faithfully back to our house again. Many a time when you go out of the door and he happens just to be leaning directly beneath you against the banisters, you feel inclined to speak to him. Of course, you put no difficult questions to him, you treat him – he is so diminutive that you cannot help it – rather like a child. 'Well, what's your name?' you ask him. 'Odradek', he says. 'And where do you live?' 'No fixed abode', he says, and laughs; but it is only the kind of laughter that has no lungs behind it. It sounds rather like the rustling of fallen leaves. And that is usually the end of the conversation. Even these answers are not always forthcoming; often he stays mute for a long time, as wooden as his appearance.

I ask myself, to no purpose, what is likely to happen to him? Can he possibly die? Anything that dies has had some kind of aim in life, some kind of activity, which has worn out; but that does not apply to Odradek. Am I to suppose, then, that some time or other he will be rolling down the stairs, with ends of thread trailing after him, before the feet of my children, and my children's children? He does no harm to anyone that one can see; but the idea that he is likely to survive me I find almost painful.
translated by Ernst Kaiser and Eithne Wilkins
from **Dearest Father**, translation, 1954

nch, regardless

image of a hum

rates and reinf

especially betwee

rfs no such un

the other to b

event from itself

# Contents

Interview  Arielle Pelenc in correspondence with Jeff Wall, page 6.  Survey  Thierry de Duve

The Mainstream and the Crooked Path, page 24.  Focus  Boris Groys  Life without Shadows, page 56

Artist's Choice  Blaise Pascal  Pensees, 1658 (extract), page 72.  Franz Kafka  Troubles of a

Householder, 1919, page 72.

# Artist's Writings  Jeff Wall  Gestus, 1984, **page 76**.  Unity

and Fragmentation in Manet, 1984, **page 78**.  Photography and Liquid Intelligence, 1989, **page 90**.  An Outline for a Context for

Stephan Balkenhol's Work, 1988, **page 94**.  A Guide to the Children's Pavilion (a collaborative project with Dan Graham, extract),

1989, **page 102**.  The Interiorized Academy, 1990, **page 104**.  Representation, Suspicions and Critical Transparency, 1990,

**page 112**.  Restoration, 1994, **page 126**.  About Making Landscapes, 1995, **page 140**.  Boris Groys in Conversation with Jeff

Wall, 1998, **page 148**.  After *Invisible Man* by Ralph Ellison, the Preface, 2001, **page 161**.  Update  Jean-François

Chevrier  The Spectres of the Everyday, page 162  Chronology  page 192  & Bibliography, List of

Illustrations, page 210.

Mimic
1982
Transparency in lightbox
198 × 229 cm

My work is based on the representation of the body. In the medium of photography, this representation depends upon the construction of expressive gestures which can function as emblems. 'Essence must appear' says Hegel, and, in the represented body, it appears as a gesture which knows itself to be appearance.

'Gesture' means a pose or action which projects its meaning as a conventionalized sign. This definition is usually applied to the fully realized, dramatic gestures identified with the art of earlier periods, particularly the Baroque, the great age of painted drama. Modern art has necessarily abandoned these theatrics, since the bodies which performed such gestures did not have to inhabit the mechanized cities which themselves emerged from the culture of the Baroque. Those bodies were not bound to machines, or replaced by them in the division of labour, and were not afraid of them. From our viewpoint, there-fore, they express happiness even when they suffer. The ceremoniousness, the energy, and the sensuousness of the gestures of baroque art are replaced in modernity by mech-anistic movements, reflex actions, involuntary, compulsive responses. Reduced to the level of emissions of bio-mechanical or bio-electronic energy, these actions are not really 'gestures' in the sense developed by older aesthetics. They are physically smaller than those of older art, more condensed, meaner, more collapsed, more rigid, more violent. Their smallness, however, corresponds to our increased means of magnification in making and displaying images. I photograph everything in perpetual close-up and project it forward with a continuous burst of light, magnifying it again, over and above its photographic enlargement. The contracted little actions, the involuntarily expressive body movements which lend themselves so well to photography are what remains in everyday life of the older idea of gesture as the bodily, pictorial form of historical consciousness. Possibly this double magnification of what has been made small and meagre, of what has apparently lost its significance, can lift the veil a little on the objective misery of society and the catastrophic operation of its law of value. Gesture creates truth in the dialectic of its being for another – in pictures, its being for an eye. I imagine that eye as one which labours and which desires, simultaneously, to experience happiness and to know the truth about society.

'A Different Climate' (cat.), Städtisches Kunsthalle, Dusseldorf, 1984

# Unity and Fragmentation in Manet   1984

**Edouard Manet**
Olympia
1863
Oil on canvas
130 × 190 cm

Manet, I think, had divided feelings about the tendency towards the disintegration of the classical unity of the 'concept of the picture' which art history assumes he could perceive in his own work. Divided feelings are divided by force. The force that divided his feelings simultaneously permitted the paradoxical unification of his pictures. This unification emerges out of the same historical conditions which gave his works, particularly the 'Salon-type' pictures of the 1860s, the character of an ironic, semiotic assemblage of heteronomous fragments or ciphers.

The condition of existing as an assemblage is incipient in his work. It is never allowed to express itself explicitly, and thereby constitute another type of picture. Manet retains a classical 'type' or 'concept', or what Ian Wallace calls an 'idea' of the picture. This is what we might call the 'Western' type of picture, and it is a monumentalistic type. Manet applies it to a range of subject matter relatively unfamiliar to it: '*la vie moderne*'. The provocations which form the language of his career take the form of illegitimate or ersatz monumentalizations. *Olympia* is, in this regard, a monumentalized subject whose monumentalization is not called for in the abstract law which appears socially in art as the typology of pictures. Thus, *Olympia* violates a taboo, and links Modernism to such exposures of what Walter Benjamin called the 'dream world' of the bourgeoisie.

I am less concerned at the moment with this aspect of exposure in Manet's work than with its relationship to historical transformations of the concept of the picture, and therefore the concept of its unity. This concept, or abstract law, articulated in the Academic, or Salon typology of pictures (and, of course, in the hierarchy of genres), is profoundly affected by Manet's provocations. But, too, its historical crisis is an engine which engenders the kind of pictures which, in the period, are provocations.

This crisis is located in the interior relations of the picture, at the level of the mechanics of its concept. This level is that of the technical means by which the human figure, the human body, is established as both *painted* and as *represented*. It is painted by means of the sensuous tracings of the painter's hand, arm and body; it is represented by means of a mechanism which inhabits it and marks its origins as modern subject: perspective.

The entire solidified corpus of European Academic painting, the institutionalized theatre of meaning and significance which identified itself as that of painting, organizes itself on this axis of the painted and the represented, the 'touched' and the 'projected,' the pagan and the professional. But, by 1860, this corpus had not only solidified into the codex of the 'joint-stock company', the 'department store' of the bourgeois Academy; it had become perceptible as a cultural body, even as a 'body politic', which had internally decayed.

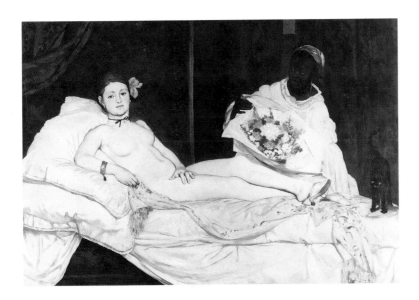

It is often said that the impact of photography, which usurped many of the utilitarian functions which held painting in place in the culture generally, was a shock effect which revealed this decay. Is Baudelaire's famous denunciation of photography in his *Salon of 1859* comprehensible as an interrogation of the degeneration of the technical and spiritual interior of the concept of the picture through which Salon painting lived? How could the culture of the 'ethereal and immaterial' imagination be threatened by a mechanism external to it, a mechanism which, from without, from 'science' and 'progress', threatened to 'impinge on the sphere of the intangible and the imaginary'? Baudelaire is a poet for whom absolute polarities are appearances only: *correspondences* predominate in his universe. Photography's 'threat' to painting was precisely in the revelation it provoked, a revelation of a kind of *correspondence*. Photography reveals its own technical presence within the concept of the picture, and so it reveals the historically new meaning of the mechanized interior of the great spiritual art of painting itself.

The 'interior mechanization' of modern painting was proclaimed as its truth at its origin. Piero della Francesca said, 'All painting is nothing but perspective'. From this vantage-point, the inner drama of painting, the drama in which the concept of the picture is engendered in the modern 'West', is articulated in a relationship of the painted body to perspective.

The painted body – the central term of the classical concept of the picture – is that 'body of the other' traced and caressed by the moving hand of the painter. Thus, the painted body is the simultaneous trace of two bodies, and so is inherently erotic. And since, despite the sexist construction of art-historical language, the hand of the painter can be either male or female, and so can the painted body, painting retains in its interior a kind of paganism, a polymorphousness, even an androgyny, which is suspicious of all asceticism, all unhappiness and all estrangement.

This painted body, however, completes itself as picture by means of a mechanism, its ever-present armature, the mechanistic opticality of the perspectival code. The body is completed as picture in the projection of that kind of space which historically receives it and permits its fundamental theatrical act to take place. That act is the act of the body's encountering its own alienation from itself, its loss of its status as 'couple', as two bodies bonded by the mark, in its disappearance into the spatial world of things and of measure along an optical, geometrical axis. It is along this axis that the painted, or the caressed, body becomes separated into space and becomes 'single'.

In this process the painted body is permeated with opticality and with geometry; it is, so to speak, disembodied by the action of its own projection into a thing-like world of

*following pages,* **Stereo**
1980
Transparencies in lightboxes
Diptych, 213 × 213 cm each

# STEREO

Pleading
1988
Transparency in lightbox
119 × 168 cm

measure. The inner drama of the picture is inescapable from this adventure of loss experienced by every painted and represented body, inescapable from the historical doubt thrown upon the caressed palpability of the figure by the kind of space which is its 'natural' home. As picture, the body shimmers on the verge of being an optical projection, a spectre, an effect of perspective. A projection always originates elsewhere than on a surface which can be touched. This is the source of the pathos of the 'painterly hand' or mark, which characterizes modernist painting throughout its history.

Renaissance, mannerist and baroque painting play all the variations of this dialectic; and historical – social, economic, political and technological – modernization intensifies the grip of perspective on culture as a whole in the development of machines.

Once the consequences of this modernization process become experienceable as culture, painting's spiritual authority is disrupted. This spiritual (and erotic) authority rested on its 'catholic', syncretic and luxuriant inclusion of the palpability of the body within the rhythmic harmonies of an ideal space – an ideal church, an ideal text, an ideal city. Catholic, baroque Europe modulated its mechanistic and progressive ideal with the curvature of the human forms which entwined to make its pictures.

The meaning and value of painting's mechanized interior is transformed in the modernization process. The peopling of the city with machines which takes place in the eighteenth and nineteenth centuries accelerates the disembodiment of the figure which was inherent in perspective but was contained and limited by the character of the *ancien régime*. The hollowing-out or voiding of the pagan body by the systems of projection, opticality and planning which were always present in painting takes place in the same historical process in which men, women and children were bound to machines in the new division of labour. In *Capital*, Marx writes:

*'While simple co-operation leaves the mode of working by the individual for the most part unchanged, manufacture thoroughly revolutionizes it, and seizes labour-power by its very roots. It converts the labourer into a crippled monstrosity, by forcing his detail dexterity at the expense of a world of productive capabilities and instincts; just as in the States of La Plata they butcher a whole beast for the sake of his hide or his tallow. Not only is the detail work distributed to different individuals, but the individual himself is made the automatic motor of a fractional operation, and the absurd fable of Menelus*

*Agrippa, which makes man a mere fragment of his own body, becomes realized'.*[1]

Here, in 1867, is expressed the great inversion of the whole past form of 'the human', the negation of the conditions under which all previous ideals of human unity could be sustained at the interior of cultural expression. Here, the division of labour and machine-industry generate phenomena whose cultural consequence is the revelation of the unravelling of the near-pastoral urban harmony of the classical ideal of earthly perfection, what ancient Greece called *kalokagathia*, with which perspective baptized itself in the Renaissance of Alberti, Piero, Leonardo and Brunelleschi. Perspective becomes threatening at the moment that the determinate negation of the ideal of human wholeness and harmony is revealed in the Marxian image of the living body-part as the crux of culture.

Perspective proved itself as a totalization, a transcendent quantitative cosmic design, and gained the status of Law in the Academy. It did not, however, automatically thereby destroy the conditions for the harmonious expression of the human body and human experience until historical development reveals capitalism's inherent negation of and hostility to the entire previous ideal of the complete development of the human being. In capitalism all bodies are projected as uniform functions of production and exchange, and can survive as bodies only in so far as they prove themselves as partial functions in the process of creation of surplus-value. The culture of the commodity is a totality guaranteed by the process of reduction of the ideal of completeness, unity and harmony, identified with the image of the body in *its* space, to a state of fragmentation and homelessness.

For the nineteenth century, Modernism, exemplified by Manet, the fragmentation of the ideal of integrity and harmoniousness of the body and its space – and so of the conditions for spatial representation – is not something imposed from outside the régime of the picture, from 'industry' or from 'mass media'. It emerges from within the historically law-governed concept of the picture itself. At the moment when science begins to appear culturally as marred with domination, painting begins its repulsion of itself from science, from the totality which produces the antithesis of integration, which produces the living body-part, the 'mass ornament',[2] the modern worker, consumer and spectator.

Manet's expression of these conditions is so intensified that it is possible to see his work as a classicism of estrangement. The figures he paints and represents are simultaneously palpable, that is, traditionally eroticized, and yet disintegrated, hollowed and

**Bad Goods**
1984
Transparency in lightbox
229 × 347 cm

even incipiently 'deconstructed' by their inscription with this crisis of perspective. In this process of emptying, they become emblematic of the new 'fragmentary' type of person produced within capitalism, the person who 'empathizes with commodities'.[3]

Some neo-conservative critics of Manet's recent exhibition at the Metropolitan Museum in New York saw him as something less than a great painter, mainly because, in effect, he did not transcend the difficulties of his epoch. But his significance for us is in that apparent non-transcendence. It is the appearance of a non-transcendent cultural expression which alone can bring out the distress implicit in the 'empathy with commodities'. In *The Phenomenology of Mind*, Hegel says: 'The distraught and disintegrated soul is … aware of inversion; it is, in fact, a consciousness of absolute inversion … The content uttered by spirit and uttered about itself is, then, the inversion and perversion of all conceptions and realities, a universal deception of itself and of others. The shamelessness manifested in stating this deceit is just on that account the greatest truth'.[4] Hegel also on this page identifies the distraught consciousness with *wit*, and a page or two earlier talks about this complete inversion of reality and thought, this state of utter estrangement as 'pure culture'.[5] This world-historical distress appears as the crisis of classical unity in Manet's pictures. This crisis is constituted by the positioning of the negated pagan body – the newly estranged body – within the negative persistence of perspective. Perspective for Manet cannot be abolished or transcended without abolishing the classical concept of the picture altogether and existing outside the law. At the same time, perspective's historical status as a law guaranteeing unity can no longer be experienced as a picture. In Manet, perspective begins its existence as a

law which cannot live 'in and for itself'; it persists only through the transgressions it provokes in the concept of the picture. Perspective is therefore a law guaranteeing estrangement in the experience of the painting.

Estrangement experienced in the experience of the picture has become our orthodox form of cultural lucidity. Cultural lucidity is, in Manet's example, rooted in a historical process in which the ancient concept of the harmony and unity of the body and its space is destroyed by society and reconstituted by the artist in a 'ruined' state, an emblematic state in which its historically negated or outmoded character and meaning become perceptible. In fact, without this perception, Manet's work may have been difficult to perceive as a picture, as something governed and guaranteed as a picture by the law. Many of his works apparently suffered this difficulty in their various first showings, particularly in the Salon.

For Manet, this state of unrelievable tension in front of the work is the specific antithesis to the somnambulistic state of 'ersatz unity' which characterizes Salon pictures. The Salon masters of the Second Empire and the Third Republic were in fact far more *collagiste* in their ecleticism than was Manet in his dandyish witticism. But their perspective disavows its status as social ruin and strains to entrench itself as hypnotic, instrumental and professional. These men are 'experts'.

Since Manet cannot break with perspective and its concept of the picture, the Salon remains the inescapable centre-point of cultural lucidity for him, no matter how degraded it becomes. Its degradation, as evidence of the complete inversion of truth it embodies, makes the Salon the site of Hegel's 'pure culture', and, as such, the immanent

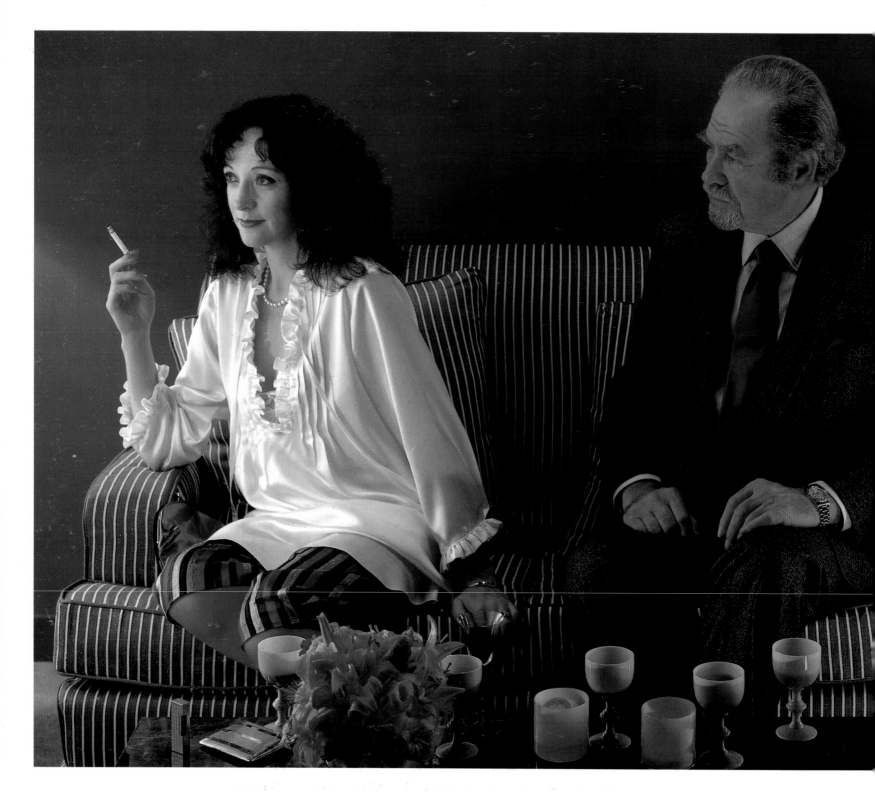

**Woman and her Doctor**
1980-81
Transparency in lightbox
101 × 156 cm

home of Manet's scandals.

In and around the Salon, Manet demonstrates decisively that the radical antithesis to instrumental, ersatz unity is not simply fragmentation, the culture of montage and of the snapshot which is already apparent in Impressionist informalism. The antithesis likewise is not a primitivist ideal of harmony constructed from archetypal bodies which alone can occupy the perfect space of unalienated perspective – or non-perspective – as in the proto-Symbolist works of Puvis de Chavannes or Gauguin. Manet's alternative consists in the negative, almost memorializing unification of the image around a ruined, or even a dead concept of the picture.

**Edouard Manet**
In the Conservatory
1879
Oil on canvas
115 × 150 cm

The dead concept of the picture, when turned towards its immanent subject, 'the painting of modern life', produces an image which is that of the mortification of modernity. With Manet, the realm of 'pure culture', the Salon, the régime of perspective, flares up and collapses into dust. In his work, the body of Antiquity and of baroque Europe appears in a picture for the last time.

Manet is the tombstone of the Salon. As such, he is outmoded by the developments in the new realms of modern art, the 'independent spaces' which reach their first maturity in the 1870s and 1880s, and which, in the intervening century, have become *our* site of absolute inversion, of 'pure culture'. Manet was in a real sense without followers after his death. He is still in the happy position of being without followers. But the contemporary culture of absolute fragmentation, which appears in and dominates the galleries of 1984, as both painting and photography, has emerged historically from the long transformation of the 'independent spaces' of modern art of the nineteenth century, into the museum-like, Salon-like precincts of our era. Manet shows that a decisive expression of Modernism originated from the process of revealing an internally mortified concept of the picture and that that exposure was not bounded by the painting itself. Rather, it formed the social image of a decayed cultural epoch and in so doing, redefined cultural space. In this sense, it participated in the development of critical concepts about cultural space in general, concepts which were formulated sharply about fifty years after Manet's death by Brecht, among others. Brecht's notion of the 'functional transformation' (*Umfunktionierung*) of modes of cultural production should be related to Manet's insistence on the 'Western' image as a ruin. Such a labour of relation would possibly create a means of access to the closed interior of the image in the dead concept of the picture which forms the empty centre of the 'Salonism' of our period. This is a dual picture-type rooted in the institutionalized culture of fragmentation: totalized montage and 'abstract art'.

1    Karl Marx, *Capital*, Vol 1, ch XIV, Progress Publishers, Moscow, 1965, p.360

2    The term is Siegfried Kracauer's. His essay, 'The Mass Ornament', was published in English in *New German Critique* No 5, Spring 1975, pp. 67-76

3    Walter Benjamin, *Charles Baudelaire: A Lyric Poet in the Era of High Capitalism*, New Left Books, London, 1973

4    G.W.F. Hegel, *The Phenomenology of Mind*, trans. J.B. Baillie, 1966, George Allen and Unwin, London, 1910, p.543

5    The sentence is: 'This type of spiritual life is the absolute and universal inversion of reality and thought, their entire estrangement the one from the other; it is pure culture'. *Ibid.*, p.541

*Parachute* No 35, Montreal, June/July/August 1984, pp.5-7

# Photography and Liquid Intelligence 1989

**Milk**
1984
Transparency in lightbox
187 × 229 cm

In *Milk*, as in some of my other pictures, an important part is played by complicated natural forms. The explosion of the milk from its container takes a shape which can't easily be described or characterized, but which provokes many associations. A natural form, with its unpredictable contours, is an expression of infinitesimal metamorphoses of quality. Photography seems perfectly adapted for representing this kind of movement or form. I think this is because the mechanical character of the action of opening and closing the shutter – the substratum of instantaneity which persists in all photography – is the concrete opposite kind of movement from, for example, the flow of a liquid. There is a logical relation, a relation of necessity, between the phenomenon of the movement of a liquid, and the means of representation. And this could be said to be the case with natural forms in general: they are compelling when seen in a photograph because the relation between them and the whole construct, the whole apparatus and institution of photography, is of course emblematic of the technological and ecological dilemma in relation to nature.

I think of this sometimes as a confrontation of what you might call the 'liquid intelligence' of nature with the glassed-in and relatively 'dry' character of the institution of photography. Water plays an essential part in the making of photographs, but it has to be controlled exactly and cannot be permitted to spill over the spaces and moments mapped out for it in the process, or the picture is ruined. You certainly don't want any water in your camera, for example! So, for me, water – symbolically – represents an archaism in photography, one that is admitted into the process, but also excluded, contained or channelled by its hydraulics. This archaism of water, of liquid chemicals, connects photography to the past, to time, in an important way. By calling water an 'archaism' here I mean that it embodies a memory-trace of very ancient production-processes – of washing, bleaching, dissolving and so on, which are connected to the origin of *technè* – like the separation of ores in primitive mining, for example. In this sense, the echo of water in photography evokes its prehistory. I think that this 'prehistorical' image of photography – a speculative image in which the apparatus itself can be thought of as not yet having emerged from the mineral and vegetable worlds – can help us understand the 'dry' part of photography differently. This dry part I identify with optics and mechanics – with the lens and the shutter, either of the camera or of the projector or enlarger. This part of the photographic system is more usually identified with the specific technological intelligence of image-making, with the projectile or ballistic nature of vision when it is augmented and intensified by glass (lenses) and machinery (calibrators and shutters). This kind of modern vision has been separated to

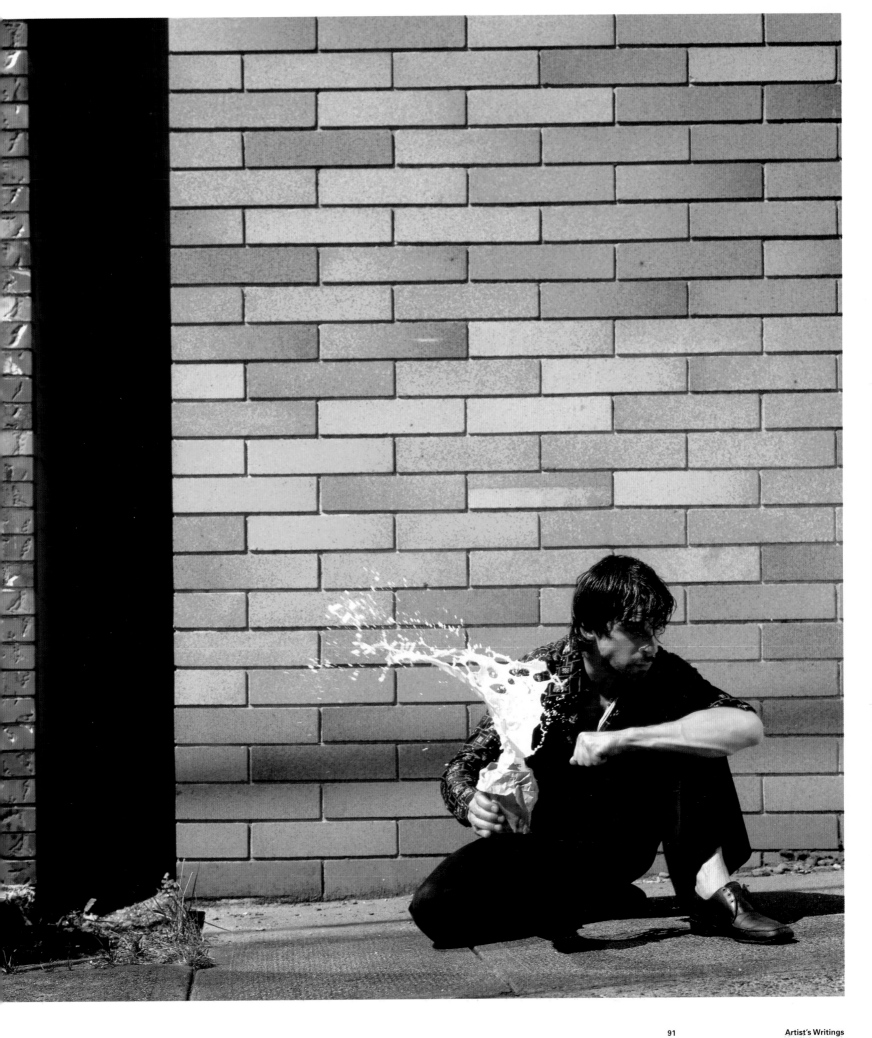

*above,* **Diagonal Composition**
1993
Transparency in lightbox
40 × 46 cm

*opposite,* **The Well**
1989
Transparency in lightbox
229 × 179 cm

a great extent from the sense of immersion in the incalculable which I associate with 'liquid intelligence'. The incalculable is important for science because it appears with a vengeance in the remote consequences of even the most controlled releases of energy; the ecological crisis is the form in which these remote consequences appear to us most strikingly today.

Now it is becoming apparent that electronic and digital information systems emanating from video and computers will replace photographic film across a broad range of image-making processes. To me, this is neither good nor bad necessarily, but if this happens there will be a new displacement of water in photography. It will disappear from the immediate production-process, vanishing to the more distant horizon of the generation of electricity, and in that movement, the historical consciousness of the medium is altered. This expansion of the dry part of photography I see metaphorically as a kind of hubris of the orthodox technological intelligence which, secured behind a barrier of perfectly engineered glass, surveys natural form in its famously cool manner. I'm not attempting to condemn this view, but rather am wondering about the character of its self-consciousness. The symbolic meaning of natural forms, made visible in things like turbulence patterns or compound curvatures, is, to me, one of the primary means by which the dry intelligence of optics and mechanics achieves a historical self-reflection, a memory of the path it has traversed to its present and future separation from the fragile phenomena it reproduces so generously. In Andrei Tarkovsky's film *Solaris*, some scientists are studying an oceanic planet. Their techniques are typically scientific. But the ocean is itself an intelligence which is studying them in turn.

It experiments on the experimenters by returning their own memories to them in the form of hallucinations, perfect in every detail, in which people from their pasts appear in the present and must be related to once again, maybe in a new way. I think this was a very precise metaphor for, among many other things, the interrelation between liquid intelligence and optical intelligence in photography, or in technology as a whole. In photography, the liquids study us, even from a great distance.

'Une autre objectivité/Another Objectivity' (cat.), Centre National des Arts Plastiques, Paris, and Centro per l'Arte

Contemporanea, Prato (Italy), Idea Books, Lyon, January 1989

# An Outline of a Context for Stephan Balkenhol's Work  1988

Trân Dúc Ván
1988
Transparency in lightbox
290 × 229 cm

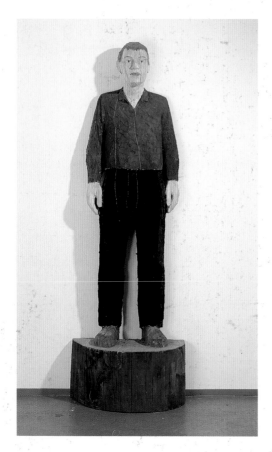

Stephan Balkenhol
Big Man with Green Shirt
1988
Painted wood
h. 250 cm

It seems as if Stephan Balkenhol's sculpture has developed in a process of reaction against the orthodoxies of radical modernist plastic art. The double triumph of the aesthetic of the utterly fragmented form and of its obverse, the militantly unified structure, a triumph which characterizes the art of the past twenty years, creates today the situation in which a sculptor might turn towards that problematic object which is always both unified and fragmented: the human body.

In the work of Beuys above all, or of Kounellis, of Anselmo, indeed of Arte Povera in general, the regime of the fragmentary has been fully legitimated. This fragment, be it a shard of plaster cast, a bit of sausage or a bundle of twigs, exists as meaningful symbol only in a context of historical and social reflection on the fate of art and its pretensions. The history of the catastrophes of our epoch, that history which Arte Povera recognized as having invalidated modern culture's earlier claims to universal truth, gave to its startling assemblages of objects the sense of power which comes from an act of scrupulous renunciation. This renunciation – of claims to any overarching authority in culture – was the prelude to a new experimentalism which excited the art of the 1960s and 1970s, and created the perspective of a new plastic language, open, tentative and incomplete by nature, and so filled with vistas of possibility and hope.

Coterminous with this new opening up of the forms of plastic art, the tightened and disciplined works of Judd or Andre indicated that any authentically new stage of sculptural development would have to include the negative moment of the serial, the inorganic and the predictable, in short, of all those aspects of the built environment which created the sense of alienation so endemic to the urbanism of the 1950s and1960s.

The sculptural production of the period since about 1964 shows a constant dialectical movement between radically shattered and fragmented procedures and equally radically unified, condensed and systematized ones. Often, these contradictory tendencies are visible in the work of a single artist, for example in Serra, or Ulrich Rückriem, who was Balkenhol's teacher in Hamburg in the late 1970s.

Both major positions exclude representation as an aim of sculpture. With few

Backpack
1981-82
Transparency in lightbox
213 × 119 cm

The
Smoker
1986
Transparency in lightbox
88 × 104 cm

exceptions, the mimetic aspects of art are replaced with the organic creation of plastic symbolic situations, as in Beuys or Kounellis, or with non-objective systematics, as with Judd. The evolution of these tendencies in fact depends on the act of exclusion of the mimetic function from sculpture and its replacement with new, experimental directions.

Along with the mimetic function, however, there disappears something very ancient and very immediate: the potential for a spontaneous form of recognition of meaning. The image of the human body remains the most directly comprehensible emblem. Across national traditions and limitations of education and language, the recognition of the attitudes, physiognomy and gestic action of the body produces a space permanently open to philosophical plastic reflection. The process of spontaneous social recognition of meaning grounds the conditions for a reception of sculpture which breaks the new bounds of the established world of art and its orthodoxies, and permits the mass of conflicting forms of cultural literacy and desire which circulate in society to impinge directly on artistic practice, or at least on reception. This interferes with the trajectory of radical modernist plastic art, which had to counterpose itself to the 'popular' world of figures and figurines, in lofty or degraded forms, which always constituted the official ideology of modern public culture. The destruction of the *logos* of the statue has been the continuous project of modernist sculpture since Duchamp and Tatlin. However, the resulting new forms, rooted in an erudite ideology of radical openness, have begun to display their own hardened and sanctified surfaces, their own museal pomp, their own monumental closure against the everyday world in the glamour of their triumph. In the glow of this new aura, younger artists worry that the victorious fragment has produced a universalism as dubious as the monuments it has toppled. Moreover, the fragment, which is by nature cryptic in the sense that Walter Benjamin defined, appears to have obscured the human body of the spectator him- or herself, that body whose reflection is searched for in every examination of objects.

The emphasis in the sculpture of the 1970s and 1980s on the non-bodily aspects of experience, on the experience of objects, whether fragmented or condensed, tends towards a polarized and static subject-object relationship. In this, the object, no matter how densely it is installed in a historical or semantic context, stands opposed to the body of the spectator as a theoretical thing, a thing which is at once sharply distinct from the body and which replaces it at the focal point of culture. This experience of the replacement of the body by things is an experience of essential alienation. The creation of a cutting, illuminating experience of alienation has rightly been given a central place in the project of experimental modernist art. However, the construction of a culturally

reified subject-object relationship, congealed into an exclusive concentration on objects, becomes exaggerated, one-sided and false when the spectator can no longer recognize him- or herself, as a theoretical social presence, in the world of things. During the 1980s, under conditions of a militant market-ideology in culture, the intensified glamour of the object-commodity has tended to expel the spectator from artistic space. Objects – and their representations, which are also objects – appear to populate the world of culture all on their own, and bodies, seemingly sidelined into obsolescence, can only peer into culture from a defunct exterior.

Under these conditions, the generation which has learned from Arte Povera and from Minimalism worries its way towards a reconsideration of the problem of the statue and its permanent functions as body-symbol and bearer of gestic meaning. Balkenhol, as a member of this generation, encounters again, from a new perspective, the problem of the statue's universalizing pretensions.

The traditional notion of the universality of meaning produced by the statue, particularly the nude, which had descended almost intact from the Greeks through to Rodin, was ruined decisively in the epoch of modernistic totalitarianism, when Fascist and Soviet art both returned to the stereotype of the noble nude in an expulsion of the challenging forms of the early avant-garde. The aggravated new monumentalism of the nude and the uniformed hero in the work of official artists in these regimes was explicitly opposed to the experimental plastic forms of Duchamp, Tatlin, Rodchenko or Picasso, forms which the actual historical process of the fragmentation of the human being through the effects of the capitalist division of labour was made visible by means of mechanomorphic images in which human figures are intermingled with objects. This

**Stephan Balkenhol**
Big Head (Man)
1992
Painted wood
h. 220 cm

avant-garde mechanomorphism was unacceptable to the tyrannies of the 1930s because
it managed to express a sense of the catastrophic character of the modernity within
which both Russia and Germany were enmeshed. The famous mechanistic figures –
Duchamp's Readymades, de Chirico's Grand Metaphysician, the Surrealist assemblages
– provided means to perceive the shock and suffering which was produced in the elab-
oration of modernization, in which men, women and children were tied economically to
machines at the core of the production process. This perception produced an extreme
reaction against the classical ideal of statuary, whose essence was the harmonious
unity of the human body. The avant-garde movements understood that industrialized
modernity destroyed the social bases for such a notion of the human image, and that,
under such conditions, any further promotion of the traditional ideal of statuary would
be in the service of a deceptive ideology of 'unity', the unity of the power-state. Thus,
statuary, either nude or uniformed, collapsed as a legitimate sculptural form. Its place
was taken by practices specifically antithetical to it, practices which investigated the
spaces which were opened by the statue's disintegration as a valid emblem of the ideal
state. The new practices themselves, in their programmatic openness, their refusal
to establish firm boundaries between exterior and interior, sought to emblematize a
different state, a more democratic, ecological one, rooted more securely in the fragile
life experiences of concrete individuals.

But the utopian impact of radically open sculpture has waned. The evident capacity
of the fragmented structures of 1970s plastic art to function as decorative elements in
the grand museological complexes of the art world of the 1980s raises the question of
how these object-clusters transcend the condition of art-commodity and retain a sense
of profound meaning, however conditional. The newer 'post-Conceptual' object-art,
which revels ironically in its commodity-status, has aggravated the kind of doubts raised
by the art which preceded it. It has not created these doubts; rather, it parasitically feeds
off them, against a backdrop of social despair and complacency.

The possibility of recovering the potential of the statue as an emancipatory body-
symbol, one which could take up the project of experimental sculpture, not dispense
with it, depends on its re-appearance as a specifically de-universalized emblem. The
statue-form cannot again intervene in sculpture by simply re-assuming its function as
model of a human ideal, as in classicism. Neither can Expressionism's inversion of this
classicism, the idealism of exemplary suffering, provide an answer. At the same time,

Movie Audience
1979
Transparencies in lightboxes
7 parts, 102 × 102 cm each

Installation, Le Nouveau
Musée, Villeurbanne
1988
**Movie Audience**, 1979

ung Workers
78-83
ansparencies in lightboxes
parts, 102 × 102 cm each

Installation, Westfälischer
Kunstverein, Münster
1988
**Young Workers**, 1978-83

the nightmare history of the uniformed statue precludes a direct reinvention of the
emblematic *figura* of an occupation or role in life, such as was accomplished so impres-
sively by nineteenth century sculpture in the tradition of works such as Constantin
Meunier's *Blacksmith*. The new statue, as it might now be proposed in Balkenhol's
work, is rarely nude, and it carries no attributes of occupation, labour or engagement.
It develops as an incompletely particularized human figure, neither wholly shrunken
into meagre individuality and solitude, nor a transcendent *Denkmodell*, either classicistic
or neo-expressionist. It is, strictly speaking, a monad: an isolated, condensed being,
sharing some of the romantic symbolism connected to the image of the solitary tree
out of which it is carved.

Balkenhol's pale monadic figures, isolated from both universality and concrete
social individuation, usually appear before us simply attired, in a dress or trousers and a
shirt. They are like people who have recently come out of hospital after a serious illness,
who cannot yet really return to active life, but who can get dressed normally and face
things again. Like convalescents, their primary occupation is to complete their recovery.
Soon, they may take up their tools and re-enter their complex, stressful social relation-
ships. The emotional world of these sculptures is arrested by their historical-aesthetic
position: they are centred between a possibly volatile renunciation of the radical
negations which brought the experimental forms of the 1970s into prominence, and
a thoroughgoing restoration of the idea of the socially-emblematic human figure as it
really must live, work and suffer in the cities of 1988.

Balkenhol's sculptures suggest that the monadic figure may be freed from its old
identity as universal abstract emblem, and so could exist not as a nostalgic residue of
a part form of unity, an oppressive reminder of the 'good old days', but as a dialectical
interrogation of the unachieved harmony of the existing world. Distressed by the
apparent decay of open-form sculpture into cultural décor, Balkenhol's figures attempt
to stand outside open form. His monad is thus a counter-experimental form, obliged to
interrogate the language of experimental sculpture, to contemplate its peculiar silences
from the viewpoint of the familiar human body. This is a body which has been erased in
the stresses of the struggle for the negation of oppressive, frightening statues, statues
of Colossai.

'Stephan Balkenhol' (cat.), Kunsthalle Basel; Portikus, Frankfurt; Kunsthalle Nürnberg, 1988-89

## Guide to the Children's Pavilion
## A collaborative project with Dan Graham (extract) 1989

Little Children (I – IX)
1988
Transparencies in lightboxes
9 parts, 135 cm ⌀ each

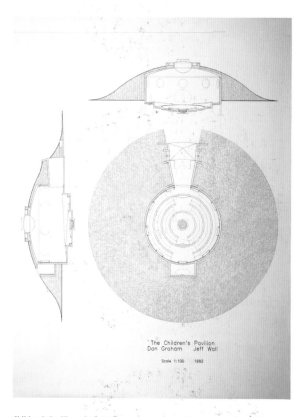

Children's Pavilion, phase 2
1993
Pencil and ink on tracing paper
120 × 100 cm

The Children's Pavilion is planned as a public building located at the periphery of a playground. Its design has not yet been finalized, though the main elements are determined. It is built into, and enclosed by, a landscaped hill. The structural shell of the hill-form is engineered in concrete. The exterior is to be a network of walkways, surrounded by lawn and shrubbery, leading to the summit.

The pavilion is entered through a portal in the form of a three-quarter circle. The interior may be a play space composed of descending walkways leading down to a central water basin, as in the drawing published here, or it may have a freer form.

The interior walls form a drum which supports a low dome, at the apex of which is an oculus. A quarter-sphere of two-way mirror glass is installed in the oculus, its convex surface bulging into the interior. Visitors inside the pavilion can look out through the oculus, and those on the summit can look down into the building. Both groups also see their own reflections on the partly-mirrored glass.

Nine round back-illuminated photo-transparencies are hung equidistant from each other around the interior. Each is a half-length portrait of a child, viewed from below against a backdrop of sky. The sky is different in each picture.

The diameter of the water basin is the same as that of the portraits. The diameter of the oculus is twice that of the portraits.

The project makes reference to different architectural types, such as the grotto, the centrally planned mausoleum (the Pantheon), the observatory or the planetarium, and attempts to rework them in a context of children's play and adult watchfulness. The oculus, with its dual qualities of transparency and reflectivity, permits visitors to the pavilion, both inside and out, to perceive themselves as they perceive others, and to emphasize the function of the pavilion as a place for 'reflective' thought as an inherent aspect of enjoyment, sociability and community and family life. The group of roundels depict children of different racial origin, all of whom are 'lightly monumentalized'. Other buildings memorialize fathers, heroes and elders; the Children's Pavilion experiments with placing people in the position normally held by their forebears.

Santa Barbara Contemporary Arts Forum, brochure, 1989. An edited version appeared in *Parkett* No 22, Zurich, 1989, pp. 66-68. Revised 1995.

## The Interiorized Academy
## Interview with Jean-François Chevrier  1990

**Francisco De Goya**
Yo lo vi (I saw it) from 'Los
Desastres de la Guerra'
1820
Etching
Approx. 15 × 21 cm

**Jean-François Chevrier**  It might be a good idea to start by clearing up certain ambiguities about your work, which is sometimes rather hastily categorized as an art of social critique. A lot of critical art is little more than the illustration of a sociological point.

Jeff Wall  **First of all, I do have a relation with the things you are talking about. I respect the work of people like Hans Haacke and Mary Kelly. These artists have carried on something during the last fifteen years which is important and which has been discredited by current opinion. The thinking about images and culture in their work – which comes from Marxism and certain traditions of psychoanalysis – to my mind remains valid. The way you use the term 'sociology' implies a formalized and even bureaucratic discipline that poses only the questions it can answer, and then credits itself with knowing something definitive about society. I think there has been a lot of art made in the 1970s and 1980s that conforms to this kind of thinking. This sense of presenting conventional militant answers to real problems is identified with what is called critical art. But, to a certain extent the objections to critical art are just prejudices. You can't criticize critical art without confronting your own conformism.**

**Chevrier**  I do not mean to contest the value of sociology or the relevance of a critical stance in art. What I do contest is the transformation of art into a minor branch of sociology.

Wall  **There are internal problems with what critical art means by 'critique'. To me, a critique is a philosophical practice which does not just separate good from bad – that is, give answers and make judgements. Rather, it dramatizes the relations between what we want and what we are. When I look back over the last fifteen years, I see a lack of development in the idea of critical art and a failure by artists to appreciate how uncompleted an image has to be, how dramatic it really is. There has to be a dramatic mediation of the conceptual element in art. Without this mediation you have only concepts on the one hand and pictures on the other. Images become a decorative completion of an already fully evolved thought. They are just illustrations. So they are boring, there is no drama. But what makes dramatization possible? I think it is a programme or a project that was once called *la peinture de la vie moderne*. I always think of the etchings of Goya underneath which he wrote: 'I saw this'.**

**Chevrier**  Isn't there a difference between a programme and a project? It seems to me that it is very difficult to base realism, which is anchored in experience, on a programme.

**A Fight on the Sidewalk**
1994
Transparency in lightbox
189 × 307 cm

Wall  **Can't you have a project which is precisely to develop a programme? Today I think that each artist has become his own academy. He has internalized commands that used to come from a real social institution to which he was directly subjected without the mediation of the market. It is a kind of spiritualization of the pre-modern situation where society – the court for example – had a direct use for art. Since then, the utility of art has been ambiguous and indirect. Now, you have to build a kind of institution inside your own psyche, something like a superego. It is a kind of comedy in the way that the dialectic of Master and Slave in Hegel can be read as comedy. The Freudian concept of superego is also related to this. Therefore any programmatic aspect in art has the character of an individual desire or, if you want to put it in 'existential' terms, of a project.**

Chevrier  You mentioned a lack of development in the idea of critical art. At the same time you define artistic praxis in terms that might be qualified as traditional. If I understand you correctly, the internalized academy that an artist constructs for himself provides him with the programmatic and even moral constraints that are no longer imposed by institutions. Isn't there a contradiction between 'critical' art and the necessity of an 'academic' structure?

Wall  **Yes, there is a contradiction. That's normal. The contradiction is that 'critical art' has regressed and fallen apart into two polar, opposed, unrelated elements, lacking mediation. The old academies trained artists to practise art – that is, to make things with their hands, to work sensually. It also taught them to think and inculcated them with a theoretical attitude. Even though it trained them to conform, this type of teaching itself created new movements and a new type of artist which were able not to conform. Today, it is always something related to what we remember as the academy that provides the type of mediation I'm talking about between the necessity for modern art to have a cognitive dimension and the equal necessity for pleasure. After 1793 it became possible not to conform, to be revolutionary. At that point the notion of the academy became a place for critical and self-critical approaches in which any struggle with conformity could be**

**Outburst**

1989

Transparency in lightbox

229 × 312 cm

The Goat
1989
Transparency in lightbox
229 × 309 cm

dramatized. The internalization of academic methods provided the ground for anti-academic, radical and critical art.

**Chevrier** Does that mean critical art is essentially a critique of art?

Wall No, but under these conditions art approaches its subject matter with a sense of its own complicity with the formation of the very thing it wants to criticize. How could you criticize others and leave yourself outside the picture? Once the bourgeois revolution had swept away the academy of the *ancien régime*, and the counter-revolution reconstructed it, art had to become self-critical. In this light, avant-garde art is a phenomenon which has revolutionary as well as counter-revolutionary origins. The internalized academy is the form in which this dialectic moves. In order to create a philosophically adequate image of a society whose relationships are based on domination, art must constantly reflect on the tendency towards domination in which it is itself implicated. To answer your question, critical art is not essentially about itself and cannot be about itself. But in order to be about something else, it has to call itself into question.

**Chevrier** It seems to me that your distinction between cognition and pleasure harks back to the era of the academies. But it also has a very puritanical ring to it.

Wall The pre-revolutionary academy was an ethical mirror of the State, and remained such in the post-revolutionary, counter-revolutionary situation. Puritanism has its other

**The Quarrel**
1988
Transparency in lightbox
119 × 176 cm

side in libertinage. We know that libertinage provided the energy for revolution, which was made by modern, puritanical types of people. Regicide is a form of libertinage. The academy could see pleasure and learning as two separate poles, and in this static form of thinking it remained pre-modern. Modern art emerged in the fusion of the two poles. Today, our type of artist is involved in negotiating these interrelationships in new, maybe more neurotic, ways. Because the pattern isn't laid down as clearly as it was in the good old days, when such things were imposed, not proposed.

**Chevrier** In the French cultural tradition there is a form of moral judgement that is at once a serious game and a source of pleasure. I'm referring to the very sophisticated tradition of the moralists that began in the seventeenth century. In some respects the moralists could be said to have subverted puritanism from within.

**Wall** One of my favourite novelists, Stendhal, is a part of that tradition. The internalized academic dialectics I am talking about developed in the discovery of that kind of play. The Surrealist idea of *humour noir* is also a fundamental part of this outlook.

**Chevrier** Where is the *humour noir* in your work?

**Wall** It is everywhere. Black humour, diabolic humour and the grotesque are very close to each other. Bakhtin talked about the 'suppressed laughter' in modern culture. Things can be laughed about, but not openly. The fact that the laughter is not open gives it a sinister, neurotic, bitter and ironic quality. It's a kind of mannerist laughter that is similar to Jewish humour, *Schadenfreude*, and gallows humour. I feel that there is a kind of 'suppressed laughter' running through my work, even though I am not sure when things are funny. *Humour noir* is not the same as the comic, although it includes the comic; it can be present when nobody seems to be laughing. It is one of the forms of the serious moral game that you mentioned. In my opinion the Hegelian analysis of the relation between master and slave is one of the most important expressions of *humour noir*. I am interested in slaves.

**Chevrier** Is that a perverse way for a master to become a critical artist?

**Wall** That's a very diabolical question. Were you educated by the Jesuits? Nietzsche said that the most instructive epochs were the ones in which masters and servants slept with

An Encounter in the Calle
Valentin Gomez Farias, Tijuana
1991
Transparency in lightbox
288 × 229 cm

each other. Pleasure is a means by which antagonists in a social struggle gain precise knowledge of each other.

**Chevrier** Coming from you, that remark doesn't surprise me. In your pictures most of the relationships between men and women are relations of force.

Wall **Maybe. But the relationships between men are also relations of force. The relations between women on the other hand are not. Society is antagonistic. People are compelled into their lives; we are unfree. The slaves must develop a 'slaves' science'. This science is the only legitimate thing to be contributed to the world by what you call 'critical art'.**

**Chevrier** Is that science a kind of sociology?

Wall **Yes, but it is a speculative sociology, to use a phrase of Gillian Rose's. If you are a slave, you must always at some level wonder what it would be like to be free. In** *The Storyteller*, **for example, I attempted to create an image of a way subjected people might try to build a space for themselves. I imagined the picture as a speculative project. All my pictures about talking, about verbal communication, are in fact about the ways people work on creating something in common, about how they work to find a way to live together.**

**Chevrier** The ancient Greeks thought that action began and ended in language. Every action worthy of remembrance formed a story. History painting is also a type of storytelling.

Wall **History painting is storytelling in the sense that Walter Benjamin gave that term. And storytelling is a way of building ethical worlds based, as Benjamin taught, on memory and dialogue. Bakhtin emphasizes the fact that an utterance derives not from one isolated individual but is already a response to the words of others. Thus the storyteller is not a hero separated from others by a special relation to language. I like your reference to antiquity because I feel that my work is in fact both classical and grotesque. Ancient art imagined the good society but was also open to the concept of the deformed. That is, it was able to recognize that it was not the society it could imagine. Now we are living at a moment when we have already imagined, and even in great and excessive detail, better ways of life than the one we are actually living. As a result, we often feel humiliated when we observe soberly the way we do live.**

*Galeries* No 35, Paris, February/March, 1990, pp. 97-103

Representation, Suspicions and Critical Transparency
Interview with T.J. Clark, Serge Guilbaut and Anne Wagner  1990

**Serge Guilbaut**  It seems that in your work you like to take parts of the intellectual discourse already articulated in the 1920s by Lukács through his interest in the 'Instructive Representation', as Tim [T. J. Clark] said earlier. It seems that some of your ideas reiterate those formed during the 1920s, but under the pressure of Conceptual art, so to speak, you managed to reshape those things into a contemporary discourse. How did you manage to keep these two critical moments alive in the blasé age of the 1980s? Don't you think it is a problem when one develops a critical discourse extracted from the 1920s, even if revitalized through the debates of the 1960s and 1970s, and apply it in the specific environment of the 1980s?

Jeff Wall  **Are you talking about the 1920s or the 1820s?** *(Laughter)* **First of all, I don't think about decades like that, as so distinct from each other. In a central way, the debates of the 1960s and 1970s were about the concepts of avant-gardism and modernist culture which were put forward in the 1920s and 1930s, and so on. I think there are continuities. The most orthodox way of thinking about culture now is to talk always about discontinuities, breaks, ruptures, leaps. As Walter Benjamin said, the only way to think legitimately about tradition is in terms of discontinuities. I accept that, but I think that it is possible to forget the meaning of something in ritually referring to it all the time. So, it's necessary, too, to develop language-forms which express the continuous aspects of the development of vanguardist culture, or post-modern culture, or whatever you want to call it. Discontinuity does not exist in isolation from what seems to be its polar opposite, so I think it is just as valid to talk about reinventions and rediscoveries, not to mention preservations. Some of the problems set in motion in culture not only in the 1920s, but in the 1820s and even in the 1750s, are still being played out, are still unresolved, we are still engaged in them. I guess that's why, at a certain point, I felt that a return to the idea of** *la peinture de la vie moderne* **was legitimate. Between the moment of Baudelaire's positioning this as a programme and now, there is a continuity which is that of capitalism itself. There have been so many theories about how capitalism has changed; it has changed but it still continues, changed, renewed, decayed, and opposed in new ways. The opposition to and critique of capitalism – the whole of what could be called 'anti-capitalist culture' – has also emerged and become a foundation of the concept of Modernism and modern art, too. I feel I'm working within and with a dialectic of capitalism and anti-capitalism, both of which have continuous histories within, and as, modernity.**

**T.J. Clark**  My question starts from a couple of things from being interested in the way

that, in your earlier pictures, you were present within the image. Indeed, one of them was declaredly a self-portrait. Whereas that becomes not true at all after a certain point.

Now, this links up, in my mind, with the critique of representation, the suspicion of the art object which, as you've discussed earlier, was so powerful in the 1960s and 1970s. This critique said words to the effect that representation is to be put aside, or excluded, because it reproduces a régime of subjectivity, a régime of the reproduction of subject positions, with the artist as the key subject position reproduced. And that subject position is itself under maximum suspicion, as it is seen as the stabilizer, or the cement of all those positions of viewing, reception, passivity, deference, which stand in the way of criticism. That still seems to be a powerful and worrying aspect to the 1960s *spiel*.

Now, as we've said, you wish to retain some of the sensibilities of painting as representation. And that is associated for you with a different suspicion, a suspicion of the photographic aesthetic of the spontaneous. That seems to you particularly inappropriate in the conditions of late capitalism, because of the ways in which the nature of things is now

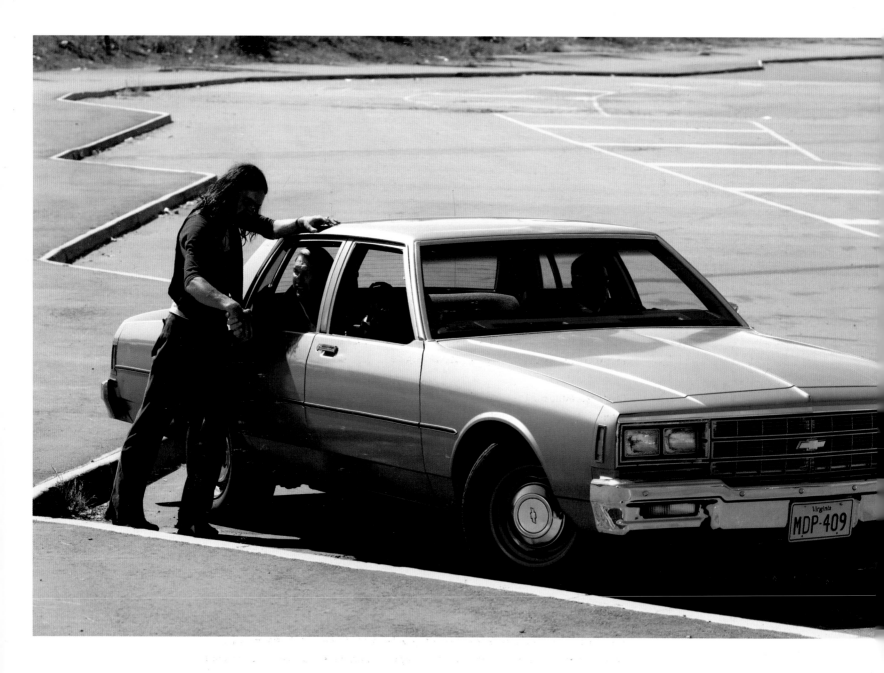

kind of deeply repressed, within, below or behind appearance. You have some interesting things to say about the way in which the nature of things may be significant in actions, gestures and interchanges between people in late capitalism. I noted, for example, this phrase from 'Gestus' (see pp. 76-77) where you spoke about 'controlled little actions', the typical, significant ones, 'more condensed manner, more collapsed, more rigid, more violent' than those apparent in earlier phases of capitalist culture. In other words, more deeply repressed. But, in terms of the reproduction of subject positions, isn't there a danger that this imagery of the controlled, the contracted, the emptied, the rigid, the collapsed in the everyday life of late capitalism, will end up being read primarily in terms of your control of the tableau? Could it be argued that what is happening here is that all these characters and situations are being de-realized and de-animated in order to be re-realized and re-animated as part of *your* own tableau, that finally the picture is one of the artist's means of control over things? It seems to me that you are dicing with an extreme difficulty here. I understand your reasons for pushing this imagery to the edge of emptiness. But it seems that it opens itself up to a reading as your own puppet show, and that you haven't actually exited from the transparencies.

**Wall** I would never claim to have exited from my work. Are you saying that it could be received as just subjective – pure *mise-en-scène* in a subjective sense?

**Clark** Yes, although the alternative would not be simply objective, but some type of critical subjectivity, some subjectivity determined to exteriorize itself or declare that its view of the scene can be defended in objective terms.

**Wall** I feel I'm doing that. You are then raising the question of the presence here of a concept of truth guiding the *mise-en-scène*.

**Clark** Yes, and I am questioning this notion of the isolated, hypnotically powerful, controlled art work as a means to entrench the image as part of a certain régime of art. And that régime is so closed, so completely entered into in your work that there seems to me the possibility that the picture dictates to the viewer a reading in terms of the kind of subjectivity which has had to be criticized deeply in the past two decades.

**Wall** Good question! You've raised several problems, but there's one I want to respond to first. You seem to be saying that most of my pictures are constructed in an atmosphere of unfreedom and constraint. It's true that in some of my writing and conversation about my work I've concentrated on that. But I think that there are many which are quite different. Pictures like *Diatribe, The Storyteller, The Thinker* or *The Guitarist* can be posited as part of a sort of programme which is distinct from works like *No, The Agreement* or *Mimic*. To make it simple, there is The Good and there is The Bad. There are conditions under which one is obliged to show the almost terminal imprisonment of people in repressed, exploitative relationships. That is a large part of the programme of what we used to call 'realism', and I can adhere to that. But I remember having an interesting discussion a few years ago with a friend, Susan Harrison, and she said that it seemed that artists (I *think* she meant male artists) think they're being more 'critical' and 'objective' if they show misery. But she said you could be just as critical and objective, if that's what you want to be, about joy and friendship. This affected me a lot in my thinking about the development of a version of the 'painting of modern life'. The social order itself, when you look at it studiously, never ceases to provide support for a programme or images of subjection and unfreedom, and we need those images, but not exclusively. So I have worked on pictures about resistance, survival, communication and of dialogue, scenes of empathy, and empathetic representations. I actually think that there is no polar

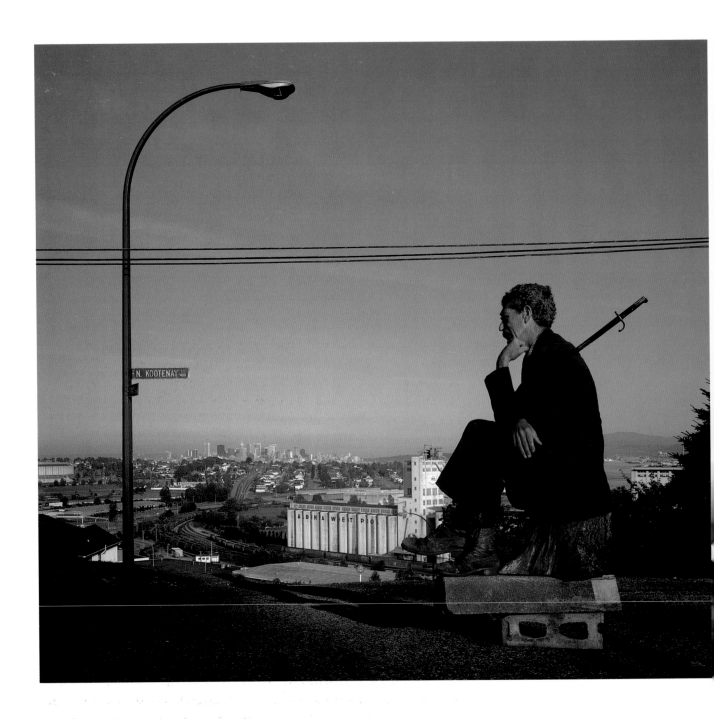

separate distinction between those two streams in what I'm doing; the distinction is more fluid. So much for the easy part of your question.

Now, to address your critique, which suggests that these images, whatever their subject matter or mood, lack any validity as critical understandings of the world and collapse into a subjectivity which cannot establish any criteria for themselves outside a kind of spectacular legitimacy as art.

**Clark**  There may be a problem with this word you've used: triangulation. Certain of these images depend on a kind of régime of positions implied with the triangle which includes the viewer. But triangulation implies the viewer as a unitary site, as an eye. This reproduces a very strange illusion of viewing, bound up with the whole aesthetic of individualism. It may be true that the work is made by one person, but it is not necessarily true that it is to be viewed by one person, or one person thinking of themselves importantly as one, it may be that it is important for one person to think of themselves importantly as one of many.

**Albrecht Dürer**
Peasant's Column
1525
Drawing
h. 22 cm

Wall  I think that this problematic of the 'unified subject' has become a bit of a sacred cow, a bit of an orthodoxy. Going back to our discussion about the avant-garde of the earlier part of the century, it's clear that, at least since 1920, the mythified, self-identified artist figure and through him, in a way, the modern political, social subject of bourgeois society in general, has gone through a devastating critique, one which has many dimensions, and from which everyone seriously involved in art has learned a great deal. But I think there has also been an absolutization of the notion of the fragmentation of the subject, just as there has been of the work of art, the image. This absolutely fragmented phenomenon has been set in the place of the totally unified idea of the subject of the previous person. I have to see this as an oscillation within a simple discourse rather than a new, or fundamentally different, evolution.

Clark  Let me interject there, and say I agree with you, but you see I was gesturing towards an exit from that when I said that instead of the viewer conceiving him or herself as a monad, fragmented or non-fragmented, it may be possible (and most works made through history have shown it to be possible) for works of art to be constructed for viewers who did not think of themselves as monads.

Wall  But I think that all good works of art have always done that. There are no closed works of art, really. My experience of works that I have really admired is a kind of out-of-body experience. That is, it's a kind of phenomenology of identification and disidentification which is continuously happening, and which is essential to the experience, and even the possibility of experience.

Clark  But look, the art of the nineteenth and twentieth centuries proposed – or came to have to accept – that the monadological viewing position was its fate. In the end that was theorized as a fate that was thrust upon it by capitalism.

Wall  By property relations …

Clark  Yes, absolutely, and by a certain régime of subjectivity and individualism within which they operated.

Wall  Personhood.

**Clark** Yes, personhood. So what I'm saying is that there really is a tremendous field of force pulling the art object back into a structure which reproduces the monadology of the first maker of the action of the work. I'd like to hear more about the way you see your work as pulling against that field of force.

**Anne Wagner** I think that this is also the risk that the work runs – that is, that it seems that some works are projected towards a specific audience, and others maybe towards a quite different one.

**Wall** **You're right that I don't really see the audience as unified or homogeneous. It is essentially splintered, inwardly divided. So, it's possible (although I don't focus too much on this in practice) that my pictures are worked out with certain splinters of The Audience in mind, or at least in the front of my mind. But, in general, my primary objective is to create a sort of identity crisis with the viewer in some form, maybe even a subliminal one. I do go through a sort of continuous process of 'imagining the viewer'. I think all artists, in the process of making a work, hypothesize an audience, invent an imaginary audience which is exactly the one which will appreciate that work profoundly. When Stendhal dedicated *The Red and the Black* to 'The Happy Few', he was doing that. This is a utopia of artists, the hypothetical world and its imaginary population.**

**Another way of looking at it is that one sets in motion a sequence of identifications, recognitions, mis-recognitions, de-identifications and re-identifications, in which the audience is continually decomposed, fractured, reformed and re-identified with itself. Anybody who has had a long relationship with a work of art knows how that happens over time.**

**Guilbaut** I thought your work was precisely different from that attitude. I thought that in fact what made its force was the rejection of the love affair with the floating signifier. I thought you did not permit the work to be a sea of meanings in which spectators could fish at random.

**Wall** **No, I don't mean it that way. I think that this process of misrecognition, of a crisis of identification in relation to representations happens in all experience, even in personal or interpersonal experience. In that sense it is objective, a condition of experience as well as a content of it.**

**The fact that I accept the fact that viewers of works cannot be marshalled into seeing**

the work in any specified way doesn't mean that I accept the idea that no signification necessarily means anything specific. There's a difference between the two attitudes. The process of experience of a work, while it must be open to the associations brought to it by different people, is still structured and regulated and contains determinations. I think it is controlled, above all, by genre, by the generic character of the picture-types and the types of subject. Bakhtin said that genre was the collective, accumulated meaning of things that has come through time and the mutations of social orders. It is the foundation of the guarantee of objectivity, the basis of the 'truth content' of representations, which Tim was asking about.

Now to return to the problem of the conceptualization of the unified subject we were talking about before, I think that this process, this phenomenology if you like, which forms the interior of the experience of any representation, in no way supports the idea of a unified, monadic subject, at least it does not do so to the extent to which the kinds of critique that Tim was referring to insisted. The idea that previous concepts of the self were rock-solid, impacted monadological ones was one of those exaggerations which the 1960s and 1970s discourse is so famous for. The interrogation of the notion of the subject in which we're still involved has changed the language-forms of culture irreversibly, and brought about a kind of Copernican revolution in which the practice of representation has been revolutionized. Representational art, like mine, which rests upon a notion of the unbroken continuity of certain aspects of modern culture, must be looked at and experienced through a dialectical understanding of the suspicions that have been brought against the unification of the dramatic space of the picture. My view is that those suspicions have transformed the atmosphere within which representations have meaning in culture, but that they have not withdrawn the legitimacy of the process or technique of – the need for – representation. No alternative has been created; however, all representation, mine included, has been augmented with a kind of critical iconophobia, an inner antagonism which compels representations to rebuild themselves with a different legitimacy. That is, the arrogant, domineering identity which Western figuration had been loaded with in the kind of language which had defined it for a long time has itself been cracked, and different identities have been able to emerge. Some of those which were animated by a very radical idea of themselves and culture, have opened up what you might call iconophobic representations, types of work in which the denunciation of the metaphysics, the laws, the power mechanisms inherent in the earlier identification process of representation are the main concern. I think there is some exaggeration in that denunciation: but I think that that exaggeration is a necessary form of thinking now. What is maybe not so clearly

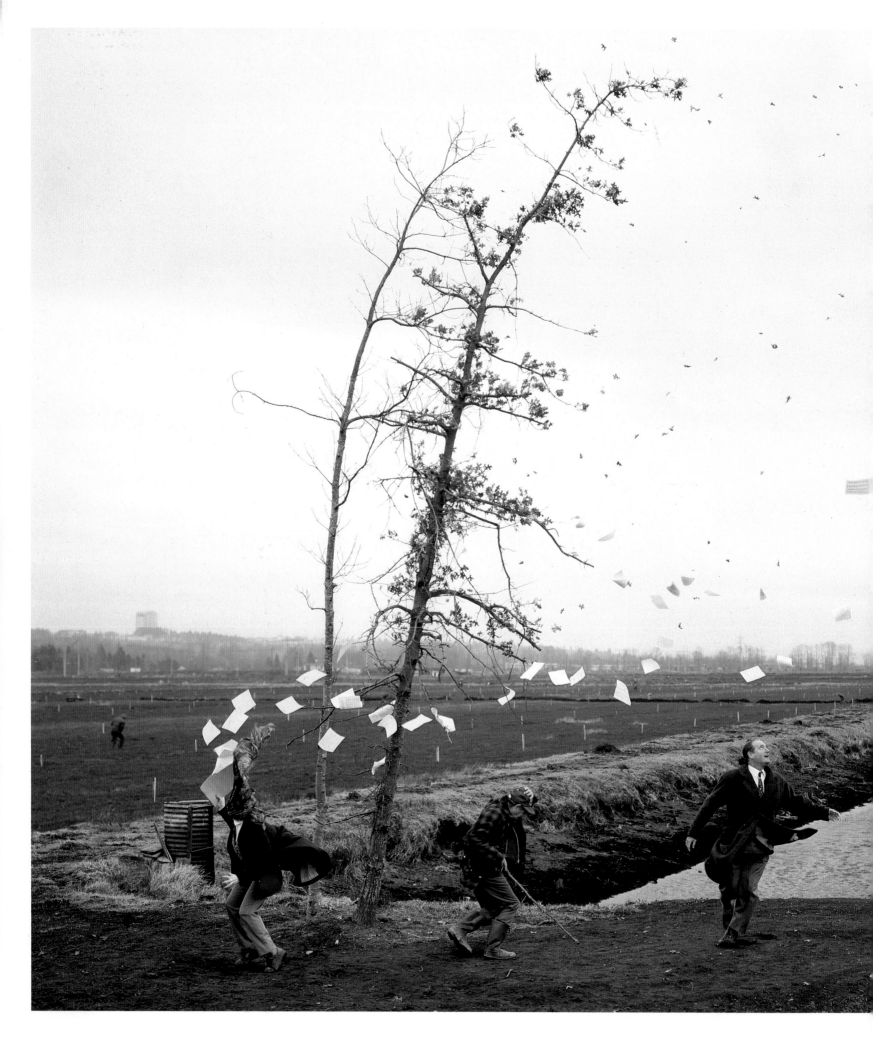

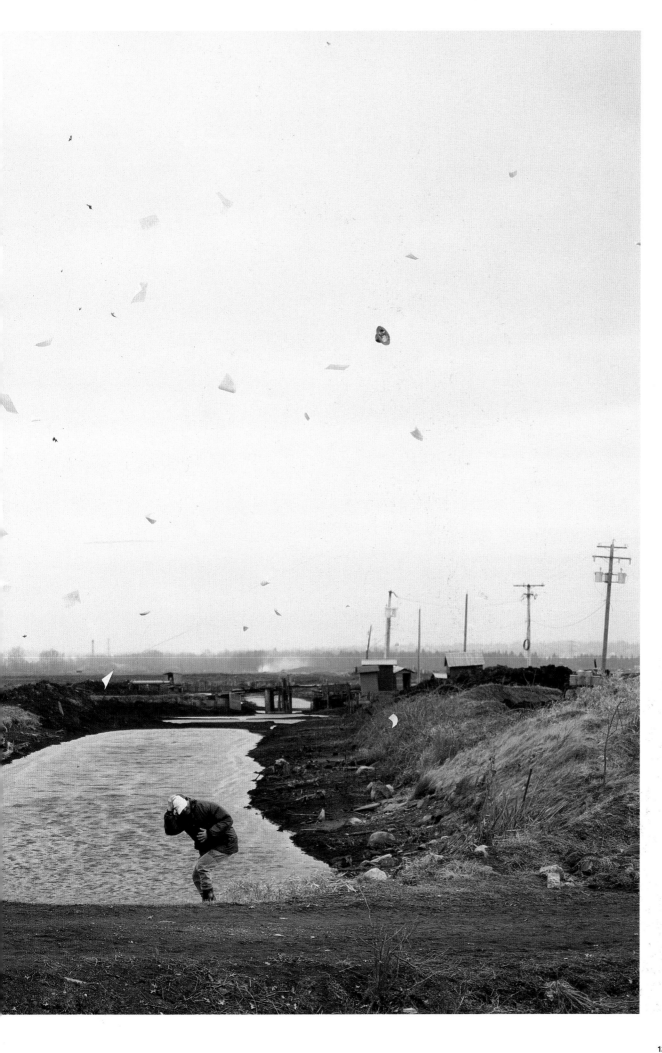

**Hokusai**
A High Wind in Yeijiri, from 'Thirty-
six views of the Fuji'
c. 1831-33
Print
Approx. 26 × 37 cm

seen is that iconographic critique simultaneously legitimates itself and the tradition of representation in the process of helping to break up the solidified identity of the idea of representation as it had come down through a kind of worn-out and corrupt humanist tradition. Ironically, it makes representations more visible now, more useful, more open to the aspirations of different people.

**Guilbaut**  So for you the opening up of the idea of the unified viewer, the unified subject, isn't just possible in the form of collage?

**Clark**  What I was trying to say before was that I think it isn't exclusive to collage, no. Let me, for a moment, go back to my point about the possible viewer who doesn't really see himself or herself as fundamentally monadological. If you look at a work like Lorenzetti's *Good and Bad Government*, I don't think it confirms the monadological unity of the viewer. It opens itself for a kind of construction of understanding misunderstanding by persons who, because of the subject matter, because of the way the subject-matter is deployed, because of the conventions of the picture, are almost forced to pluralize themselves. It is only at a certain point in history that one-point perspective became part of the whole protocol, ideology, regime of individualism, personhood and representation. And it is the case that art objects, particularly pictures, seem to confirm a unified subject position. They may confirm by trying to work against it. The alternative I'm positing is one which existed for much of the history of art-making. This is a relationship in which literally there is a single body, a single person, viewing the artwork. But the singularity is remade and contradicted by the artwork. The work powerfully takes up the individual and confirms and remakes the individual as part of a collectivity.

Wall  **Don't you think it is rather unsatisfying to suggest that, because there is an ideological concept of the legal person – who is a legal possessor of property and derives personhood from that concept of property – that we should totalize that to the point where we can no longer accept any form of individuation as legitimate? Things are, of course, more complicated. For example, the discussion can move in another stage where we see the biological individual – who is, indeed, a social being – totalized as a monadological person in the constitutional rhetoric of capitalism. Is capitalism, then, the horizon under which cultural critique is worked out? Critique suggests alternatives, and without the composition of alternatives, even speculative ones, critique looses its reason for existing. It continues as a kind of moral aura, without direction, endless and formal**

critiquing and critiquing, as we've seen in the past decade or so. This is a cipher for the position that feels that any contestation over forms of property, which ground this notion of the unified person, has been resolved in favour of the existing order, the existing economy and state. I don't think this is true, and I agree with you that there are alternatives which can be recognized in the experience of the art works.

The concept of the unified subject, the unified person, or the monadic person, is a historical condition which we move through in a historical process which can't be jumped over. The new situation in which representation exists is a kind of transitional one, maybe. Through it, we've been able to see the inner fragmentations of what previously seemed to be traditionally unified works, their inner suturings, inner twists, self-denials and so on. That has always been my experience of older art. The paradigmatic image of, say, realism, which was worked out in the 1970s, the one that suggested that realism was naive in that it unreflectively configured a reality too complex for it, that probably had to be expressed in order to break the spell that such realism had on many people, even after decades of avant-gardist fragmentations. The fact I feel that that critique itself moved too linearly to a polar opposite position, and became somewhat sterile in the process, doesn't mean that I could deny the necessity of the process of critique. I feel absolutely the opposite, and don't think that my pictures have any point of contact with the neo-conservative return to tradition, which counterposes figuration and representation against Modernism and experimentalism. My work comes out of the process of exper-imental critique, but is itself an experimental critique of aspects of that process.

Guilbaut  In a sense, I see your project as an important one because you try to redefine what a picture should be, could do, the way – excuse the loaded reference – Diderot or Pollock tried to reinvent the notion of tableau in a period of cultural and political crisis. This is such a bleak moment in our cultural life that this type of study, this type of critical reassessment and analysis of what representation can be is – by recalling a long historical past – crucial. But this redefinition of the parameters of a renewed critical type of art after the implosion of Conceptual and post-Conceptual attempts is in my mind, if not impossible, certainly difficult at least.

Wall  Difficult, but possible. To shift this discussion, which has been between some art historians and critics and an artist, in a different direction, I think it's important to see that Conceptual and post-Conceptual attitudes and approaches have played an important part in what we could see as a radical reworking of the field of art history

in the same period in which the kind of artistic experimentation we've been talking
about was elaborated. Since my pictures and my work as a teacher have a connection
with the fact that, as a young artist, I went to university and studied art history rather
than going to art school, this topic is of particular interest to me. For example, when
the concept of a painting of modern life emerged with particular crystal clarity in the
nineteenth century, it changed the way the history of art could be seen. It was possible
to rethink the modernity of the works of earlier artists. The way Manet worked with
seventeenth century Spanish painting is a central example. At this point, I think a certain
very important evolution in the history of Western art was taking place. Manet's art
could be seen as the last of the long tradition of Western figuration, and of course at
the same time, as the beginning of avant-gardism. The avant-garde counter-movement
against the idea of the painting of modern life of course built itself entirely upon it.
Whether you look at Rodchenko, Arp or Pollock, you will see that the attitude towards
tradition and the antagonistic acceptance of the logos of tradition, derives from the idea
of building monumental forms which express and explain what exists in modernity – so
they are actually counter-monumental. So it seems to me that the general programme of
the painting of modern life (which doesn't have to be painting, but could be) is somehow
the most significant evolutionary development in Western modern art, and the avant-
garde's assault on it oscillates around it as a counter-problematic which cannot found a
new overall programme. This thinking both transformed art history and came out of its
developing relationship with the whole discourse of modernity, out of the rearticulation
of art history on the basis of the new critical theories of the 1960s and 1970s. This new
situation provides the means for rebuilding that neglected field, aesthetics, as well. For
me, none of my work could have been done without the turmoil within art history. Serge,
you and I once had a discussion in a class in which I accused you art historians of being
more avant-gardist than the artists, because art historians were trying to keep thinking
about what avant-gardism meant, and by implication, what it means, or, where it went.
They were more interested in it than many artists, who seem to have gone on to other
things, like expressing themselves. You cringed at my point, but I think you appreciated
it at the same time – maybe because you also feel that there has been and still can be a
fusion of discursive work between art historians, writers, along with artists, something
which the generation of the 1960s and 1970s did experience in things like Conceptual art,
where writing and making art works were not considered such unrelated things.

*Parachute* No 59, Montreal, July/August/September 1990, pp. 4-10

**Doorpusher**
1984
Transparency in lightbox
249 × 122 cm

## Restoration
## Interview with Martin Schwander  1994

**Martin Schwander**  In an interview, published in 1990, you said, ' ... the process of expe-
rience of a work, while it must be open to the associations brought to it by different people,
is still structured and regulated and contains determinations. I think it is controlled, above
all, by genre, by the generic character of the picture-types and the types of subject. Bakhtin
said that genre was the collective, accumulated meaning of things that has come through
time and the mutations of social orders. It is the foundation of the guarantee of objectivity,
the basis of the "truth content" of representations ... '[1] With these comments in mind, I'd
like to know what genre tradition you are connecting *Restoration* with.

**Jeff Wall  I'm not so sure what the genre of the panorama picture is. The curious thing
about the phenomenon of genre is that it operates whether the artist is very much
conscious of it or not. That is what Bakhtin was referring to when he spoke about it as
an aspect of what he called 'collective memory'.[2] You do not really have to be conscious
of the generic structure of the work you're doing to do it, even to do it well. The work
you do will have such a structure in any case. Genre is a fluid construct that operates
regardless of the consciousness of the artist. It is fluid in that it isn't so clear whether
its 'constructs' can be very strictly defined, its borders easily located.**

**I think my panorama picture is something like one of those eighteenth century
pictures that depict activity going on in a public building, like a church, where people
are carrying on their normal business, as for example in a painting by Hubert Robert.
The fact that it is the restoration of a picture that is going on in my picture may be
secondary. The immediate theme of the picture, its subject, may be secondary.**

**Schwander**  Even though you refer with the title of the work to the clearly visible, skilled
process of restoration?

**Wall  Yes, I think it is possible for the dramatic theme of the picture to be dominated by
the overall pictorial character of the work. To take again the example of Hubert Robert,
you can imagine two pictures by him, both of typical public scenes. And in the two
pictures two completely different kinds of things may be happening, and yet if the
pictures were structured similarly, they may be more similar than different in terms
of their generic identity, regardless of the subject.**

**Schwander**  The right hand side of the picture with the two restorers at work can also be
seen as a portrait of two young women. With *Adrian Walker* you made a portrait of a young

Adrian Walker, artist, drawing
from a specimen in a laboratory
in the Dept. of Anatomy at the
University of British Columbia,
Vancouver
1992
Transparency in lightbox
119 × 164 cm

man who is concentrating so intensely on his work that he seems to be removed to another sphere of life.

Wall  But I don't think it is necessarily clear that *Adrian Walker* is a portrait. I think there is a fusion of a couple of possible ways of looking at the picture generically. One is that it is a picture of someone engaged in his occupation and not paying any attention to, or responding to the fact that he is being observed by, the spectator. In Michael Fried's interesting book about absorption and theatricality in late eighteenth century painting[3], he talks about the different relationships between figures in pictures and their spectators. He identified an 'absorptive mode', exemplified by painters like Chardin, in which figures are immersed in their own world and activities and display no awareness of the construct of the picture and the necessary presence of the viewer. Obviously, the 'theatrical mode' was just the opposite. In absorptive pictures, we are looking at figures who appear not to be 'acting out' their world, only 'being in' it. Both, of course, are modes of performance. I think *Adrian Walker* is 'absorptive'. The fact of it being or not being a 'portrait' of a specific real person, again, may be secondary in the structure. The title, because it names him, makes it appear that he is such a specific, real person. But it's easily possible that

*Adrian Walker* is simply a fictional name that I decided to make up to create a certain illusion, like 'Emma Bovary'. Even though that's not true and there is such a person, and that is him, I don't think there is necessarily any resonance of that in the structure of the work, generically speaking. The nature of the picture gives no guarantees that that identification matters at all. So, like a lot of pictures, it is a bit of a hybrid. Portraiture seems to be a social relationship, sustained by empirical and historical evidence, corroborating the identity of someone who appears in a particular picture; it doesn't seem to be a pictorial relationship or a pictorial phenomenon, as such.

But when you have a picture of a figure absorbed in some activity you begin to move outside of the boundaries of portraiture, strictly speaking, into a kind of picture in which people are identified, and identified with, primarily by their physiognomy and their actions and less by their names, less by their personal, empirical, historical, social identity and more by their generic identity as controlled by the type of picture they're in.

**Schwander** Isn't there a difference, though, between works like *Restoration* and *Adrian Walker* and many of your other works, because in the two just mentioned 'principal actors' are not actors, but rather persons who 'are playing themselves', presenting and impersonating themselves?

Wall  **They are performing, they are as you say, 'performing themselves'. In the Bourbaki picture, I was working with people who are actually professional restorers, so they give an authenticity to the scene. But, if it were necessary, we could have used actors, performers who are not restorers but who could have gone to an atelier and studied, and would have been able to imitate restorers. So, again, I have to say that the fact that someone really is what they appear to be in a picture is not a pictorial matter. Here's another example of how fluid this aspect is. Some years ago I made a picture called *The Guitarist*, which I think is generically very similar to *Adrian Walker*. In it you see a young girl playing the guitar, and a young boy listening to her. They are both about fifteen. The girl who was performing couldn't actually play the guitar. I had to teach her a couple of basic chords and have her place her fingers properly on the neck and so on, so it would**

appear that she was playing a chord. But because she was inexperienced and unskilled, her hands weren't really 'natural', not correct. I showed a test shot to a friend of mind, a very good guitarist, and he immediately commented on the position of the hands, saying it's obvious she knows next to nothing about playing the guitar. We discussed the idea of him coming and giving her a few lessons so she could make her hands look like she was more competent. But finally I didn't do that because it seemed to me just as interesting, no, more interesting, that she was really a complete beginner, trying to make the kinds of sounds she was interested in from her favourite records. I wanted it to be about young people just beginning to learn a language, a new language. So, in that picture the girl was really 'herself', someone who couldn't play guitar but who was very interested in imitating someone who could – that is, interested in learning to play. But at the same time, in terms of my pictorial subject, she was a character of that type, exhibiting that desire, that character. For example, if the performer by chance knew how to play the guitar better, maybe I would have had to ask her to imitate someone who couldn't play it as well.

**Schwander**  In *Restoration*, the restorers simulate – and hopefully anticipate – the preservation of a large-scale panorama picture, which really is in alarmingly poor condition.

Wall  I was interested in the massiveness of the task the figures are undertaking. That for me was an important part of the theme. There might be associations of that massiveness with the futility of ever bringing the past into the 'now'.

**Schwander**  Another futile venture was probably the attempt to render a 360-degree panorama picture in a two-dimensional medium.

Wall  A panorama can never really be experienced in representation, in any other medium. I made a 180-degree panorama photograph of a 360-degree picture, and so had to show only half of it. The geometry of that struck me as appropriate, harmonic, one to two. It itself expresses the fact that the panorama is unrepresentable. Maybe this unrepresentability was one of its great historical flaws. The fact that panoramas emerged so strikingly, and then died out so quickly, suggests that they were an experimental response to a deeply-felt need, a need for a medium that could surround the spectators and plunge them into a spectacular illusion. The panorama turned out to be entirely inadequate to the challenge. The cinema and the amusement park more or less accomplished what the panorama only indicated. The panorama has pretty much

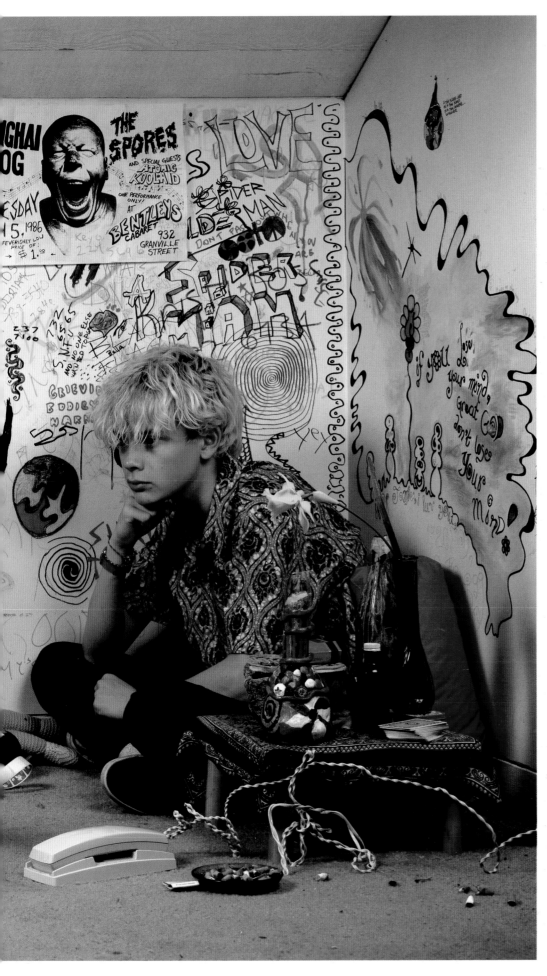

**The Guitarist**
1987
Transparency in lightbox
119 × 190 cm

**Jean-Auguste-Dominique Ingres**
The Odalisque with the Slave
1843
Oil on canvas
76 × 105 cm

always been understood as a proto-cinematic phenomenon, a precursor also of other forms of mass culture. Lately, with 'virtual reality' devices, we've come back in a way to a 'panoramic aesthetic' which doesn't want to have any boundaries. The interesting tension in the picture for me is that between the flatness of the photograph I'm making and the curved nature of the panorama's space. Because you can see it curve away from you and disappear, I see it as a kind of making-explicit of the situation that exists with every picture which renders the illusion of volume and curved space on a flat plane. The fact that the panorama can be seen escaping from view is one of the things which most interested me in making the work. The idea that there is something in every picture, no matter how well-structured the picture is, that escapes being shown. I've always been interested in this. In a few pictures I've done I've concentrated on showing people talking. Speech is something which by definition cannot be adequately depicted in a photograph or a picture, and so to me it always seemed fascinating as that thing which was forever escaping, a sort of will-o'-the-wisp, something that can never be located in the picture, but it is what the picture is about, what it is showing somehow. In fact, in the Bourbaki picture, there is a pair of restorers on the farthest scaffold who can be seen having a conversation, one which cannot be heard because they are so far away. I thought about those round buildings where you can hear a conversation way on the other side if you stand in one special spot. These things are subtle elements of mobility, of restlessness, of the fugitive. The stillness and stable composition of the picture, in general, intensifies this fugitive sense.

**Schwander**  But at the same time the picture depends too on the contrast between the drama of the vast space of the picture and the almost intimate depiction of the two restorers in the foreground.

**Wall**  I find that very poetic and very political. One can make gestures that are very intimate and personal in a public scene, and they become sort of models of behaviour. I think that in the arts, crafts and professions people develop patterns of behaviour which function as social models. These women, as restorers, are acting-out a kind of conceptual model of what their idea of civilization is like, their idea of a certain valid way of life. I think one of the historical roles of pictorial art was to make images which in a way are models of behaviour, too. First, they are conceptual models of what a picture should be, because every picture can be thought of as a proposal of a model of what a valid picture is. But, also, the behaviour of the figures in the picture may be models, or

at least proposals of models, of social behaviour, of whatever kind. So, in the panorama picture, the characters are developing, and enacting, an intimate, meditative relation to a work of art through their practice, their work. This is a kind of statement.

Schwander  The title you gave the work has itself a political dimension.

Wall  *Restoration* has a post-revolutionary, even counter-revolutionary implication. I was interested in the double entendre in the title, the idea that the panorama and the 'regime' of representation in which it is involved could be identified with an *ancien régime*, which ironically we are preserving, and even resuscitating, bringing back to life.

Schwander  In many of your works you integrate pictorial concepts handed down through art history. This unambiguous handling of tradition, which is reflected in the works themselves, distinguishes you from the representatives of a 'purist' and modernist conception of the avant-garde which held true up into the 1960s.

Wall  I think that Modernism as it is commonly construed overemphasizes the rupture, the break with the past. The emphasis on discontinuity has become so orthodox and routine that I prefer to concentrate on the opposite phenomenon. It's just as significant historically. Another aspect is that the photographic image by its physical nature is figurative, and so it is linked objectively to all figurative traditions, traditions which necessarily preceded both photography itself, and modern art. So it seems we are in a permanent relationship with a figurative form of art, a figurative mode of depiction of things. This mode is bigger, more extensive, than our concept of art, and certainly more extensive than our idea of modern art or Modernism in art. Figuration rests on something spontaneous, which is the recognition of appearances by the human eye. So it has a kind of phenomenological base, even a physiological base, which is not so directly available to other forms of art, to experimental and conceptual forms. This is probably why the critique of a phenomenological basis to representation has been an important part of the traditions of experimental art in the twentieth century – for example, Duchamp's attack on the 'retinal'.

Schwander  *Restoration* can also be considered a homage to the traditional forms of skilled work – painting and restoration. But on the other hand this picture was produced with advanced computer technology.

**Restoration**
1993
Transparency in lightbox
137 x 507 cm

Wall  I like the fact that these different technologies collide in the picture. The layering of technologies is part of the nineteenth century 'spirit of the panorama', and we are still involved with that spirit in our own fascination with technological spectacle.

One paradox I have found is that, the more you use computers in picture-making, the more 'handmade' the picture becomes. Oddly then, digital technology is leading, in my work at least, towards a greater reliance on handmaking because the assembly and montage of the various parts of the picture is done very carefully by hand by my collaborator and operator, Stephen Waddell, who is a painter.

Schwander  This complicated and complex method of production gives you for the first time the possibility to continuously control and change all the elements that are important for the composition of the picture while it is being developed. Paradoxically these accumulative work-methods based on the most advanced visual technology recall the evolution of large, narrative and dramatic paintings of the past which painters constructed in their ateliers, step by step from a number of models and studies.

Wall  It has curious resemblances to the older way of painting in the way you can separate the parts of your work and treat them independently. A painter might be working on a large canvas and, one afternoon, might concentrate on a figure or object, or small area. Part of the poetry of traditional painting is the way it created the illusion that the painting depicted a single moment. In photography, there is always an actual moment – the moment the shutter is released. Photography is based in that sense of instantaneousness. Painting, on the other hand, created a beautiful and complex illusion of instantaneousness. So past, present and future were simultaneous in it, and play with each other or clash. Things which could never co-exist in the world could easily do so in a painting. That is something photography was never suited for, although cinema is. The early 'composite photographs'[4] were unconvincing, and it's no mystery why serious photography went in the opposite direction for a hundred years. Computer montage

has destroyed that barrier. In my computer pictures I can conjure something up by an assemblage of elements created with their pictorial unification in mind.

Schwander How do you assess the artistic quality and the significance of the Bourbaki panorama in art history?

Wall The Bourbaki panorama is worth preserving, for two main reasons. First, it is a beautiful pictorial construction. For its size, it is a very good painting. I have had the opportunity to examine it carefully every day for three weeks. Most of it is very nicely painted in its rather conventional, naturalistic style. There are a few bad areas, but I have the impression those are things added later, in botched restorations. Some of the horses in the foreground are not so good. But the atmospheric treatment of the landscape is excellent; there are many good figures and figure groups, very well-handled. The composition is remarkable, and, as a pictorial conception it is, in my opinion, one of the most interesting pictures of the nineteenth century. It should be much better-known and appreciated than it is. The second reason is the originality of the subject. Castres was not a great artist, but he did have one great inspiration. I guess being in the Bourbaki army was the great experience of his life, something like Stendhal's experience of Napoleon's campaigns. The subject of the defeated army receiving asylum and assistance from the army of another country and from its citizens is very unusual, particularly in a work on this scale. Usually, huge war pictures deal with victory, spectacle or defeat and not with assistance, sanctuary and healing, as Castres' does.

Schwander When you first saw the Bourbaki panorama you were working on *Dead Troops Talk*, a picture which depicts circumstances from the war in Afghanistan. Is there any connection between these two pictures? Is it an 'anti-war' statement?

Wall Not necessarily. An 'anti-war' statement would be one which insists that war has

no validity, and therefore we should not engage in it, for any reason. Castres does not say that. To me, he expresses a sensitivity to the sombre grandeur of a great defeat. His image of the long lines of suffering soldiers moving through the landscape like spectres is very moving, but it says very little about the validity of war as such. In a sense, war pictures cannot really be 'anti-war'. They can, however, repudiate military glamour, the glamorization of combat and strategy, and focus on suffering.

Schwander  In Castres' picture, women – mostly peasants – rush toward the soldiers to bring them food and give them assistance. In your picture, young women are trying to save Castres' picture from deterioration.

Wall  To be a restorer, you must be in a very complex relationship with the past. Why would young people want to undertake this immense and tedious labour of preservation and repair, to work for such a long time in such a dusty place, so patiently, to preserve a monument which they themselves realize is part of a tradition – a patriarchal tradition – that they are probably battling with in the other aspects of their lives? To place a young woman in such a position is in my view something very pictorial.

Schwander  Accordingly, women have another kind of relationship to the past than men …

Wall  Maybe, because it seems that so many restorers are women. In any case, I think there is something striking in the confrontation of a young woman (or a group of young women) with a monumental painting; that something is evocative, dramatic, what I called 'pictorial'. It is almost as if as soon as you think of the two elements, 'young woman-big painting', your mind's eye grasps it as a pictorial situation, as something charged. There is a certain irony in it, obviously.

Schwander  Could you elaborate on this ironic aspect?

Wall  Well, the most obvious aspect is the relation to the men who made the picture, and the tradition in which it was made. The restorers have to have a special relationship with those men. They also have a special relationship with previous generations, in general, a special interest in the things left behind by past generations. I would see it as a special relationship with the male ancestral line. It's a kind of 'family romance'.

**Schwander**  Perhaps it also has to do with a sublimated form of erotic relationship …

**Wall**  In a way. But, I also think that, in pictures, everything has an erotic aspect. Everything pictorial has an erotic aspect – you could even say that everything erotic is pictorial and everything pictorial is erotic. I mean erotic here in the sense that there is pleasure to be gained from the picture, and that pleasure has a relation to the whole being of the person experiencing that pleasure, to their sexuality, too. The pleasure is physical. And when there are figures, images of beings, in the picture which gives pleasure, then there is a process of fantasizing that takes place, often unconsciously. The spectator will fantasize according to his or her desire, fantasize relationships between figures in the picture, and between him or herself and such figures. In old-fashioned pictures, which were illustrations of well-known stories, the spectators usually knew the story, and the relationships involved, and so their own fantasizing was shaped by that. So they knew something concrete about links between characters. In modern-type pictures we don't have the story, so the fantasizing is more free-form, and maybe more intense. There are obviously works of art in which an erotic relationship between the figures is an explicit theme, like Picasso's 'artist and model' extravaganzas. I see that as a kind of narrativization of something that already exists in the structure of every picture, and so, in a way, as no more erotic than any other picture.

**Schwander**  Unlike in the case of Picasso, the erotic as such is not an explicit subject in your work. On the contrary, a lot of your works are about the obstacles or even the impossibility of human relations; they deal with aggression and alienation among people.

**Wall**  I don't think that's true of all of my work. I've made pictures about contact and communication, friendship and closeness, too. I admit they're mostly about indirect contact, verbal communication. Up to now, the indirect eroticism of the pictorial as such has interested me more than any specifically erotic themes. But, in principle, I don't draw too sharp a line between the two approaches. An image of an erotic subject which could not provide the pleasure given by a beautiful pictorial construct would maybe not be something aesthetically interesting.

**Schwander**  In *Restoration*, human relations play a subordinate role. They make up a kind of 'subtext' lacking plot or drama.

Wall I think this brings us back to the question of genre. When I was doing dramatic pictures; like *Mimic*, for example, I was interested in a certain type of picture, one I identified with painters like Caravaggio, Velázquez or Manet. In that type of thing, the figures are in the foreground, they are life-size, they are close to the picture surface, and the tension between them is what is central. Behind them, there is a space, a background. That is a very traditional kind of picture, I think. But I have gotten interested in other types of picture, and other types of pictorial space. I have made quite a few pictures which are very differently structured, in which the figures are further away from the picture plane, smaller, and more absorbed in the environment. You could say it's a move from Caravaggio to Vermeer or Brueghel. I am not necessarily interested in different subject matter, but rather in different types of picture. A different kind of picture is a different way of experiencing the world, it is a different world almost. *Restoration* is more this latter type of picture, which does not require the kind of dramatic intensity of the earlier pieces. Nevertheless, the next picture I'm doing is more in the line of *Mimic*. It is not a question of doing one or the other, but of opening different paths, and following them simultaneously.

1    'Representation, Suspicions and Critical Transparency. An interview with Jeff Wall by T. J. Clark, Serge Guilbaut and Anne Wagner', *Parachute* No 59, Montreal, July/August/September 1990, p. 8, in this volume, pp. 112-125

2    Michail M. Bakhtin (1885-1975), Russian semiologist and scholar of the humanities, contemporary of the Russian Formalists. Investigating the concept of early structuralist linguistics, he was interested in issues concerning aesthetic form, especially the interaction of content, material and form in language. Jeff Wall refers here to Bakhtin's comments in *Problemy tvorcestva Dostoevskogo*, Moscow, 1963, *Problems of Dostoevsky's Poetics*, trans. R. W. Rotsel, Ann Arbor, 1973 (translation, 1963).

3    Michael Fried, *Absorption & Theatricality: Painting and Beholder in the Age of Diderot*, University of Chicago Press, 1980

4    'Composite photography' is a photographic technique especially used for taking pictures of large groups of people. The picture was composed in a kind of 'collage' from separately made paper contacts. The technique was first described in 1854 by Wilhelm Horn in *Photographisches Journal* Vol 1, 1854, p. 87. Principal representatives were Henry Peach Robinson (1830–1901) and the Swedish painter Oscar Gustav Rejlander (1813–1875).

'Jeff Wall Restoration' (cat.), Kunstmuseum, Luzern; Kunsthalle Düsseldorf, 1994

## About Making Landscapes 1995

I make landscapes, or cityscapes as the case may be, to study the process of settlement as well as to work out for myself what the kind of picture (or photograph) we call a 'landscape' is. This permits me also to recognize the other kinds of picture with which it has necessary connections, or the other genres that a landscape might conceal within itself.

Plato, in *The Statesman*, wrote: 'We must suppose that the great and the small exist and are discerned not only relative to one another, but there must also be another comparison of them with the mean or ideal standard. For if we assume the greater to exist only in relation to the less, there will never be any comparison of either with the mean. Would not this doctrine be the ruin of all the arts? For all the arts are on the watch against excess and defect, not as unrealities, but as real evils, and the excellence of beauty of every work of art is due to this observance of measure'.

This fundamental criterion of idealist, rationalist aesthetics – that of the harmonious and indwelling mean or normative abstract standard – remains important in the study of development in the conditions of capitalist – or anti-capitalist – modernity. But it is important as a negative moment because the most striking feature of historical, social and cultural development in modernity is its unevenness.

Contemporary cultural discourse, which prides itself on its rigorous critique of idealism, has almost invalidated the idea of the harmonious mean, characterizing it as a phantom of rationalism. At the same time, the survival of the concept of measure, as the universal standard of value in the exchange of commodities, implies that measure is for us not a moment of transcendental revelation and resolution, but one of inner conflict and contestation – the contestation over surplus value, which implicates and binds all of us. From this immanently negative and antagonistic perspective, development can only be overdevelopment (aggravated development) or underdevelopment (hindered, unrealized development).

Translating these opposites into stylistic terms, we could see overdevelopment as a sort of mannerist-baroque phenomenon of hypertrophy and exaggeration – a sort of

**The Jewish Cemetery**
1980
Transparency in lightbox
62 × 229 cm

typical postmodern 'cyberspace'. Underdevelopment suggests a poetics of inconclusive-ness, filled with a secessionist rural pathos. But the 'Arte Povera' of underdevelopment is no less malformed than its opposite; both are formed by an antagonistic or alienated relation to the concept of measure, and their unity around this concept is a threshold between aesthetic thought and political economy. So, one way of approaching the problem of the 'politics of representation' is to study the evolution of a picture as it works itself out in relation to the acts of measuring which constitute its very form. (For example, in the Academic tradition the relation between the shorter and longer sides of a pictorial rectangle were subject to prescriptive harmonic interpretation.)

In classicism the work of art is made by imagining the picture's or statue's subject as perfectly harmonious in its internal proportions, and then depicting that subject in a composition, and on a rectangle, both of which are equally well-measured. That is, both are exercises in harmonics. The measure and proportions of the picture themselves imply, and reflect, the serenity of ideal social relations.

Baroque aesthetics expressed both this Poussinian form and others – for example, that which we may identify with Breugel's sixteenth century 'anticipatory baroque' – oddly, complexly-balanced compositions filled with bumpy, ragged, rough forms, simultaneously regular and irregular, hectic, complicated, carnivalesque and fractalized.

It's convenient to suggest (after Bakhtin) that Breugel's grotesque, or the movement towards it, is the 'true' modern one, the one in which the negativity of modern measure, the non-identity of the phenomenon with itself, the intangibility of meaning, is best made visible. I prefer to evade the polarization implicit in such a conclusion. The negative moment of measure may also be formulated as an *excess* of measure, in the manner of caricature. Harmony may therefore be thought of as a special, even a 'sovereign', instance of the grotesque.

However that may be, we could anyway say that in a modern type of picture there will tend to be a distinction, or disparity (if not an open conflict) between the over- or underdevelopment of the motif or phenomenon pictured, and the still successfully-

**The Old Prison**
1987
Transparency in lightbox
70 × 229 cm

**The Bridge**
1980
Transparency in lightbox
60 × 229 cm

**The Pine on the Corner**
1990
Transparency in lightbox
119 × 149 cm

measured and harmonious nature of the picture itself. The experience of the tension between form and content records and expresses mimetically something of our social experience of tormented development, that which is not achieved or realized, or that which, in being realized, is ruined – and also all the unresolved grey areas in between where hope and alternatives reside.

Studying settlement forms is therefore not separable from working out picture-types; it's not possible to do the former without doing the latter. A successful picture is a source of pleasure, and I believe that it is the pleasure experienced in art that makes possible any critical reflection about its subject matter or its form. That pleasure is a phantom affirmative moment, in which the pattern of development of settlements is experienced as if people didn't really suffer from it.

My landscape work has also been a way to reflect on internal structural problems in other types of pictures. In doing that, it's been possible to rethink, for myself, some rather obvious and conventional things about the genre of landscape as a genre.

Most evidently, a picture tends towards the generic category of landscape as our physical viewpoint moves further away from its primary motifs. I cannot resist seeing in this something analogous to the gesture of leave-taking, or, alternatively, of approach or encounter. This may be why a picture of a cemetery is, theoretically at least, the 'perfect' type of landscape. The inevitably approaching, yet unapproachable, phenomenon of death, the necessity of leaving behind those who have passed away, is the most striking dramatic analogue for the distant – but not *too* distant – viewing position identified as 'typical' of the landscape. We cannot get too distant from the graveyard.

So, we could reason that the peculiar or specific viewing distance at which the picture-type 'landscape' crystallizes is an example of a threshold-phenomenon or a liminal state. It is a moment of passage, filled with energy, yearning and contradiction, which long ago was stabilized as an emblem, an emblem of a 'decisive moment' of vision or experience, and of course of social relationships too.

In making a landscape we must withdraw *a certain distance* – far enough to detach ourselves from the immediate presence of other people (figures), but not so far as to lose the ability to distinguish them as agents in a social space. Or, more accurately, it is just at the point where we begin to lose sight of the figures as agents, that landscape crystallizes as a genre. In practical terms, we have to calculate certain quantities and distances in order to be in a position to formulate an image of this type, especially in photography, with its spherical optics and precise focal lengths.

I recognize the 'humanist' bias in this construction, and the recurrence of the idealist

notion of measure in it, but I think it's valid as a way of thinking analytically about the typology of pictures, which, unlike some other art forms, are radically devoted to the semblances of the human being. This is just one of the senses in which we have not gotten 'beyond' idealist aesthetics.

To me, then, landscape as a genre is involved with making visible the distances we must maintain between ourselves in order that we may recognize each other for what, under constantly varying conditions, we appear to be. It is only at a certain distance (and from a certain angle) that we can recognize the character of the communal life of the individual – or the communal reality of those who appear so convincingly under other conditions to be individuals.

Modernist social and cultural critiques and theory have concentrated on revealing the social semblance, the social mask, of liberal idealism's most important phantom, the 'subject', sovereign, individuated and free. What has been at stake is the visibility of the determinations which, in so far as they are repressed in or as social experience, make possible the appearance of this 'ideological ghost', this creature of 'second nature'. If that were to be an artist's intention, it could probably be realized entirely through a self-reflexive approach to a 'humanist' typology of landscape as I've outlined it. In modernity's landscapes, figures, beings or persons are made visible as they vanish into their determinations, or emerge from them – or more likely, as they are recognized in the moment of doing both simultaneously. Thus they are recognized as both free and unfree; or possibly misrecognized, first as unfree, then as free, and so on. Another way of putting this is that, in a landscape, persons are depicted on the point of vanishing into and/or emerging from their property. I think this phenomenology is analogous to, or mimetic of real social experience, extra-pictorial experience. The liminal condition of landscape has been for me a sort of measure, or mean. I have been trying to reflect on, and study other constructs, other picture-types which I feel have in some important senses crystallized out of landscape.

*following pages,* **The Holocaust Memorial in the Jewish Cemetery**
1987
Transparency in lightbox
119 × 216 cm

**Artist's Writings**

**Boris Groys**  Jeff, I recently saw your black and white pictures for the first time at Documenta X (1997). In the same room you also hung a small light box, *A Sunflower* (1995) which seemed to be some kind of self-quotation, emphasizing the change in your work. What is the grounding for this change in direction?

Jeff Wall  **Two or three reasons, I guess. The first is that, when I began working in colour, more than twenty years ago, I thought that, by working in colour, I was somehow excluding black and white from my practice. That exclusion remained in my mind. Photography contains so many possibilities there is no reason to presume that one is more central than any other. So, even though I practiced colour photography exclusively for quite some time, I always had the idea that, in order to stay really involved with the medium, this exclusion would eventually have to be resolved.**
    **Black and white photographs always struck me as being about luminosity in a way**

A Sunflower
1995
Transparency in lightbox
74 × 90 cm

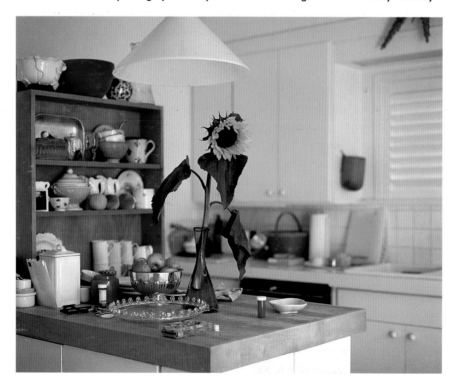

Rear, 304 East 25th Ave.,
Vancouver, 9 May 1997,
1.14 & 1.17 p.m.
1997
Black and white photograph
246.5 × 363 cm

similar to my transparencies. Black and white pictures seem to contain an intense sense of the luminous, maybe because of the absence of colour, the fact that everything is based on the relation of tones, of relative brightness. It has something to do with the pure presence of light, which is more evident because of the lack of colour.

Finally, in many ways it is conventional to think that black and white photography refers primarily to the past, to the history of photography. I disagree with that, although I also acknowledge the truth in it. That is, I think that although a black and white picture seems to belong to the past, to the era before colour photography was perfected, it nevertheless continues to exist and develop now, in the present. It is marked by the present, as the present, just as it suggests an earlier era.

My generation entered into the practice of photography through a sort of contestation with what the medium – or the art form – had come to be. For many years the main thinking in photography was how one could pull away from orthodox aesthetics of photography. I think that had a positive effect that led to many important innovations and a general broadening of the discourse. Nevertheless, after a while it became clear to me that the contestation had taken place on the ground established by photography. But artists can now think of themselves as photographers independently of the history of photography. Therefore, I could think of myself as a photographer in a way I couldn't ten or fifteen years ago.

Of course, I still also work in colour.

**Passerby**
1996
Black and white photograph
229 × 335 cm

**Volunteer**
1996
Black and white photograph
221.5 × 313 cm

**Groys** Your colour photographs are presented on a light box; the black and white are on paper. I had this feeling with the black and white works that you introduced luminosity into the picture itself, but there is also a new kind of tension between the picture and its narrative, its content. The black and white pictures seem more about the content. I think the light acted as 'quotation marks' around the image: it told the viewer that what is seen is a fiction, a quotation.

**Wall** **I don't feel the black and white work had more narrative. But I agree with you that the illuminated transparency could be interpreted as producing a kind of 'alienation effect'.**

**Groys** I wouldn't say alienation, I would say *epoché*. You show the picture as a phenomenon. It somehow neutralizes the image.

**Wall** **But there is a similarity. An alienation effect can create a rift between the documentaristic aspect of photography and the narrative. The pictorial occurs in that rift, in that space. I don't think that transparency and illumination have any privileged status vis-à-vis opacity and paper. The picture itself is the phenomenon you speak of, not some technical characteristic within photography. It tends to be real and unreal at the same time.**

**Groys** But on a formal level, somehow the light box quoted the avant-garde tradition, the blank space, pure light, degree zero. All that suggested that you had some kind of pure phenomenon, not a picture and its claim to show reality.

**Wall** **I think my relation with photography is changing. For a long time, as I said, it was necessary to contest the classical aesthetic of photography as rooted in the idea of fact, and the factual claim made by photography both within and outside of art. I accept that claim, but I don't think that it itself can be the foundation for an aesthetic of photography, of photography as art. I could work through that problem by making photographs that put that factual claim in suspension while still involving factuality for the viewer. I tried to do this by emphasizing the relations between photography and other picture-making arts, mainly painting and the cinema. In those, the factual claim**

**Sunken Area**
1996
Transparency in lightbox
218 × 274 cm

Artist's Writings

**A Partial Account (of events
taking place between the hours
of 9.35 a.m. and 3.22 p.m.,
Tuesday 21 January 1997)**
1997
Transparency in lightbox
2 parts, 56 × 402.5 cm each

has always been played out in a subtle and more sophisticated way. This was what
I thought of as a mimesis of the other arts, something that could uniquely be done as
photography. What I began to realize later was that this mimesis was taking place on
the foundation provided by photography itself.

**Groys**  Maybe we could speak about the changing position of photography in general.
I have the feeling that in recent years there has been quite a change, in that a lot of large-
scale photography is just substituting itself for the painting of the nineteenth century. That
is, painting can no longer do what nineteenth-century painting did: say something about
the world. In the wake of all the self-reflexive and self-destructive avant-garde movements
of the twentieth century, painting became obsessed with its own thingness, its materiality
and structure; it could no longer 'just' depict the world. Now what we see are huge
photographs as paintings: they are discussed in pictorial terms, with a stress on the intent,
the content and narrative. The social criticism is of the social position of the photographic
artist. I am worried that we are forgetting the avant-garde, and that the whole picture is a
quotation, a suspension. The whole history of the critique of the image is being forgotten.

Wall  **I don't know if I see that as a danger. The avant-garde attempted to create barriers
to the spontaneous reception of an image, what you're calling an uncritical reception.
I don't believe that earlier audiences did have such a direct and spontaneous relationship
to the image, nor did they believe that the image immediately showed them reality.
I don't see such a complete historical fracture between pre-avant-garde modern art and
the avant-garde, although I know there is a change. As the idea of the avant-garde ages
and develops, I don't think it gets weaker; instead I think it evolves, develops, and gets
more complex and interesting. For example, I think the early thinking within the avant-
garde overemphasized the 'epistemological break'. Many of the new elements we
identify with as the avant-garde critique of art were already present in both the
production and reception of earlier art. For example, the idea that earlier art publics did
not recognize the nature of the image as a phenomenon is obviously untrue. It is simple
to point to Mannerism as an extremely sophisticated movement in which all these
aspects are present at a highly evolved form. On the other hand, the avant-garde was
not unanimous in dispensing with saying something about the world outside the work.**

**Groys** Well, would you say that your works are capable of showing some factual truth about the world? The avant-garde break is to say, 'you can make an image, but the claim that the image says something true about the world is illusionary'. That is where it departs from nineteenth-century realism.

Wall  **There are different ways of saying something about the world. I have put it in terms of the relation between poetry and prose. There is prose, a kind of institutionalized writing in which various regulators control the claims made by the text. For example, in journalism (the prose most important for the avant-garde) there are institutional elements which underwrite the relation of the text to the event in question. There are controlled 'truth claims' being made, and we tend to accept them – although in democracies they are always being hotly debated. In this sense we accept that, unlike art, journalism does say something about the world outside the text.**

    **Then there is poetry, which does not make any of the claims journalism does, but still it makes some claim to have some articulation or expression about things, like nature, mood, time, event, and so on. It makes a claim we can't define, but one we still accept. Most artists, at least most good ones, would probably admit at some point that they are making poetic claims for their work and its relation to what is not their work. I am satisfied with making that claim.**

    **This is a way we can also bridge the divide between the nineteenth and the twentieth centuries. Serious art in the nineteenth century also made the kinds of claims we're talking about. How could it not, since similar claims have been made since the beginning of art? Nineteenth-century realism, at least the good art in that movement – Manet, Cézanne, Seurat – is misunderstood if it is taken to be making prosaic claims. They were firmly inside the tradition which acknowledged the phenomenal nature of the image, which the avant-garde took over by emphasizing. That emphasis emerged in the push towards abstract art.**

**Groys** But the artists you named are actually early Modernists and their artistic practice precedes the avant-garde. The avant-garde drew a very clear formal line between itself and its cultural context. It is, of course, an aggressive strategy which pushes the spectator to see the artwork in a very specific way, and today, many artists of our generation dislike this aggressiveness. They also don't want to be classified based on some purely formal criteria.

**Polishing**
1998
transparency in lightbox
162 × 207 cm

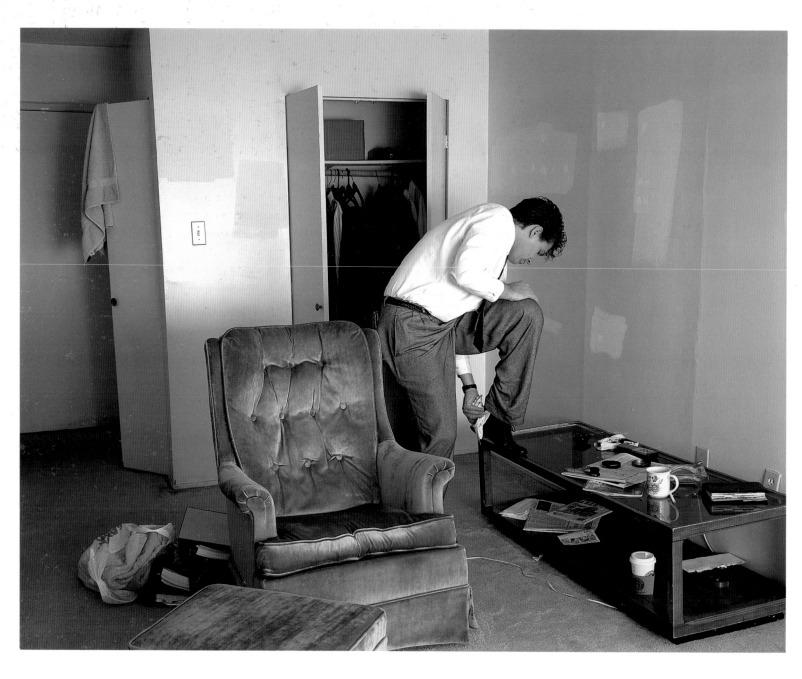

I understand that, but I must confess that I am nostalgic for those clear-cut exclusions. There is a danger that the postmodern, in striving for openness and inclusiveness, turns into a purely commercial strategy of seeking acceptance by all possible audiences for all possible – and potentially conflicting – reasons. How can an artist today draw a line between himself and his cultural context if he doesn't do so on the level of form?

Wall  **I think it is natural for an artist who is trying to make good work, who is trying to participate in a long tradition of artists making good work, to separate himself from his 'context'. Mostly, the 'context' is just the name given to the surrounding mediocrity. All good work emerges somehow from an environment characterized by not-so-good or average cultural production, and some have taken that to mean that there is a direct and unmediated kinship between important, good work and its surroundings. Good work is not simply the product of its context, in fact it may not even be welcome in that context. Any distinction achieved will always be achieved on the level of artistic form – there is no other effective way of drawing the line.**

Boris Groys and Jeff Wall, 'Die Photographie und die Strategien der Avantgarde: Jeff Wall im Gespräch mit Boris Groys', *Paradex*, Cologne, November, 1998. Revised 2001.

**River Road**
1997
Transparency in lightbox
90 × 119 cm

A Villager from Aricaköyü
Arriving in Mahmutbey -
Istanbul, September, 1997
1997
Transparency in lightbox
209 × 271.5 cm

# After *Invisible Man* by Ralph Ellison, the Preface  2001

Ralph Ellison
Invisible Man
1952
Cover of artist's copy

Based on the novel *Invisible Man* (1952) by Ralph Ellison, *After Invisible Man by Ralph Ellison, the Preface* is the second in an informal series of pictures I have made using literary works as subjects. The first was *Odradek, Taboritská 8, Prague, 18 July 1994* (see page 73), made in Prague in 1994. Kafka's story 'Troubles of a Householder' (see pages 72-73) tells of the existence of Odradek, a small wooden object that is also a living being of some kind. I imagined that Odradek was still living somewhere in the city, and that if I went there, I would be able to catch a glimpse of him under a staircase, as described in the story.

Ralph Ellison wrote *Invisible Man* over a period of about seven years, beginning just after the end of World War II; the narrative, however, seems to relate to events that precede the War. The story is told in the first person by an unnamed narrator, a black man who is around eighteen years old when the action begins. His story is one of naiveté, delusion, catastrophe and disillusionment, and moves from his boyhood in the South to his 'internal exile' in New York. In the preface, the narrator describes his subterranean dwelling place, his 'hole': a forgotten room in the cellar of a large apartment building on the edge of Harlem. His accidental fall into this cellar during a riot concludes the action of the novel. In the epilogue he contemplates his life, his struggle and the ironies that have driven him into 'hibernation' as an 'underground man'.

My picture suggests that, like Ellison, the narrator took if not seven years at least some considerable time to write his book, and that he has lived in the cellar all that time. The room has been furnished and even cluttered with his possessions, some purchased, some found, some fabricated, a few saved from the time before he went underground. The text does not go into great descriptive detail; rather, it emphasizes one major element: the ceiling is covered with 1,369 light bulbs, which the invisible man has scavenged, hung and wired, connecting them illegally. He says, 'My hole is warm and full of light. Yes, full of light. I doubt if there is a brighter spot in all New York than this hole of mine, and I do not exclude Broadway. Or the Empire State Building on a photographer's dream night.' And later on, 'I have been boomeranged across my head so much that I now can see the darkness of lightness. And I love light. Perhaps you'll think it strange that an invisible man should need light, desire light, love light. But maybe it is exactly because I am invisible. Light confirms my reality, gives birth to my form. Without light I am not only invisible, but formless as well; and to be unaware of one's form is to live a death. I myself, after existing some twenty years, did not become alive until I discovered my invisibility.'

# Contents

Interview Arielle Pelenc in correspondence with Jeff Wall, page 6. Survey Thierry de Duve,

The Mainstream and the Crooked Path, page 24. Focus Boris Groys, Life without Shadows, page 56.

Artist's Choice Blaise Pascal, Pensées, 1658 (extract), page 72. Franz Kafka, Troubles of a

Householder, 1919, page 72. Artist's Writings Jeff Wall, Gestus, 1984, page 78. Unity

and Fragmentation in Manet, 1984, page 78. Photography and Liquid Intelligence, 1989, page 90. An Outline for a Context for

Stephan Balkenhol's Work, 1988, page 94. A Guide to the Children's Pavilion, a collaborative project with Dan Graham, (extract),

1989, page 102. The Interiorized Academy, 1990, page 104. Representation, Suspicions and Critical Transparency, 1990,

page 112. Restoration, 1994, page 126. About Making Landscapes, 1996, page 140. Boris Groys in Conversation with Jeff

Wall, 1998, page 148. After Invisible Man by Ralph Ellison, the Prologue, 2001, page 161. Update Jean-François

Chevrier The Spectres of the Everyday, **page 162**. Chronology page 192. & Bibliography, List of

Illustrations, page 210.

Within the context of contemporary art as it has been defined since the 1960s, and particularly since 1967 (with Arte Povera, post-Pop Conceptual art, Photorealism, and so forth), Jeff Wall's work is increasingly anti-systematic yet at the same time perfectly defined, controlled and open. Without denying the historical and critical contributions of the so-called 'neo-avant-gardes' listed above, the work situates itself on grounds of experience that demand mental gymnastics from the viewer, opposing the perceptual habits and interpretative categories that have solidified since the 1960s. It invites us to rethink, even to reconstruct, the very idea of art history and the resulting art we define as 'contemporary', in its institutional and consumerist forms. Today, while the light-box technique borrowed from urban advertising continues to exert its effects on a public fascinated by the aesthetics of the media, Wall cannot help but observe the enormous gap between his 'pictorial' practice and the orthodoxy issuing from Pop art. His pictures, whether illuminated from behind or presented in large black-and-white panels, continue a tradition that emphasizes the autonomy of the image, its composition or internal construction, over religious or decorative, iconographic programs. In 1977, seeing the works of Diego Velázquez and Francisco Goya at the Prado had been a turning point for the artist. It led him to take up the pictorial tradition of the 'painters of modern life' from the nineteenth century and which Manet, in particular, had already reinterpreted and updated to meet his own concerns. Wall recognized Baudelaire's text 'The Painter of Modern Life' (1859) as a source for his own practice, and this

has oriented his work to this day. Baudelaire's essay has essentially supported Wall in his attempt at the critical reconstruction of a pictorial tradition broader than modern and contemporary art.

In the mid 1980s, this critical reconstruction of a pictorial tradition was often confused with so-called 'art photography', as distinguished from the 'straight' photography practised principally in reportage. The critical dimension of Wall's photographic pictures appeared in this context as a pure effect of the anti-pictorial advertising technique of the light box. In 1986 he summed up his position in a few concise lines, often repeated by his commentators: 'The fascination of this technology for me is that it seems that it alone permits me to make pictures in the traditional way. Because that's basically what I do, although I hope it is done with an effect opposite to that of technically traditional pictures. The opportunity is both to recuperate the past – the great art of the museums – and at the same time to participate with a critical effect in the most up-to-date spectacularity. This gives my work its particular relation to painting. I like to think that my pictures are a specific opposite to painting.'[1] Fifteen years later, these words have retained their historical relevance, and offer a very precise definition of a strategy of ambiguity, if not a dialectic. Never the less it is uncertain whether their author could still unreservedly subscribe to them. The emphasis of Wall's project has now shifted. The opposition to painting has retreated into the background, since the 'return to painting' that rose like a great wave in the 1980s has now receded. Moreover, since then the spectacularity of the light boxes as a means for

8056, Beverly Blvd., Los Angeles,
9 a.m., 24 September 1996
1996
Black and white photograph
219.5 × 269 cm

Office Hallway, Spring St., Los
Angeles
1997
Black and white photograph
202 × 242 cm

the actualization/vulgarization of pictorial imagery has been trivialized. In 1986 Wall still saw himself engaged in an anti-traditionalist battle, at once anti-painting and anti-photography, in the name of a critical tradition. He worked against the postmodern revival of pictorial 'cuisine' and the canons of straight photography defined as a pure 'way of seeing', spontaneous and unstaged. What has come of all this today? On the question of straight photography Wall's position has always been clear, but over time it has evolved. For Wall, the dogma of direct snapshot photography has three disadvantages: it stresses a spontaneous gaze – a very difficult thing to achieve – over critical analysis, thereby encouraging the repetition of existing responses to a world reduced to aesthetic appropriation; it represents contemporary life, or social situations, without the knowledge and participation of those living through them, the social actors (particularly troubling in 'exotic' contexts); and finally, it tends to reduce the world to a collection of things seen, miniature souvenirs, instead of re-presenting the world as a thing *to be seen*, in the reality of perception and on the scale of the body. For the viewer, this conception of the image as a pure trace or notation of an experience results in a feeling of distance from or inconsistency in the image, along with a lack of intimacy as one stands before it. The feeling is too often compensated by compulsive consumption (enjoying the sheer quantity of images; zapping) or by the fetishistic appropriation of rare and precious icons.

In the late 1970s Wall therefore resolutely opted for the *tableau*: an autonomous picture on the scale of the viewer's body. He also opted for performance, that is, for acting, following post-war Italian neorealist cinema's use of non-professional actors who'd play a role which is more or less familiar, if not indeed their own. The decision to elevate photographic figuration to the scale of the actual body (the body of the viewer) clearly recalled the tradition of academic naturalism as practised in the second half of the nineteenth century. A few critics, attached to the anti-naturalist dogma of modern art, began to accuse Wall of a neo-*pompier* style. It is true that the late 1970s saw a revisionist re-evaluation of academic production, against the overly simplified history of the triumph of the pictorial avant-garde since Manet. It is also true that, seen from the heights of modernist dogma on the autonomy of non-figurative work ('concrete', 'pure', stripped of any representation), Wall's compositions could be confused with the recurrent forms of a pre- or post-Pop photorealism, or with photographic pictorialism (exactly what straight photography had defined itself against). But these misunderstandings and overly distant parallels were inevitable in the context of an historicist inflation of the discourses on contemporary art which continued into the 1980s.

At the same time, any artist who had waged a battle against photography had to admit defeat. All the possibilities of photography which, since Impressionism, had been brought into play in painting and film – and rejected from photography itself because of the purist dogma of the snapshot image – can no longer be developed polemically today, against the grain of the snapshot. In 1982, the work *Mimic* (see page 77) already made a first

**Picture for *Parkett***
1997
Black and white photograph
19 × 24 cm

**Torso**
1997
Black and white photograph
24 × 19 cm

**Shapes on a Tree**
1998
Black and white photograph
24 × 19 cm

**Just Washed**
1997
Transparency in lightbox
47 × 52 cm

**Peas and Sauce**
1999
Transparency in lightbox
49 × 61 cm

pro-photographic statement. It was the initial turning point in an attempt – as yet not clearly declared or theorized – to reactivate the iconography and aesthetics of street photography with the techniques of cinematographic staging. Beginning in 1978, the early light-box pictures developed a more domestic iconography, or referred to stronger pictorial models (Eugène Delacroix in *The Destroyed Room* [1978, see pages 14-15], Eduouard Manet in *Picture for Women* [1979, pages 32-33], or the tradition of the topographic landscape in *The Bridge* [1980, page 143] and *The Holocaust Memorial in the Jewish Cemetery* [1980, pages 140-141]). Today the vein of urban landscapes continues with *The Flooded Grave* (1998–2000), a new view of a cemetery combined with fantastic imagery. But the model of street photography (and neorealism) is confirmed in *Man with a Rifle* (2000), while memories of Impressionism – shadows and shades – haunt *Tattoos and Shadows* (2000). For Documenta X in 1997, Wall even laid aside the light-box technique in order to rework a repertoire of everyday imagery associated with the black-and-white print and the snapshot. *Housekeeping, Citizen* and *Volunteer* (all 1996) are condensations or syntheses of multiple snapshots recorded in the viewer's memory. The great masters of street photography and reportage – Henri Cartier-Bresson, Eugène Atget, Robert Frank – often claimed that their best images had symbolic value drawn directly from life, encapsulating an historical moment or concentrating the energy of an everyday micro-event. The black-and-white *tableaux* exhibited at Documenta X are generic figures, summed up

in a nominal title. They do not aspire to carry the authority of a symbol but concentrate a multiplicity of formerly dispersed images drawn from what Marcel Proust called 'the archives of memory'. Indeed this effect of concentrating images that are normally buried and dispersed explains the impact of these photographic *tableaux*, before which even the most resistant viewer recognizes the memory of images at work, beyond any direct reference, citation or parody. Thus, *Passerby* (1996, see page 150) is an emblematic image of street photography, condensed into a *tableau*; it responds, in black and white, to *Trân Dúc Ván* (1988, see page 95). The dark paranoia of *Passerby* counterpoints *Citizen*, an image of peace and abandon. In these images, what Walker Evans called the 'documentary style' holds pictorial drama at a distance without, however, denying it – unlike the dogmatic practitioners of snapshot photography.

It is within Wall's very conception of the *tableau* as a specific image, as a singular piece, that the model of the snapshot finally asserts itself. What is particularly original in Wall's current approach within the context of contemporary art and photography is his building up of a corpus of works piece by piece, or through closely defined groups like that presented at Documenta X. As he conceives and develops it, the figurative *tableau* is a singular composition in the same way that the snapshot isolates a moment of 'modern life' and fixes 'things seen'. (Both these terms, *la vie moderne* and *choses vues*, stem from the pictorial and literary culture of the nineteenth century, before the rise of the mass media.) Unlike the majority of artist-photographers who have

**Diagonal Composition No. 3**
2000
Transparency in lightbox
74.5 × 94 cm

**Diagonal Composition No. 2**
1998
Transparency in lightbox
52.7 × 63.7 cm

emerged since the late 1970s, Wall avoids the series and the thematic or typological group, and even the notion of variations, excepting the *Diagonal Compositions* (of which there are now three, 1993 [see page 93], 1998 and 2000). The reprises from one image to another are iconographic or speculative, rather than strictly thematic. He has, for example, depicted three images of cemeteries in Vancouver, but they do not constitute a deliberate development in a thematic sequence; rather there is simply the reprise of a motif, or a particular interest for specific places, in the city where he lives. He works by the piece, without forcing relations between one *tableau* and the next, and is antithetical to the idea of installation. Just as a novelist is said to get caught up in his characters only to draw away from them, so the 'painter of modern life' can get caught up in his depicted figures. Parallels between the works spring from a retrospective interpretation by both the artist and the viewer, rather than from the artist's pre-determined decision to vary motifs or figures. What interests him retrospectively in his own images can even contradict the ideas first put forth in the work.[2] More than offering an extrapictorial truth in photography, the snapshot therefore runs counter to the model or program of the painting of modern life.

For twenty years now, Wall's *tableaux* have been reconstructions of things seen, micro-events, gestures and situations. He literally 'recomposes' what had caught his attention elsewhere; thus the process of composition replaces snapshot recording. *Tattoos and Shadows* and *Man with a Rifle* are two images of this kind, like *Morning Cleaning,*

*Mies van der Rohe Foundation, Barcelona* (1999), and *Office Hallway, Spring St., Los Angeles* (1997). In *Tattoos and Shadows*, a group of three figures in a Vancouver backyard forms the nucleus of a suburban tribal community, like the earlier *The Vampires' Picnic* (1999, see pages 18-19). But the vampires' feast was an imaginary composition, a fantastic, grotesque genre scene, elaborated as such (like *Dead Troops Talk [A Vision After an Ambush of a Red Army Patrol Near Moqor, Afghanistan, Winter 1986]* [1992, see pages 38-39]). In *Tattoos and Shadows*, the uncanniness is more discreet, and the grotesque here – if one can speak of grotesque – has been reduced to a parody of Impressionism's ordinariness, conceived as the painting of outdoor leisure. The young woman of Asian origin lying in the grass appears to have no family relation with the two other figures. She seems to have been inserted into the decor, as though she were a hybrid from elsewhere, existing on another level of reality than the couple who frame her – like a mermaid, for example. But this 'literary' interpretation should not resolve or suture the enigma of the scene: what relation links the three figures? Nothing in the image provides the key to this enigma, and it is precisely this kind of question that often accounts for our curiosity in snapshot imagery from everyday life.

In the pictorial tradition where this photographic *tableau* is situated, marked in particular by Edouard Manet's *Le Déjeuner sur l'herbe* (1863, see page 52), the enigmatic relation between the figures may stem from an arbitrariness which the painter desires and actively pursues. The figures often form a heterogeneous group and

**Georges Seurat**
Sunday Afternoon on the Island of
the Grande Jatte
1884-86
Oil on canvas
207 × 308 cm

constitute a sampling of society, as in Georges Seurat's *Sunday Afternoon on the Island of the Grande Jatte* (1884-86). Indeed that painting is a monument, a painting of everyday life that proceeds by the montage of elements, of figures and figure-groups, rather than a unitary narrative or dramatic composition, as was the norm in traditional history painting. *Tattoos and Shadows* links the paradoxical monuments of Manet, Monet and Seurat to the minor mode of the snapshot. The group of three figures constitutes a shrunken, modern tribe, each of whose members is an isolated individual. The sociological analysis is remarkable. The three figures enjoy the peace of a sunny afternoon in silence, without a word. In earlier *tableaux*, such as *Diatribe* (1985, see pages 42-43), *The Storyteller* (1986, see pages 50-51), *A Ventriloquist at a Birthday Party in October, 1947* (1990, see pages 8-9) Wall had introduced speaking situations onto the silent stage of pictorial representation, the 'painted theatre'. Here, the silence of an everyday snapshot image corresponds to the activity of reading in which the male figure is absorbed, and to the dreamy postures of the female figures. Unlike *The Vampires' Picnic*, the artifice does not stem from the implausible (though the intrusion of the fantastic), but instead from an interruption in narrative continuity that underlies the naturalistic norm. The question of the relations between the figures, or, more generally, between the figurative elements, accounts for our interest in these compositions, and moves the very idea of composition closer to enigma rather than mastery and knowledge.

The model of the snapshot, combined with a staged performance, is what orients Wall's neorealism. But what he calls 'near documentary' is also, more broadly, a matter of descriptive figuration and a way of defining a rhetoric, a collection of commonplaces from modern life. The frozen gestures in this painted theatre are obviously dissociated from the action drawn from ordinary life, but as a composition the *tableau* inserts them in a descriptive space. The snapshot recording instead often reduces itself to an *inscription*. The 'depiction', in contrast, distinguishes the description-reconstruction from the snapshot's simple inscription. This distinction includes the difference between a recorded event and its re-enactment; the inscription refers the viewer to the past, while the descriptive figuration takes place in the actual space of the *tableau*. *Citizen* is not an image of leisure time in the park, but an image of civic peace. The viewer is confronted with an image of intimacy as conveyed on a certain plane: the photographic surface. This image has been exactingly arranged down to the smallest detail so as to connect the pleasure of contemplation with the confident abandon of the figure. The studious vigilance of a second figure, seated behind a table at the back end of the park, corresponds to a critical alertness in the back of the viewer's mind; so the viewer, too, can abandon himself to contemplation *and* study the image, mentally reconstitute the composition. *Citizen* reinvents the commonplace of peaceful public space – an idea often contradicted elsewhere in Wall's work, from *Mimic* (1982, see page 77) to *Man with a Rifle*. Finally, a question remains: what is the citizen dreaming of? His carefree abandon might

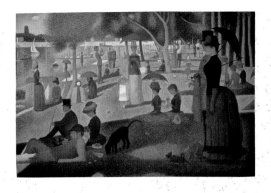

*following pages,* **Morning
Cleaning, Mies van der Rohe
Foundation, Barcelona**
1999
Transparency in lightbox
187 × 351 cm

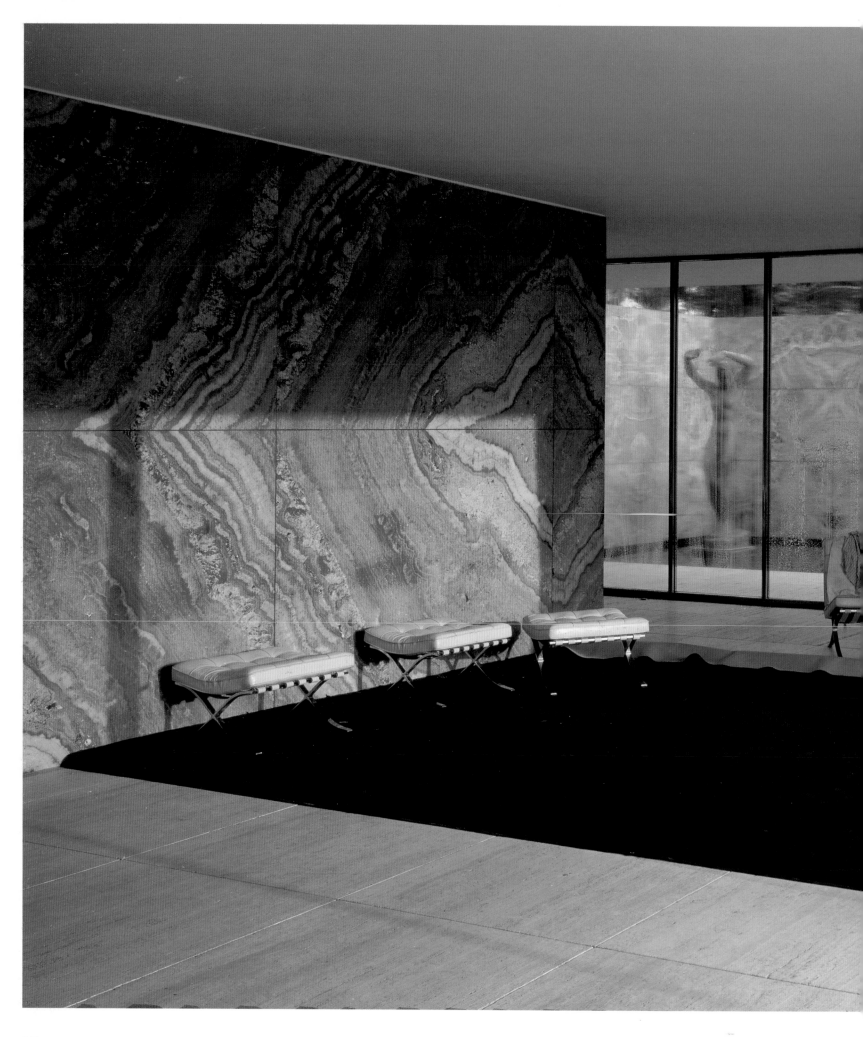

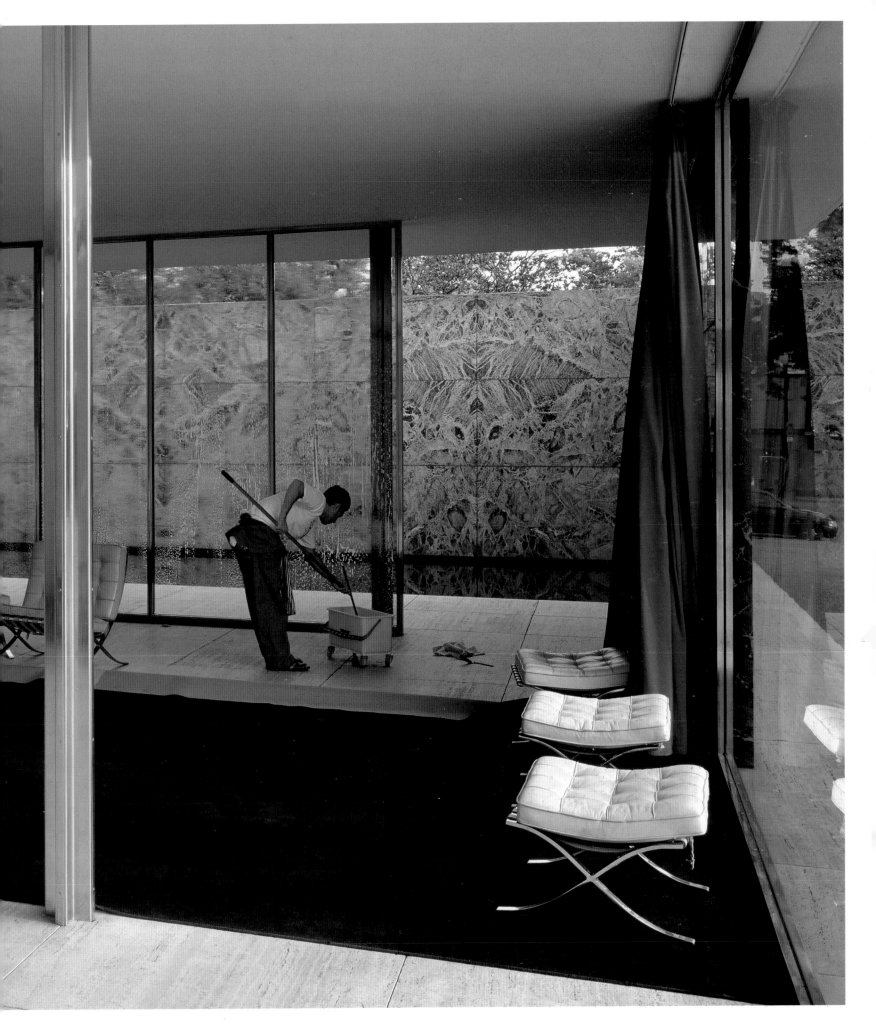

**Housekeeping**
1996
Black and white photograph
203 × 260 cm

transport him to the regions of *Insomnia* (1994, see page 66). For him, the public space of the park may only be a refuge from domestic violence seen in that earlier work.

Similarly, *Housekeeping* is not just an instant randomly plucked from the workday of a chambermaid. Here, the commonplace to be revisited is the anonymity of the hotel room, wiped clean of any trace of inhabitation. It is the antithesis of the domestic 'interior' as defined by Walter Benjamin: 'inhabiting means leaving traces'. *Housekeeping* can equally be interpreted as presenting the motif of the haunted house, an idea developed by Jeff Wall in his essay on Dan Graham's *Alteration to a Suburban House* (1978), in reference to Philip Johnson's Glass House (1951). The housekeeper leaves the room, erasing herself. The moment depicted, like a snapshot, is when the perfectly cleaned room is about to freeze into the image of an empty and lifeless interior, a spectral haunt. The housekeeper seen from behind has already withdrawn, she is on the verge of disappearing, between the present and a future past, between presence and absence. The idea that any use of the room has been erased, wiped away, contrasts with the evocative disorder of *The Destroyed Room* (1978, see pages 14-15). Here again, as in *Citizen*, the revisited commonplace calls up contradictory figures: the void references fullness, just as cleanliness references disorder. The anonymity of the room fits perfectly with the spectral presences – Virginia Woolf's 'invisible presences' – which populate everyday life. In contrast to what Emile Zola maintained, the painter of modern life is not a 'witness to the present' –

a kind of hypostatized present. A 'neorealist' present is reworked, as indicated in the prefix 'neo': it is haunted by figures from the past, by archaisms. '*Mal informé, celui qui se crierait son propre contemporain*': 'Ill-informed, he would proclaim himself his own contemporary', noted Mallarmé. Realism stands apart from the dogma of current events by the intrusion of the fantastic into the everyday. In *The Vampires' Picnic* (1991, see pages 18-19), the fantastic is treated as a genre in its own right, an iconographic program. But it appears more discretely in the neorealist vein, as a deviation from the present and the commonplace, rather than as an untimely or unusual event.

Even outside the great fantastic compositions of 1991 and 1992, *The Vampires' Picnic* and *Dead Troops Talk*, the spectral dimension had always gathered, to varying degrees, on the stage of photography's painted theatre. The fantastic has always been associated with the critique of everyday life by figuring daily life in a situation of crisis. The spectral is generally the intrusion of the non-contemporary into the contemporary. When Wall follows the logic of the genres of painting, as he did in the early 1990s, it tends to be absorbed by grotesque horror. However, in the neorealist current that moves beyond such genres, it may also be related to a suspension of time which is not necessarily on the order of the fantastic, but as an endless present experienced as an instance of peace or happiness. This suspended time has to do with the effect of interruption produced by the snapshot. But its pictorial reconstitution refers us above all to the very nature of the *tableau*, as a pacifying form or '*promesse de bonheur*' (Stendhal).

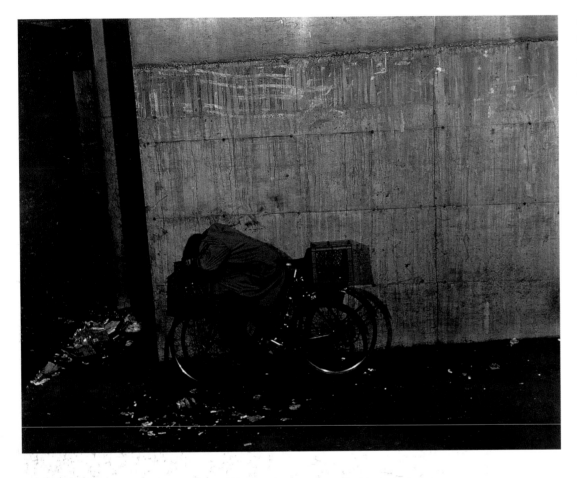

And this pacifying dimension of the *tableau* – analyzed particularly well by Jacques Lacan – is broadly confirmed in Jeff Wall's most recent works, whereas in the 1980s it was seemingly reserved only for his landscapes, and indeed, for rather melancholic landscapes.

One might say that any picture of modern life stages the ambivalence of pacified tensions and conflicts. Since the 1980s, Wall's pictures have primarily shown situations of constraint and apparently inescapable alienation; increasingly he seems concerned with revealing that which, in the very act of figuring these situations, leads on the contrary to access and liberation. In a work such as *Milk* (1984, see pages 90-91) the 'liberation' was explosive: the effect of an extreme tension, the upsurge of a contained force, with all the beauty of the gesture in the spurt of milk. Wall had already considered that the painting of modern life contained its own healing properties. Today the constraints on modern life seem to have been at once relaxed and tightened, without diminishing in ambivalence. *Cyclist* (1996), for example, is quite obviously a somber image: a male figure has collapsed onto the handlebars of his bicycle, leaning against a sheer concrete wall. The situation is as cold as the architecture, with no exit. But in the course of an interview with the artist in September 1998, in which I discussed the figure in those terms, Jeff Wall contradicted me, remarking that the cyclist may simply be resting. Both interpretations are justified, to the extent that the signs of rest and defeat, of abandon and renunciation, are particularly reversible. And this reversibility itself constitutes the 'pacifying

*opposite,* **Cyclist**
1996
Black and white photograph
229 × 302.5 cm

*below,* **Citizen**
1996
Black and white photograph
192 × 244 cm

dynamic' of the *tableau*.

    *Citizen* is not a simple image of peace altered by an effect of strangeness. The 'dynamic of pacification' goes beyond the silence, bringing uncertainties and ambiguities into the composition and the narrative – particularly in connection to the cyclist's undefined mental activity. Here, picture-making is inseparable from storytelling; both these activities are more fundamental, more primitive, than the institutional categories of painting and literature. The image-*tableau* has a certain solidity; the quality of things stands up or 'hangs together'. But you never really know what will happen, because this solidity hinges on the viewer's games of interpretation. The *tableau* hangs on the wall, it generates a space of contemplation: but how, within what story or history? By means of what precarious arrangement? The risk run by the artist is not only that things fall apart, that the composition won't hang together; it is also the risk of fixing a form that is too dense, too solid. The resulting form could block the viewer's own narrative movement, with its peculiar twists and detours. *The Crooked Path* (1991, see page 45) depicts a passage through a suburban lot, allowing one to bypass the well-marked public way. Significantly Wall's first computer-altered image was entitled *The Stumbling Block* (1991, see page 20). Digital technology allows one to introduce disjunctive elements into the continuity of the photographic image. The 'block' on the ground is a municipal employee; a passerby runs into him. The title is a play on words, with an analytical ring to it. The healing properties of the 'stumbling block' are paradoxical: they invert the idea of

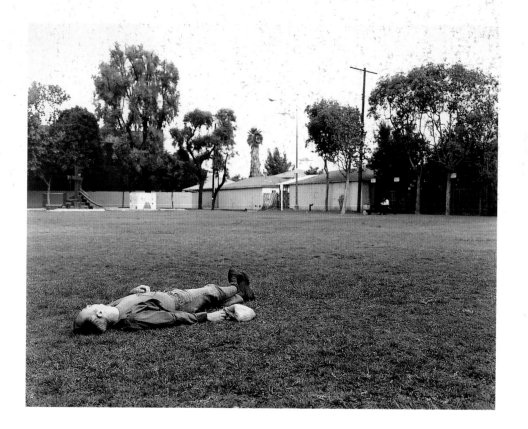

a psychic 'blockage', because this blockage can reside in a compulsive routine (particularly in the context of a business-oriented metropolis) or conversely, in inertia. The healing occurs in the interruption provoked by the act of stumbling. The depressed businessman, seated on the sidewalk to the right, has also cut short his trajectory, like the skateboarder to the left. The obstacle-man, for his part, is lying down, 'passive, gentle and indifferent', as Wall remarks. 'He is there so that ambivalent people can express their ambivalence by interrupting themselves in their habitual activities.'[3]

The image that stands up, that hangs together on the wall, also brings the opposite position into play: 'stretching out'. Such posture has recurred since *The Storyteller* but also appeared in some of Wall's earliest images; *Stereo* (1980), and, more cryptically, in *The Destroyed Room*, inspired by Delacroix's *Death of Sardanopoulos*. In 1984, Wall published a lengthy essay on Manet,[4] the painter of *Olympia* (1863) and *Le Déjeuner sur l'herbe* (1863). From *The Storyteller* to *Tattoos and Shadows*, his pictures work out the enigmatic utopia of a 'luncheon on the grass', a common ground for strange characters linked by their strangeness and solitude. This Utopia has its fantastic side, sepulchral and grotesque, in *The Vampires' Picnic* and *Dead Troops Talk*. The solitude of *Insomnia* is also the reverse of *Citizen*. In each case, the recurrent figure of a recumbent person expresses an idea of extensive space that introduces contact with the ground, whether a floor or the earth, soil or grass. This contact operates with respect to the landscape as a

pictorial genre that grasps the territory yet maintains a distance. But an action can 'hollow out' space, particularly in the foreground, *The Well* (1989, see page 92) was a first, very literal indication of that direction, taken up again metaphorically two years later in *An Encounter in the Calle Valentín Gomez Farias, Tijuana* (see page 111), and brought to a culmination today with the sumptuous *Flooded Grave*. Indeed, no image can really 'stand up' without its ground – whether solid and gaping open. Thus one rediscovers in the world of images the whole modern and archaic experience of the human species, between the living and the symbolic, between biology and culture. To play on words, the 'outstretched' (*l'étendue*) is a more-or-less open surrounding space, and the figure of a recumbent female body; it is at once the support and the collapse of an 'upstanding' anthropological position (*homo erectus*) which is also a psychic position ('hanging together', 'standing up') as well as a sociopolitical position ('taking a stance', 'upholding').

The body and the landscape, conflicts and processes of pacification in both their social and psychic dimensions: today more than ever, these are the two poles of a programme to reinvent the commonplaces of the painting of modern life. But 'commonplace' must be understood literally and in all its possible meanings (as Rimbaud wished to be read). The idea of a landscape – visually, a stretch of land – is associated with the model of a community rhetoric. (In French the words *lieu* et *lien*, 'place' and 'tie', differ only in their final letter.) But whoever speaks of places and ties speaks also of attachment, ensnarement and

**Green Rectangle**
1998
Transparency in lightbox
129.5 × 163 cm

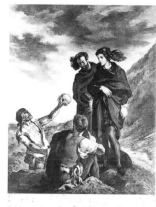

entanglement, which must be unravelled (*Untangling*, 1994, see page 113). And in the same way, the rhetoric of commonplaces is subject to the discord of fantasy: *A Fight on the Sidewalk* (1994, see page 105) is as much a fantastic scene – two bodies entwined, mingled; the gaze of a third person; the wall covered with censored graffiti – as it is a representation of urban violence. More recently, *The Flooded Grave* has returned to the vein of the lyrical, 'animated' landscape, first seen with *A Sudden Gust of Wind (After Hokusai)* (1993, see pages 120-121). *The Flooded Grave* brilliantly conjugates three registers: the specific view and place in Vancouver; the 'other' space or 'heterotopia', as defined and distinguished from Utopia by Michel Foucault in 1967[5]; and yet another space, a third dimension, the slice of ocean floor at the bottom of the freshly opened tomb. The pleasure of contemplation stems first of all from the combination of these three registers, corresponding to three perspectives: the wide-angle view of the cemetery, with a glimpse of the city in the distance, perhaps evoking a film set; the two diverging lines of the tomb in the foreground, which concentrate the heterotopic effect; and a reversed, tilted perspective into the grave, like the still lifes of Georges Braque or Paul Cézanne. The gaze swings between the expansion of the landscape and the depth of the aquatic tomb. The latter is not an ordinary cavity in a cemetery, it has not simply been dug but was fabricated in the studio. Inside one distinguishes three more levels: a first above the water, then two more beneath it. A border of foam marks the passage from the first to the second level. The gaze circulates beneath the

water, more than simply penetrating the surface.

It is clearly a marine environment, a miniature sea with 'touches' or *strokes* of brilliance, shiny spots that contrast with the grey plywood sheets laid around the open tomb and the bluish tarp gleaming on the right, its folds evoking the richness of baroque drapery. The entire image plays on an enormous poetic commonplace, revised by psychoanalysis: death as a return to a prenatal, oceanic world. The viewer can appreciate the reinvention of the commonplace by contemplating the way the two environments – land and sea, the ground and the watery deep – are integrated like two 'elements': natural elements and elements of composition. *The Flooded Grave* is the antithesis of Eugène Delacroix's painting *Hamlet and Horatio in the Graveyard* (1839), where a gravedigger has just unearthed Yorrick's skull, which he hands to Hamlet. Here the oceanic flora and fauna replace the skull, the aquatic environment being the opposite of skeletal dryness. There is a reduction and pacification of the sublime, which feeds on the anxiety of death. Beyond the tomb stretches the realistic landscape of a melancholy cemetery. The tomb itself opens up to another world, a peaceful stretch of ocean. The violence of the open tomb – a motif more frequent in film than in the history of painting – is a dissonance, rather than an expression, of the sublime. The opening is neither excessive nor infinite. If there is infinity here it is contained, and plays above all on the contrast between the aquatic environment and an unseen, cadaverous or stony dryness.

In 1989 Wall published 'Photography and Liquid Intelligence',[6] to which *The Flooded Grave*

**Eugène Delacroix**
Hamlet and Horatio in the
Graveyard
1839
Oil on canvas
81.5 × 66 cm

**A Donkey in Blackpool**
1999
Transparency in lightbox
195 × 250 cm

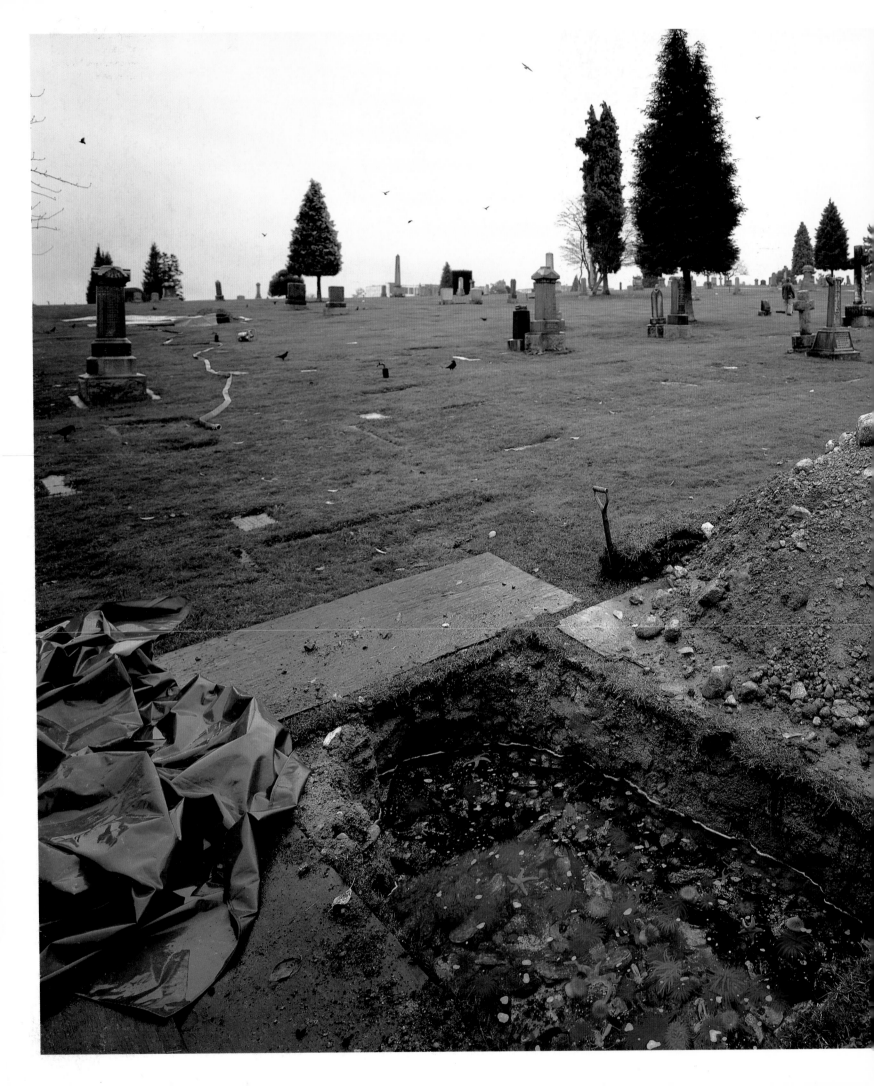

**Man with a Rifle**
2000
Transparency in lightbox
226 × 289 cm

responds on several points. Liquid intelligence contrasts with everything that is dry in the forensic precision of the photographic gaze. There is a liquid intelligence of life and death that alters the gaze. Another gaze forms in the almost ocular *cavity* of the tomb; and the conclusion of 'Photography and Liquid Intelligence' already indicated this other gaze: 'In photography, the liquids study us, even from a great distance.' Here, that distance has been reduced. And for this reason the immersion remains circumscribed, localized. Wall's text noted that modern vision, in its technological character, 'has been separated to a great extent from the sense of immersion in the incalculable'. The image of the oceanic tomb produces a feeling of immersion, but in a very measured way, by successive strokes and adjustments. In *A Sudden Gust of Wind*, the effect of the sublime was reduced, contained within the limits of realism and *breath* (natural or lyrical). Here the immersion into the infinite, the incalculable, is calculable, and it is the conjunction of these two contradictory dimensions that renders the image so convincing.

On the neorealist side of a reinvented street photography, *Man with a Rifle* is also a picture of fantasy and calculation, inspired by things seen. Here, calculation is exposed not to the incalculable, but to the imprecision and failures of a gesture: the man doesn't know what he's aiming at. (Or rather, no one ever really knows … ) This uncertainty is gratingly funny, since desire cannot help but miss its target if it confuses itself with its object. The man with the virtual rifle aims at emptiness, at the void between things, between the passersby. He aims at a centre that seems to be defined above all by absence, somewhere between the parking metre and the tree. The viewer doesn't know what the man with the imaginary rifle is aiming at (it isn't the two passersby across the street, in any case), but we can see a blonde woman in profile, fully lit on the edge of the image, and we can just barely distinguish her features. We can also make out the writing on the stores behind the woman, unlike the illegible text of the posters on the right. The image has the dissymmetry of an imaginary aim reworked by the desire to see, a visual drive whose object ('woman'?) escapes, revealing only glimmers of light and figures of passage (the Baudelairean '*passante*'?).

*Man with a Rifle* stages the 'evil eye' or the 'appetite of the eye' as discussed by Lacan in *The Four Fundamental Concepts of Psycho-analysis*,[7] an appetite which the *tableau* is supposed to pacify. The eye's 'voracity' is associated in the *tableau* with a gesture of optical violence, since in any case, all action is reduced to a gesture in the painted theatre. Lacan well established the relation between this 'gesture as displayed movement' and the play between the pictorial gaze and the evil eye.[8] The gesture of the man with an imaginary rifle is not an action; its only effect is visual, as part of the *tableau*. As Lacan remarks: 'All action represented in a picture appears to us as a battle scene, that is to say, as something theatrical, represented as a gesture. And, again, it is this insertion in the gesture that means that one cannot turn it upside down, whether it is figurative or not. If you turn a transparency around, you realize at once it is being shown to you with the left in the place of the right. The direction of the gesture of

**Clipped Branches, East Cordova
St., Vancouver**
1999
Transparency in lightbox
72 × 89 cm

**A Sapling Supported
by a Post**
2000
Transparency in lightbox
55 × 46.5 cm

the hand indicates sufficiently this lateral symmetry.'[9] Lacan mentions, in reference to the Peking Opera: 'One fights as one has always fought since time immemorial, much more with gestures than with blows … In these ballets, no two people ever touch one another, they slip into different spaces in which are spread out whole series of gestures. The gaze, too, 'slips into different spaces', just as it 'slips through the wings'[10] in the compositional techniques of the painted theatre. *Man with a Rifle* associates the stillness of gestures and movements in the *tableau* with the miming of a deadly aim. But the gaze slips away, just as the object of his aim has done. Here is where the *tableau* exerts its pacifying effect, which is 'taming, civilizing, enchanting'. The *tableau* puts the gaze back in motion, makes it circulate, while warding off the deadly and powerful fascination of the evil eye.

'The evil eye is the *fascinum*', says Lacan, 'it is that which has the effect of arresting movement and, literally, of killing life. At the moment the subject stops, suspending his gesture, he is mortified. The anti-life, anti-movement function of this terminal point is the *fascinum*, and it is precisely one of the dimensions in which the power of the gaze is exercised directly.'[11] The painter, or the artist who composes photographic *tableaux*, is one who plays with and outwits the mortifying gaze. The painter plays like the man with the imaginary rifle, like children playing war, within the *tableau*'s safe space of pacification. The painter plays with an aiming device, but he sets the gaze to work in the light of the 'liquid intelligence' that multiplies the resonances like so many master 'strokes.' These plays of light produce shadows which, in the space of the *tableau*, resemble marks

on luminous bodies (*Tattoos and Shadows*). Here is where the photographer's 'creation of the gaze' is related to that 'succession of small dirty deposits juxtaposed', which, for Lacan, defines pictorial work. And Jeff Wall never ceases to depict exactly that, though often by antithesis, since photography is not painting. His pictures are haunted by things to be cleaned, where men and women work to uncover a ground that is never a pure surface.

**Postscript**

Five recent pictures from 2001 confirm the breadth of the repertory that today distinguishes Jeff Wall among the crowd of artist-photographers, who generally 'specialize' in a genre or a cliché-chosen from among the pictorial and photographic traditions.

*After Invisible Man by Ralph Ellison, the Preface* (1999-2001) – a novel more well known than read – is one of Wall's great imaginary compositions, patiently constructed by the addition and computer montage of figurative elements. A black man, seen from behind, sits alone in a huge, cavernous, particularly cluttered room, drying a kitchen utensil while considering a text – his own – set before him. Several earlier pictures, *Diatribe* (1985), *The Storyteller* (1986), *A Ventriloquist at a Birthday Party in October, 1947* (1990) and *Dead Troops Talk (A Vision After an Ambush of a Red Army Patrol Near Moqor, Afghanistan, Winter 1986)* (1992), in particular, had staged situations depicting speech, whether realistic or fantastic. Here, the narrative activity of the character is solitary, like that of Adrian Walker, the painter who copied an anatomy lesson (*Adrian Walker, artist, drawing from a specimen in a laboratory in*

*the Department of Anatomy at the University of British Columbia, Vancouver*, 1992). But Adrian Walker worked in daylight, in an aseptically clean cubicle, while the decor of the invisible man is an illuminated cave, a windowless underground refuge: an assemblage-environment of found objects, mingled with everyday furniture and utensils.

The man is seated beside his bed, a bed encrusted in the decor. The room is illuminated by hundreds of bare bulbs hanging from the ceiling, like a magic cave. All the elements, down to the slightest postcard, are 'period pieces', like in any good cinematographic reconstruction. The wealth and minutiae of photographic realism – straight description – are placed at the service of fantasy, of the play and enchantment of fiction. The lines of the composition, underscored by the orientation of the chairs in the room, converge toward a rectangle formed by the grey wool blankets, apparently insulating the walls, that seem to be set between two wooden pilasters attached somehow to the brickwork. The man is seated awkwardly on a chair; the armchair where one can sit down comfortably and listen to records is empty. The overcharge of the room can be interpreted as the silent, mute exuberance of a suspended listening. In the visual field of the picture, the 'invisible' black man becomes a figure of silence, of the inaudible. The chamber-cavern of the invisible man echoes with muffled light. This same quality of silence is also to be found in the two black-and-white images from 2001, both *Untitled,* distinguished as *Forest* and *Night*. At first glance they evoke the marginal, precarious situation of the homeless. In both cases the moment represented refers to an uncertain situation. The characters are displaced to the left

of the image – as though they could disappear, like spare wheels, marginal figures. The characters' 'marginality' is, first of all, a matter of composition. The couple in *Untitled (Forest)* is leaving a sputtering campfire coaxed from out of a dip in the terrain; the man is already almost invisible behind the screen of leafless brush (it is a winter scene). In *Untitled (Night)*, the vague pool, a pond like the kind dug out for animals in zoos, is a troubled mirror that almost fully occupies the lower half of the composition, with the exception of the narrow platform where a human and animal group has taken refuge. The illuminated decor of *After Invisible Man by Ralph Ellison, the Preface* stands out against this shadowy background: this 'invisible' human being appears where others (whites) are hardly visible and tend to disappear from the composition altogether. The magic cave –

**Untitled (Forest)**
2001
Black and white photograph
230 × 290 cm

**Untitled (Overpass)**
2001
Transparency in lightbox
229 × 290 cm

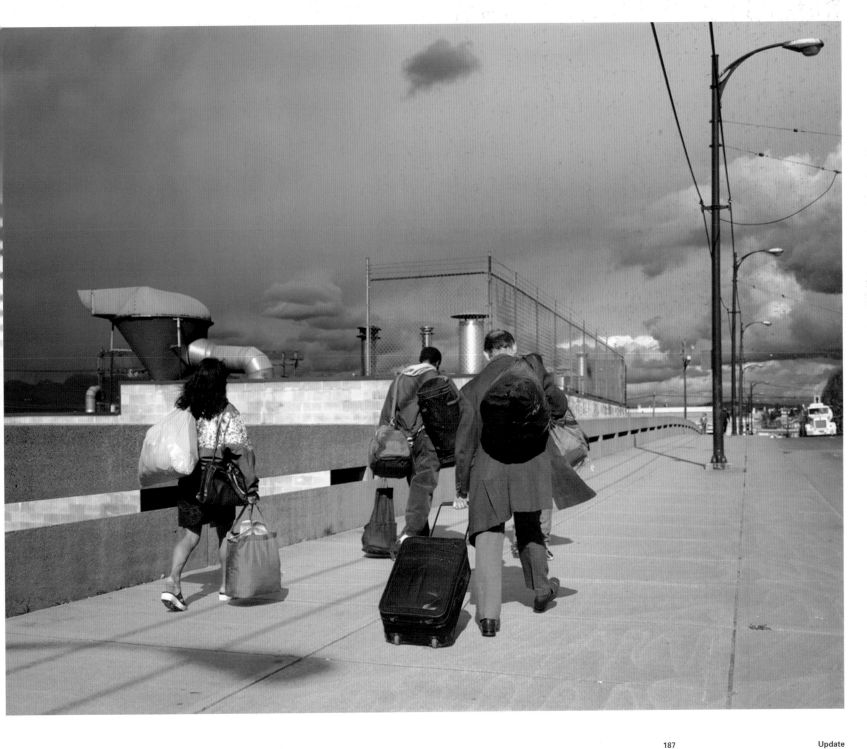

the scene of writing, the place of fiction – is hollowed out of this material of shadow and light that associates sensations of cold and distance, despite the artistic warmth traditionally evoked by the nuanced photographic rendering of shades of black and white. The sputtering fire of *Untitled (Forest)*, in a nook of the woods, answers the spectral depth of reflection in the stagnant water of *Untitled (Night)*. The two images decompose the dark side of the utopian luncheon on the grass, which has remained active in Jeff Wall's imagination as witnessed, for example, in *Tattoos and Shadows* (2000).

*Untitled (Overpass)* (2001) and *Untitled (Dawn)* (2001) are most closely connected to the neorealist model reworked via street photography. *Untitled (Dawn)* shows a vacant street corner at dawn, in Vancouver. Somehow it suggests earlier pictures of ambiguous urban encounters, like *The Agreement* (1987) or *Bad Goods* (1984). But Wall seems convinced that the 'theatre of the city' can do without figures and be reduced to no more than the view of a place. *Untitled (Dawn)* is proof of that. The enigma of the place *entre chien et loup* (between dusk and darkness, dog and wolf) replaces the dramatic ambiguity produced by the narrative suspense. In *Untitled (Overpass)*, the dramatic situation is reduced to its simplest expression. One cannot speak of actual characters here. The idea of figures, which can reposition the snapshot and street photography within a pictorial tradition, is preferable. Four travellers on a footbridge, loaded down with baggage, are seen from behind (one of them, in the lead, is hardly visible). They have no distinguishing features, they could be anybody. Who are they? Migrants, exiles? The surroundings are cold, unwelcoming. What are they doing? Just crossing a bridge, with long strides, in broad daylight. But they form a group: figures grouped in an urban landscape. And this group captured in movement lends its dynamic to the landscape. *Untitled (Overpass)* confirms that for the painter of modern life, people are not necessarily characters; the anonymous crowd is a physical and dynamic quality of the urban landscape. The representation of modern life is first of all a matter of topographical figuration: pure landscape. Yet a question remains. People cross an overpass. It's clear, as cutting as architecture, bright like the daylight (without the shadow effects and phantasmagoria of the other four pictures). But beneath the footbridge there might be anything, just as one does not know where these people came from, or where they will go. Everything in the picture is perfectly visible, yet the invisible is there, beneath the bridge, behind the image.

Translated from the French by Brian Holmes

1  Interview with Els Barents, 'Typology, Luminescence, Freedom', in Jeff Wall, *Transparencies*, Schirmer/Mosel, Munich, 1986, p. 100.

2  For example, one can compare the 1987 text on *The Storyteller* with the interpretation that Wall recently gave during a dialogue we carried out in Brussels in 1998, organized by the Fondation pour l'architecture (forthcoming in French in an anthology of essays and interviews to be published by the École nationale supérieure des Beaux-arts, Paris). In the 1987 text, inspired by Walter Benjamin, Wall remarked: 'The *figura* of the storyteller is an archaism, a social type which has lost its function as a result of the technological transformations of literacy ... However, as Walter Benjamin has shown, such ruined figures embody essential elements of historical memory, the memory of values excluded by capitalist progress and

*left,* **Rainfilled Suitcase**
2001
Transparency in lightbox
90 × 120 cm

*right,* **Cuttings**
2001
Transparency in lightbox
90 × 120 cm

seemingly, forgotten by everyone. This memory recovers its potential in moments of crisis. The crisis is the present. The recovery parallels the process in which marginalized and oppressed groups reappropriate and re-learn their own history.' Ten years later, I asked Jeff Wall if he was still working as explicitly on the idea of archaism considered as a historical reserve and a counter-culture. He answered that he had recently looked again at *The Storyteller* and saw that the relation of the groups depicted in the image tended to contradict the unilateral interpretation given in the 1987 text. The two men who listen to the narrator, at lower left, are clearly attentive; the story interests them, it is effective. But the couple at a distance, on the embankment above, display a feeling of skepticism and detachment.

3    'Arielle Pelenc in Correspondence with Jeff Wall', see in this volume p. 21.

4    'Unity and Fragmentation in Manet', *Parachute*, No 35, Montreal, Summer, 1984. See in this volume pp. 78-89.

5    Michel Foucault, 'Des espaces autres', lecture given in 1967, published in 1984 in the journal *AMC*, reprinted in *Dits et écrits*, vol. 4, Paris, Gallimard, 1994; published in English under the title, 'Of other spaces', *Diacritics*, Vol 16, No 1, trans. Jay Miskowiec, 1986, pp. 22-27.

6    'Photography and Liquid Intelligence', *Une autre objectivité/Another Objectivity* (cat.), Centre National des Arts Plastiques, Paris, and Centro per l'Arte Contemporanea, Prato (Italy), Idea Books, Lyon, January 1989. See in this volume pp. 90-93.

7    Jacques Lacan, *The Four Fundamental Concepts of Psycho-analysis*, ed. Jacques-Alain Miller, trans. Alan Sheridan, Norton, New York and London, 1981.

8    Ibid.

9    Ibid. [translation slightly modified]

10   In the French art historical tradition, the notion of the theatrical 'wings' (*coulisses*) has been extended to the discourse on classical painting and theorized as a kind of slipping or sliding of the gaze through illusionistic spaces arranged for precisely that effect.

11   Lacan, op. cit.

**Untitled (Night)**
2001
Transparency in lightbox
229 × 300 cm

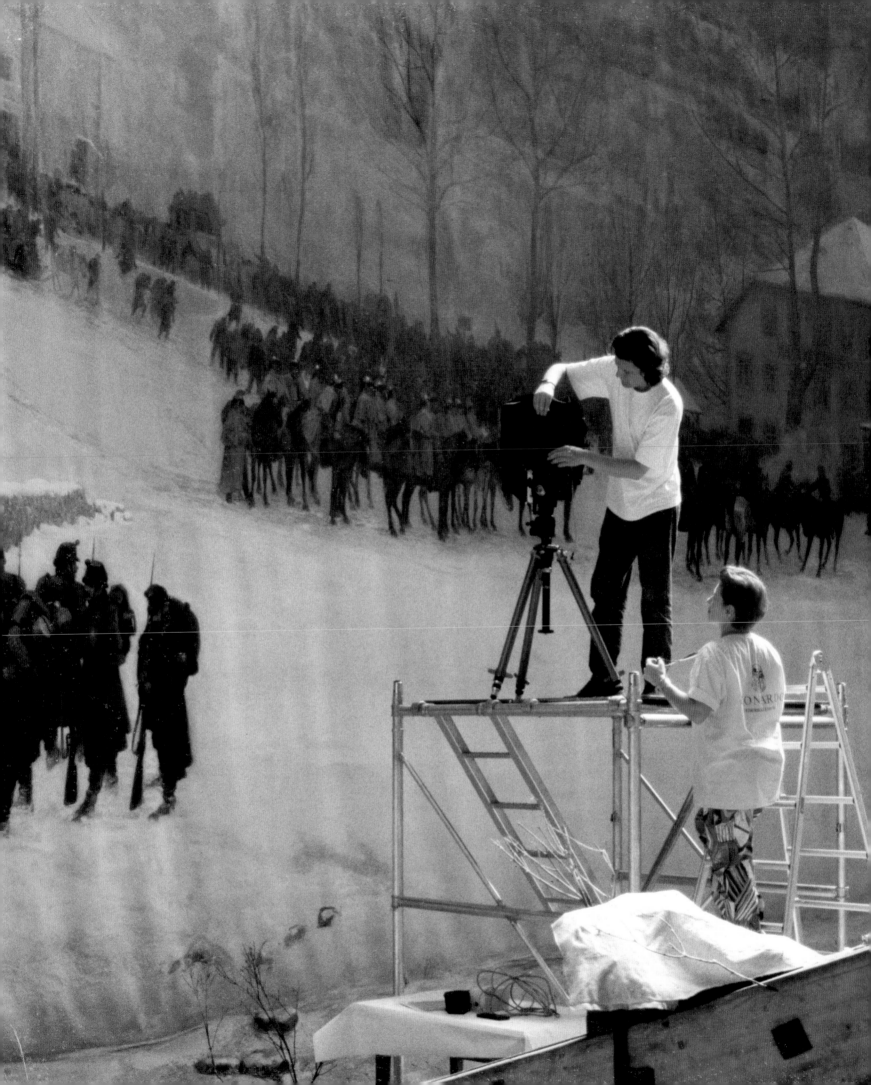

# Contents

**Interview** Arielle Pelenc in correspondence with Jeff Wall, page 6. **Survey** Thierry de Duve The Mainstream and the Crooked Path, page 24. **Focus** Boris Groys Life without Shadows, page 56. **Artist's Choice** Blaise Pascal Pensées, 1658 (extract), page 72. Franz Kafka Troubles of a Householder, 1919, page 72. **Artist's Writings** Jeff Wall Gestus, 1984, page 76. Unity and Fragmentation in Manet, 1984, page 78. Photography and Liquid Intelligence, 1989, page 90. An Outline for a Context for Stephan Balkenhol's Work, 1988, page 94. A Guide to the Children's Pavilion (a collaborative project with Dan Graham, extract), 1989, page 102. The Interiorized Academy, 1990, page 104. Representation, Suspicions and Critical Transparency, 1990, page 112. Restoration, 1994, page 126. About Making Landscapes, 1995, page 140. Boris Groys in Conversation with Jeff Wall, 1998, page 148. After *Invisible Man* by Ralph Ellison, the Preface, 2001, page 161. **Update** Jean-François Chevrier The Spectres of the Everyday, page 162. **Chronology** page 192 & Bibliography, List of Illustrations, page 210.

## Selected exhibitions and projects
## 1964-79

**1964-1970**
Studies fine art, **University of British Columbia**,
Vancouver, MA in art history 1970

**1969**
'Focus '69',
**Bau-Xi Gallery**, Vancouver (group)

'557, 087',
**Seattle Art Museum**, Seattle (group)

'Photo Show',
**S.U.B. Art Gallery**, University of British Columbia,
Vancouver (group)

'995,000',
**Vancouver Art Gallery**, Vancouver (group)

'Four Artists: Tom Burrows, Duane Lunden, Jeff Wall,
Ian Wallace',
**Fine Arts Gallery**, University of British Columbia,
Vancouver (group)

'Information',
**Museum of Modern Art**, New York (group)
Cat. *Information*, Museum of Modern Art, New York,
text Kynaston McShine

Text, 'Meaningness', *Free Media Bulletin*, No 1, with
Duane Lunden and Ian Wallace, Intermedia Press,
Vancouver

Text, *Landscape Manual*, Fine Arts Gallery, University of
British Columbia, Vancouver

**1970-73**
Doctoral research, **Courtauld Institute of Art**,
University of London

**1971**
'Collage Show',
**Fine Arts Gallery**, University of British Columbia,
Vancouver (group)

**1973**
Text, 'Cine-Text (Excerpts) 1971', essay in Lucy
Lippard's book *Six Years: The Dematerialization of the
Art Object, 1966-72*, Praeger, New York

**1974**
Returns to Vancouver

**1974-75**
Assistant Professor, Department of Art History, **Nova
Scotia College of Art and Design**, Halifax, Canada

**1976-87**
Associate Professor, Centre for the Arts, **Simon Fraser
University**, Vancouver

**1978**
**Nova Gallery**, Vancouver (solo)

**1979**
**The Art Gallery of Greater Victoria**, Victoria, British
Columbia (solo)
Cat. *Jeff Wall*, Art Gallery of Greater Victoria, Victoria,

## Selected articles and interviews
## 1964-79

**1969**

Wheeler, Dennis, 'The Limits of the Defeatured
Landscape: A Review of Four Artists', *Arts Canada*,
Toronto, June

from *Landscape Manual*, 1970

## Selected exhibitions and projects
## 1980-84

text by Jeff Wall, 'To the Spectator'

**1980**
'Roger Cutforth, John Hilliard, Dan Graham, Jeff Wall',
**Hal Bromm Gallery**, New York

'Pluralities 1980',
**National Gallery of Canada**, Ottawa (group)
Cat. *Pluralities/1980/Pluralités*, National Gallery of
Ontario, text on Jeff Wall by Willard Holmes

Text, 'Stereo, 1980', *Parachute*, No 22, Montreal

**1981**
'Directions 1981',
**Hirshhorn Museum and Sculpture Garden**,
Washington DC; **Sarah Campbell Blaffer Gallery**,
University of Houston, Houston (group)
Cat. *Directions 1981*, Hirshhorn Museum, Washington
DC, texts Mirand McClintic and Jeff Wall

'Westkunst: Zeitgenössische Kunst seit 1939',
**Rheinhallen Messegelände**, Cologne (group)
Cat. *Westkunst: Zeitgenössische Kunst seit 1939*,
Rheinhallen Messegelände, Cologne, text Laszlo Glozer

**1982**
'Documenta VII',
**Museum Fridericianum**, Kassel (group)
Cat. *Documenta VII*, Museum Fridericianum, Kassel,
texts Rudi Fuchs, Germano Celant and Coosje van
Bruggen

Installation, 'Westkunst: Zeitgenössische Kunst seit 1939',
Rheinhallen Messegelände, Cologne; **Movie Audience**, 1979

**David Bellman Gallery**, Toronto (solo)

**1983**
**The Renaissance Society,** Chicago (solo)
Cat. *Jeff Wall. Selected Works*, The Rennaissance
Society, University of Chicago, text Ian Wallace

Text, 'The Site of Culture: Contradiction, Totality and
the Avantgarde', *Vanguard*, Vancouver, May

**1984**
'Jeff Wall: Transparencies',
**Institute of Contemporary Arts**, London; **Kunsthalle
Basel** (solo)
Cat. *Transparencies*, Schirmer/Mosel, Munich, texts
Jean Christophe Ammann, Ian Wallace and Jeff Wall ('A
Note on Movie Audience')

'A Different Climate: Aspects of Beauty in Contemporary
Art',
**Stadtisches Kunsthalle**, Dusseldorf (group)
Cat. *A Different Climate: Aspects of Beauty in
Contemporary Art*, Städtische Kunsthalle, Dusseldorf,
texts Jeff Wall and Jürgen Harten

**Galerie Rüdiger Schöttle**, Munich (solo)

## Selected articles and interviews
## 1980-84

**1980**

Graham, Dan, 'The Destroyed Room of Jeff Wall', *Real
Life Magazine*, New York, March

**1981**

Wallace, Ian, 'Revisionism and its Discontents:
Westkunst', *Vanguard*, Vancouver, September

**1982**
Wallace, Ian, 'The Era of Judgement: the 7th
Documenta', *Vanguard*, Vancouver, December/January

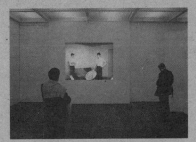

Kuspit, Donald B., 'Looking Up Jeff Wall's Modern
"Appassionamento"', *Artforum*, New York, March
Gordon, Kim, 'Unresolved Desires: Redefining
Masculinity in Some Recent Art', *ZG*, New York

Installation, Documenta 7, Kassel; **Double Self-Portrait**,
1979

**1983**

Johnen, Jörg, and Schöttle, Rüdiger, 'Jeff Wall',
*Kunstforum*, Cologne, September

**1984**

## Selected exhibitions and projects
### 1984-87

'Difference: On Representation and Sexuality',
**New Museum of Contemporary Art**, New York; **The
Renaissance Society**, Chicago; **Institute of
Contemporary Art**, London; **The List Visual Arts
Center**, MIT, Cambridge (group)
Cat. *Difference: On Representation and Sexuality*, New
Museum of Contemporary Art, New York, texts Kate
Linker, Laura Mulvey, Craig Owens and Lisa Tickner

Text, 'Unity and Fragmentation in Manet', *Parachute*,
No 35, Montreal, Summer

Text, 'Dan Graham's Kammerspiel' in catalogue, *Dan
Graham*, The Art Gallery of Western Australia

### 1985
'Jeff Wall and Günther Förg: Photoworks',
**Stedelijk Museum**, Amsterdam (group)
Cat. *Jeff Wall en Günther Förg: Fotowerken*, Stedelijk
Museum, Amsterdam, text Els Barents

### 1986
**Galerie Johnen & Schöttle**, Cologne (solo)

**The Ydessa Gallery**, Toronto (solo)

### 1987
Appointed Professor, Department of Fine Arts,
**University of British Columbia**, Vancouver

'Zeitgeschichten/Blow-Up',
**Wurttembergischer Kunstverein**, Stuttgart; **Haus am
Waldsee**, Berlin; **Kunstverein**, Frankfurt; **Kunstverein**,
Hamburg; **Kunstverein**, Hannover (group)
Cat. *Zeitgeschichten/Blow-Up*, Wurttembergischer
Kunstverein, Stuttgart, et al., texts Tilman Osterwald
and Jean Fisher

'Young Workers',
**Museum für Gegenwartskunst**, Basel (solo)
Pamphlet, *Durchleuchtende Gesichter*, Museum der
Gegenwartskunst, Basel, text Jorg Zutter

'L'epoque, la mode, la morale, la passion: Aspectes de
l'art, d'aujourd'hui, 1977-1987',
**Musée National d'art Moderne**, Centre Georges
Pompidou, Paris (group)
Cat. *L'epoque, la mode, la morale, la passion: Aspectes
de l'art, d'aujourd'hui, 1977-1987*, Musée National
d'art Moderne, Centre Georges Pompidou, Paris, text
Catherine David

'Documenta VIII',
**Museum Fridericianum**, Kassel (group)
Cat. *Documenta VIII*, Museum Fridericianum, Kassel,

## Selected articles and interviews
### 1984-87

DIFFERENCE: ON REPRESENTATION AND SEXUALITY
December 8-February 10, 1985

**Kate Linker,** *Guest Curator*, Ray Barrie, Victor Burgin, Hans Haacke, Mary Kelly, Silvia
Kolbowski, Barbara Kruger, Sherrie Levine, Yve Lomax, Jeff Wall, Marie Yates
**Jane Weinstock,** *Guest Curator/Film & Video*, Max Almy, Judith Barry, Raymond Bellour,
Dara Birnbaum, Theresa Cha, Cecilia Condit, Jean-Luc Godard, Stuart Marshall, Martha Rosler,
Philippe Venault

*The film program will be shown at Joseph Papp's Public Theater from January 25 through
February 3, 1985*

ON VIEW
December 8, –February 3, 1985

**Organized by Marcia Tucker,** *Director*, Robin Winters, Shelley Hull, John Hernandez,
Jarvis Rockwell (The Window), Susan Dallas-Swann (WorkSpace), Krzysztof Wodiczko
(A Special Projection), Linda Montano (Mercer Street Window)

**The New Museum of Contemporary Art**, 583 Broadway, New York City 10012   (212) 219-1222

Barry, Judith, 'Spiegelbeeld: Notities over de
Achtergrond van Jeff Wall's Dubbelzelfportret',
*Museum Kunst und Journaal*, No 6, Amsterdam
Wood, William, 'Three Theses on Jeff Wall', *C Magazine*,
No 3, Toronto, Fall

### 1986
Honnef, Klaus, 'Jeff Wall', *Kunstforum*, No 84, Cologne,
August/September

Barents, Els , interview in *Jeff Wall Transparencies*,
Schirmer/Mosel, Munich, 1986; Rizzoli, New York,
1987
Fol, Jac, 'Jeff Wall: le Mur Ecran', *Des Arts*, Paris, Autumn
Newman, Michael, 'Revising Modernism',
*Postmodernism*, Institute of Contemporary Arts,
London

### 1987

stedelijk museum
## günther förg en jeff wall
**fotowerken**
**27 sept. t/m 24 nov. 1985**
**zaal 20-23**

texts Manfred Schneckenburger and Edward Fry

**Galerie Johnen & Schöttle**, Cologne (solo)

**1988**
'Utopia, Post-Utopia: Configurations of Nature and
Culture in Recent Sculpture and Photography',
**Institute of Contemporary Art**, Boston (group)
Cat. *Utopia, Post-Utopia: Configurations of Nature and
Culture in Recent Sculpture and Photography*, Institute
of Contemporary Art, Boston, texts Alice Jardine, Eric
Michaud, Abigail Solomon-Godeau, Fredric Jameson
and David Joselit

**Le Nouveau Musée**, Villeurbanne (solo)
Cat. *Jeff Wall*, Le Nouveau Musée, Villeurbanne, text
Frédéric Migayrou

**Westfälischer Kunstverein**, Münster (solo)
Cat. *Jeff Wall*, Westfälischer Kunstverein, Münster,
texts Marianne Stockebrand, Andreas Thielman and
Jeff Wall

'ROSC '88',
**The Guinness Hop Store**, Dublin (group)
Cat. *ROSC '88*, The Guinness Hop Store, Dublin, texts
Aidan Dunne, Olle Granath and Patrick Murphy

'Presi X Incantamento: La Nouva Fotografia
Internazionale',
**Padiglione d'Arte Contemporanea**, Milan (group)
Cat. *Presi X Incantamento: La Nouva Fotografia
Internazionale*, Padiglione d'Arte Contemporanea,
Milan, texts Gregorio Magnani, Daniela Salvioni and
Giorgio Verzotti

'Carnegie International',
**Carnegie Museum of Art**, Pittsburgh (group)
Cat. *Carnegie International*, Carnegie Museum of Art,
Pittsburgh, texts John Caldwell, Vicky A. Clark, Thomas
McEvilley, Lynne Cooke and Milena Kalinovska

Text, 'La Mélancholie de la Rue: Idyll and Monochrome
in the Work of Ian Wallace 1968-82', in catalogue *Ian
Wallace: Selected Works 1970-87*, Vancouver Art
Gallery, Vancouver

Text, 'Into the Forest: Two Sketches for Studies of
Rodney Graham's Work', in catalogue, *Rodney Graham:
Works 1976-88*, Vancouver Art Gallery, Vancouver

Text, *Kammerspiel de Dan Graham*, Daled/Goldschmidt,
Brussels (French translation of English original by
Claude Gintz)

Text, 'Bezugspunkte im Werk von Stephan Balkenhol',
in catalogue, *Stephan Balkenhol*, Kunsthalle Basel

jeff wall

5 mars - 15 mai 1988

vernissage le vendredi 4 mars,
à partir de 18 h

LE NOUVEAU MUSÉE

Selected articles and interviews
**1987-88**

Wood, William, 'Jeff Wall', No 13, *C Magazine*, Toronto,
Spring

**1988**

Ainardi, Dolène, 'Jeff Wall, Chroniques du temps
présent', *Halle Sud/Genève*, 2nd trimester
Couderc, Sylvie, 'Distance et Possesion: les
Photographies de Jeff Wall et de Clegg & Guttman',
*Artefactum*, Antwerp, September/October
Diep, Tran, 'Velasquez sous les néons', *Libération*,
Paris, 4 March
Francblin, Catherine, 'Jeff Wall: la Pose et la Vie',
*Art Presse*, Paris, March
Soutif, Daniel, 'Wall au Clair du Mur', *Libération*,
Paris, 3 May

EDITIONS DALED-GOLDSCHMIDT

# KAMMERSPIEL DE DAN GRAHAM

PAR JEFF WALL
TRADUCTION DE CLAUDE GINTZ

Gintz, Claude, 'Suite a Suivre', *Art Press*, No 133, Paris,
February

Beyer, Lucie, 'Jeff Wall, Spotlight', *Flash Art*, Milan,

## Selected exhibitions and projects
### 1988-89

## 1989

'Bestiarium Theatergarden: The Garden as Theater as Museum',
**P.S.1, Institute for Contemporary Art**, Long Island City, New York; toured to **Teatro Lope de Vega**, Casino de la Exposicion, Seville; **Galerie du Confort Moderne**, Poitiers (group)
Cat. *Bestiarium Theatergarden: The Garden as Theater as Museum*, P.S.1, Institute for Contemporary Art, New York, et al., text Frédéric Migayrou, Chris Dercon, Naomi Miller, Dan Graham, Antje von Graevenitz, Joanne Lamoureux, Richard Sennett and Marianne Brouwers

**Marian Goodman Gallery**, New York (solo)
Cat. *Jeff Wall*, Marian Goodman Gallery, New York, text Catherine Francblin

'Jeff Wall - Dan Graham: Pavilion des Enfants',
**Galerie Roger Pailhas**, Marseilles; **FRAC Rhones-Alpes**, Lyon; **Galerie Chantal Boulanger**, Montreal (solo)
Cat. *Children's Pavilion*, Galerie Roger Pailhas, Marseille, texts Jeff Wall, Dan Graham and Frédéric Migayrou

'Images Critiques: Jeff Wall, Dennis Adams, Alfredo Jaar, Louis Jammes',
**Musée d'art moderne de la ville de Paris**, (group)
Cat. *Images Critiques*, Musée d'art moderne de la ville de Paris, texts Béatrice Parent and Arielle Pelenc

'Magiciens de la terre',
**Centre Georges Pompidou**, Paris; **La Grand Halle de la Villette**, Paris (group)

'Une autre objectivité/Another Objectivity',
**Centre National des Arts Plastiques**, Paris; toured to **Centro per l'Arte Contemporanea Luigi Pecci**, Prato, Italy (group)
Cat. *Une autre objectivité/Another Objectivity*, Idea Books, Milan, texts Jean-François Chevrier, James Lingwood and Jeff Wall

**Galerie Johnen & Schöttle**, Cologne (solo)

'Foto-kunst: Arbeiten aus 150 Jahren, Du XXéme au XIXéme Siécle, Aller et Retour',
**Staatsgalerie**, Stuttgart (group)
Cat. *Foto-kunst: Arbeiten aus 150 Jahren, Du XXéme au XIXéme Siécle, Aller et Retour*, Staatsgalerie, Stuttgart,

## Selected articles and interviews
### 1988-89

February
Celant, Germano, *Unexpressionism: Art Beyond the Contemporary*, Costa and Nolan Spa., Genoa, and Rizzoli, New York
Chevrier, Jean-François, 'Les Peintres de la Vie Moderne', *Galeries*, Paris April/May
David, Catherine, 'Picture for Women', *Cahiers du Musée d'Art Moderne*, Paris, Spring
James, Geoffrey, 'Pictures from an Explosive World', *Maclean's*, Toronto, 11 January

## 1989

Migayrou, Frédéric, 'Bestiarium', *Galeries*, No 33, Paris, October/November

Bankowsky, Jack, 'Jeff Wall', *Artforum*, New York, November
Decter, Joshua, *Flash Art*, Milan, November
Faust, Gretchen, *Arts Magazine*, New York, April
Heartney, Eleanor, *ArtNews*, New York, December
Johnson, Ken, 'Small World', *Art in America*, New York, April
Joselit, David, *Art in America*, New York, January
Reid, Calvin, 'Jeff Wall', *Arts Magazine*, New York, December
Shottenkirk, Dena, *Artforum*, New York, March

Graw, Isabelle, *Flash Art*, Milan, March/April

## Selected exhibitions and projects
### 1989-90

texts Jean-François Chevrier and Ursula Zeller

'Symposium: Die Photographie in der Zeitgenössischen Kunst. Eine Veranstaltung der Akademie Schloss Solitude',
Lectures published by Edition Cantz, Stuttgart

Text, 'Four Essays on Ken Lum', in catalogue, *Ken Lum*, Winnipeg Art Gallery, Winnipeg; Vancouver Art Gallery, Vancouver; Witte de With, Rotterdam

Text, 'Boys on TV (aus Eviction Struggle)', *Parkett* 22, Zurich

### 1990
'Jeff Wall 1990',
**Vancouver Art Gallery; Art Gallery of Ontario** (solo)
Cat. *Jeff Wall 1990*, Vancouver Art Gallery, texts Jerry Zaslove and Gary Dufour

'The Children's Pavilion; A Collaborative Project by Dan Graham and Jeff Wall',
**Marian Goodman Gallery**, New York; **Santa Barbara Contemporary Arts Forum** (solo)
Brochure, *A Guide to the Children's Pavilion* (co-authored with Dan Graham), Santa Barbara Contemporary Arts Forum, Santa Barbara

'Culture and Commentary: An Eighties Perspective',
**Hirshhorn Museum**, Washington DC (group)
Cat. *Culture and Commentary: An Eighties Perspective*, Hirshhorn Museum, Washington DC , text Kathy Halbreich, Maurice Culot, Vijak Mahdavi, Bernardo Nadal-Ginard, Michael M. Thomas and Sherry Turkle

**The Ydessa Hendeles Art Foundation**, Toronto (solo)

'The First Tyne International: A New Necessity',
**National Garden Festival**, Gateshead (group)
Cat. *The First Tyne International: A New Necessity*, National Garden Festival, Gateshead, texts Declan McGonagle, Annelie Pohlen, Jeff Wall, Dan Graham, Jon Bird, Simon Herbert and Thomas McEvilley

'Passages de l'Image',
**Centre Georges Pompidou**, Paris; toured to **Fundacio Caixa de Pensions**, Barcelona; **Wexner Center for the Visual Arts**, Ohio State University; **San Francisco Museum of Modern Art** (group)
Cat. *Passages de l'Image*, Musée Nationale d'Art Moderne, Centre Georges Pompidou, Paris, texts Jean-François Chevrier, Louis Marin and Catherine David

'Life Size: A Sense of the Real in Recent Art',
**The Israel Museum**, Jerusalem (group)
Cat. *Life Size: A Sense of the Real in Recent Art*, The

## Selected articles and interviews
### 1989-90

Clark, T. J., Gintz, Claude, Guilbaut, Serge and Walker, Anne, 'Three Excerpts from a Discussion with Jeff Wall', *Parkett* 22, Zurich
Parent, Beatrice, 'Light and Shadow: Christian Boltanski and Jeff Wall', *Parkett* 22, Zurich
Pelenc, Arielle, 'Jeff Wall. Excavation of the Image,' *Parkett* 22, Zurich

### 1990

Ledes, Richard C., 'Dan Graham and Jeff Wall at Marian Goodman', *Artscribe*, New York, May
Russell, John, 'Dan Graham and Jeff Wall: The Children's Pavilion', *New York Times*, 12 January
Spector, Nancy, 'The Children's Pavilion: Jeff Wall and Dan Graham's Collaborative Project', *Canadian Art*, Toronto, Summer
Woodard, Josef, 'An Artspace Not for Children Only', *Artweek*, 28 October 1989
van den Boogerd, Dominic, 'De architectuur vanhet kinderspel: Dan Graham and Jeff Wall: het Children's Pavilion', *Archis*, Amsterdam, June 1991

Installation, 'Culture and Commentary: An Eighties Perspective', Hirshhorn Museum, Washington DC; **Young Workers**, 1978-83

Tazi, Nadia, 'Quand passe l'image', *L'Autre Journal*, Paris, October

## Selected exhibitions and projects
### 1990-92

Israel Museum, Jerusalem, texts Suzanne Landau, Douglas Crimp, Carolyn Christov-Bakargiev, Germano Celant, Robert Storr and Christian Leigh

**The Carnegie Museum of Art**, Pittsburgh (solo)

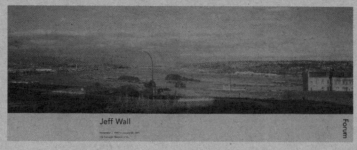

'Weitersehen 1980-90',
**Museum Haus Lange and Museum Haus Esters**, Krefeld (group)
Cat. *Weitersehen 1980-90*, Museum Haus Lange and Museum Haus Esters, Krefeld, text Julian Heynen

**1991**
**Galerie Rüdiger Schöttle**, Munich (solo)

**Galleria Christian Stein**, Milan (solo)

'Metropolis',
**Martin-Gropius Bau**, Berlin (group)

**Galerie Johnen & Schöttle**, Cologne (solo)

'Jes: Dan Graham, Ludger Gerdes, Jeff Wall',
**Centre Internationale d'art contemporain de Montreal** (group)

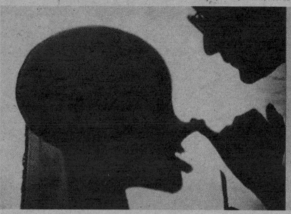
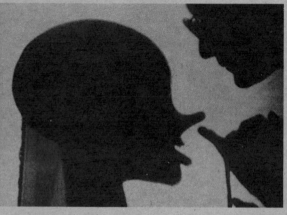

'Sguardo di Medusa',
**Castello di Rivoli**, Museo d'arte contemporanea, Turin (group)
Cat. *Sguardo di Medusa*, Castello di Rivoli, Museo d'arte contemporanea, Turin, text Ida Gianelli

Invitation card, Christian Stein Gallery, Milan

'Lost Illusions: Recent Landscape Art',
**Vancouver Art Gallery**, Vancouver (group)
Cat. *Lost Illusions: Recent Landscape Art*, Vancouver Art Gallery, Vancouver, text Denise Oleksijczuk

**San Diego Museum of Contemporary Art** (solo)
Brochure, *Notes on a Work by Jeff Wall*, San Diego Museum of Contemporary Art, California, text Madeleine Grynsztejn

Text, 'Tradition and Counter-Tradition in Vancouver Art: A Deeper Background to Ken Lum's Work', *Witte de With: The Lectures 1991*, Witte de With Center for Contemporary Art, Rotterdam

**1992**
**Louisiana Museum**, Humlebaek (solo)

## Selected articles and interviews
### 1990-92

Chevrier, Jean-François, 'Jeff Wall: L'Académie Intérieure', *Galeries*, Paris, February/March
Clark, T.J., Guilbaut, Serge, and Wagner, Anne, interview with Jeff Wall, 'Representations, Suspicions and Critical Transparency', *Parachute*, No 59, Montreal, July/August/September
David, Catherine, 'Ouvertures: Nanni Moretti, Bruce Nauman, Jeff Wall', *Parachute*, Montreal, October/November/December

**1991**
Marzo, Jorge Luis, 'Escenografias de la vida cotidiana', *Lapiz*, No 65, Madrid, February

Watson, Scott, 'The Generic City and Its Discontents: Vancouver Accounts for Itself', *Arts Magazine*, New York, February

Gardner, Colin, *Artforum*, New York, February

Chevrier, Jean-François, 'Jeff Wall, The Story Teller,' *Forum International 7*, Antwerp, March/April
Zabunyan, Elvan, 'Memoire et réalité mises-en-scéne', *Les Lettres Françaises*, Paris, January
Linsley, Robert, 'Painting and the Social History of British Columbia', *Vancouver Anthology: The Institutional Politics of Art*, edited by Stan Douglas, Talon Books, Vancouver

**1992**

## Selected exhibitions and projects
### 1992-93

Cat. *Jeff Wall*, Louisiana Museum, Humlebaek, texts
Ingrid Fischer Jonge and Hans Erik Wallin

**Marian Goodman Gallery**, New York (solo)

**Palais des Beaux-Arts**, Brussels (solo)

'Cameres indiscretes',
**Centre d'Art Santa Monica**, Barcelona; **Circulo de
Bellas Artes**, Madrid (group)
Cat. *Cameres indiscretes*, Centre d'Art Santa Monica,
Barcelona, texts Robert Linsley and José Lebrero Stals

'Pour la suite du monde',
**Musée d'art contemporain de Montreal** (group)
Cat. *Pour la suite du monde*, Musée d'art contemporain
de Montreal, texts, Réal Lussier and Gilles Godmer

'Territorium Artis',
**Kunst-und Austellungshalle der Bundesrepublik
Deutschland**, Bonn (group)
Cat. *Territorium Artis*, Kunst-und Austellungshalle der
Bundesrepublik Deutschland, Bonn, texts Pontus
Hulten and Wenzel Jacob

'The Binary Era: New Interactions',
**Musée Communal d'Ixelles**, Brussels, toured to
**Kunsthalle Wien**, Vienna (group)
Cat. *The Binary Era: New Interactions*, Musée Communal
d'Ixelles, Brussels, Editions Ludion, texts Charles
Hirsch, Jean-Louis Moigne, René Berger, Derrick de
Kerckhove and Michel Baudson

### 1993
'Dead Troops Talk',
**Kunstmuseum, Luzern**, toured to **Irish Museum of
Modern Art**, Dublin; **Deichtorhallen Hamburg;
Stadtische Kunsthalle**, Dusseldorf (solo)
Cat. *Jeff Wall. Dead Troops Talk*, Kunstmuseum, Luzern,
et al., text Terry Atkinson

**Fondation Cartier**, Jouy-en-Josas (solo)

**Galerie Roger Pailhas**, Marseille (solo)

'The Children's Pavilion',
**Museum Boymans-van Beuningen**, Rotterdam,
toured to **Magasin, Centre Nationale d'Art
Contemporain**, Grenoble (group)

'The Sublime Void: An Exhibition on the Memory of the

## Selected articles and interviews
### 1992-93

Avgikos, Jan, *Artforum*, New York, September
Lagiera, Jacinto, *Beaux Arts Magazine*, Paris, May

Meuris, Jacques, 'Les Images Lumineuses de Jeff Wall',
*Art et Culture*, Brussels, April
van Mulders, Wim, 'Jeff Wall: de cinematografische
fotografie van het moderne', *Kunst & Cultuur*, Brussels,
April

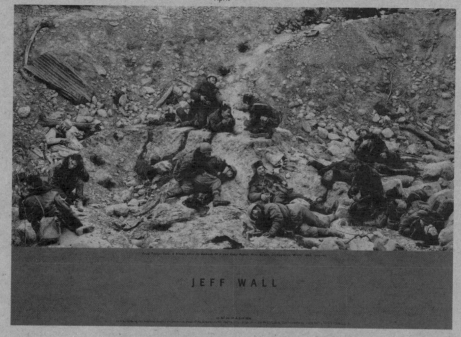

JEFF WALL

Linsley, Robert, and Auffermann, Verena, monograph,
*Jeff Wall The Storyteller*, Museum für Moderne Kunst,
Frankfurt
Seamon, Roger, 'The Uneasy Sublime: Defiance and
Melancholy in Jeff Wall's Documentary Spectacle',
*Parachute*, Montreal, April/May/June

### 1993
'Das Kind im Kasten', *Der Speigel*, No 31, Hamburg
Gardner, Belinda, 'Dialektik der Schönheit', *Hamburger
Rundschau*, 3 March 1994
Jäger, Kerstin, 'Steine im Weg', *Kölns Stadtillustrierte*,
Cologne, May/June
Mack, Gerhard, 'Manets Vampire: Jeff Wall und Seine
arrangierten Genreszenen: Licht-bilder als
Innenansichten unserer Epoche', *Die Woche*, Hamburg,
10 March
van den Boogerd, Dominic, 'Digitale allegorieën',
*Metropolis M*, No 5, Amsterdam, October
'Die große Illusion', *Süddeutsche Zeiting Magazin*,
Munich, May

2 juillet - 30 septembre 1993 - Vernissage le 2 juillet à 19 heures
61, cours Julien 13006 Marseille, tel 91 42 18 01 fax 91 42 96 41
Galerie Roger Pailhas

# Jeff Wall
Nouvelles images

## Selected exhibitions and projects
## 1993-94

Imagination',
**Palais Royale des Beaux-Arts**, Antwerp (group)
Cat. *The Sublime Void: An Exhibition on the Memory of the Imagination*, Palais Royale des Beaux-Arts, Antwerp, edited by Bart Cassiman, Greet Ramael, Frank Vande Veire

'Post-Human',
**Foundation Asher Edelman**, Pully, Lausanne, **Deste Foundation**, Athens; **Castello di Rivoli**, Turin; **Deichtorhallen,** Hamburg (group)
Cat. *Post-Human*, Foundation Asher Edelman, Pully, Lausanne, text Jeffrey Deitch

Lecture, 'Monochrome and Photojournalism in On Kawara's "Today Paintings"',
**DIA Center for the Arts**, New York

### 1994
'Pictures of the Real World (In Real Time)',
**Paula Cooper Gallery**, New York (group)

**White Cube**, London (solo)

**Galerie Rüdiger Schöttle**, Munich (solo)

'The Epic and the Everyday',
**Hayward Gallery**, London (group)
Cat. *The Epic and the Everyday*, Hayward Gallery, London, text James Lingwood

**Galerie Johnen & Schöttle**, Cologne (solo)

**De Pont Foundation**, Tilburg, The Netherlands (solo)
Cat. *Jeff Wall*, De Pont Foundation, Tilburg, The Netherlands, text Michael Newman

'The Ghost in the Machine',
**MIT List Visual Arts Center**, Cambridge (group)
Cat. *The Ghost in the Machine*, MIT List Visual Arts Center, Cambridge, text Ron Platt

**Museo Nacional Centro d'Arte Reina Sofia**, Madrid (solo)
Cat. *Jeff Wall*, Museo Nacional Centro d'Arte Reina Sofia, Madrid, text José Lebrero Stals

**Neue Gesellschaft für Bildende Kunst**, Berlin (solo)
Cat. *Jeff Wall*, Neue Gesellschaft für Bildende Kunst, Berlin, texts Frank Wagner and Scott Watson

**Kunstmuseum, Luzern; Kunsthalle, Düsseldorf** (solo)
Cat. *Jeff Wall. Restoration*, Kunstmuseum, Luzern, et al., texts Martin Schwander and Arielle Pelenc

WHITE CUBE

Jeff Wall

The Giant

Open from
Friday 11 February until Saturday 26 February 1994

44 Duke Street
St. James's
London SW1Y 6DD
Tel: + 44 71 930 5373  Fax: + 44 71 930 9973
Open: Friday and Saturday 12-6pm or by appointment
In collaboration with Patrick Painter editions

JOHNEN & SCHÖTTLE

ERÖFFNUNG.
FREITAG. 9. SEPTEMBER 1994   20 – 22 UHR

JEFF WALL

● GROSSE BRINKGASSE 17-19   D – 50672 KÖLN
TELEFON 02 21 – 52 45 05   FAX 52 75 96
DI – FR 14 – 18 UHR   SA 11 – 14 UHR
BIS 8. OKTOBER 1994

## Selected articles and interviews
## 1993-94

Crow, Thomas, 'Profane Illuminations, Social History and the Art of Jeff Wall', *Artforum*, New York, February

### 1994

Bickers, Patricia, 'Wall Pieces: Jeff Wall Interviewed', *Art Monthly*, No 179, London, September

Boddy, Trevor, 'Plastic Lion's Gate: A Short History of the Post Modern in Vancouver Architecture'; Seamon, Roger, 'Uneasy in Eden: Jeff Wall and the Vancouver Syndrome', *Vancouver: Representing the Postmodern City*, ed. Paul Delany, Arsenal Pulp Press, Vancouver
Disch, Maddalena, 'The Stumbling Block', *Temporale, Rivista d'arte e di cultura*, No 32/33, Lugano
Lewis, Mark, 'An Interview with Jeff Wall', *Public 9*, Toronto
Millar, Jeremy, 'Digital Phantoms', *Creative Camera*,

**THE EPIC & THE EVERYDAY**
CONTEMPORARY PHOTOGRAPHIC ART

23 June - 29 August 1994
**Hayward Gallery**
London

## Selected exhibitions and projects
### 1994-95

### 1995

'Public Information: Desire, Disaster, Document',
**San Francisco Museum of Art** (group)
Cat. *Public Information: Desire, Disaster, Document*,
San Francisco Museum of Art, text Gary Garrells

'Spirits on the Crossing Travellers to/from Nowhere',
**Setagaya Museum**, Tokyo; **National Museum of
Modern Art**, Kyoto; **Hokkaido Museum of Modern Art**,
Sapporo (group)
Cat. *Spirits on the Crossing Travellers to/from Nowhere*,
Setagaya Museum, Tokyo, texts Diana Nemiroff, Shinji
Kohmoto and Yuko Hasegawa

'Micromegas',
**The American Center**, Paris; toured to the **Israel
Museum**, Jerusalem (group)

'About Place: Recent Art of the Americas',
**Art Institute of Chicago** (group)
Cat. *About Place: Recent Art of the Americas*, Art
Institute of Chicago, text Madeleine Grynstejn

'Whitney Biennial',
**Whitney Museum of American Art**, New York (group)
Cat. *Whitney Biennial*, Whitney Museum of American
Art, New York, texts Klaus Kertess, Lynne Tillman, John
Asbery, Gerald M. Edelman and John G. Hanhardt

Lecture, **Tate Gallery**, London

**Marian Goodman Gallery**, New York (solo)

'Projections: Alfred Stieglitz, Walker Evans, Brassaï,
Weegee, Cindy Sherman, Jeff Wall',
**Ydessa Hendeles Art Foundation**, Toronto (group)

'Jeff Wall',
**Museum of Contemporary Art**, Chicago; toured to **Jeu
de Paume**, Paris; **Museum of Contemporary Art**,
Helsinki, **Whitechapel Art Gallery**, London (solo)
Cat. *Jeff Wall*, Museum of Contemporary Art, Chicago,
et al., texts Jean-François Chevrier and Briony Fer

'Kwangju Biennale',
**Kwangju Museum of Contemporary Art** (group)
Cat. *Kwangju Biennale*, Kwangju Museum of
Contemporary Art, Korea, texts Jean de Loisy, Kathy
Halbreich, Oh Kwang-su, Anda Rottenberg, Sung Wan-
kyung, Clive Adams, You Hong-june

---

## Selected articles and interviews
### 1994-95

London, February/March
Muniz, Vik, 'Angels don't fly too well in photographs',
*Blind Spot*, No 12, New York
van Winkel, Camiel, 'Blind Figures', *Archis*, Amsterdam,
No 12, December

### 1995

Abrioux, Yves, 'Jeff Wall: Jeu de Paume, Paris, and
Whitechapel, London', *Untitled, a review of
contemporary art*, No 10, London, Spring
Criqui, Jean-Pierre, 'Jeff Wall, Jeu de Paume',
*Artforum*, New York, March
Freedman, Adele, 'Vancouver to Paris', *Canadian Art*,
Vol 13, No 1, Toronto, Spring

Bangma, Anke, 'Rotterdam and the Children's Pavilion
by Dan Graham and Jeff Wall', *Witte de With Cahier 3*,
Witte de With Center for Contemporary Art, Rotterdam,
February
Crow, Thomas, 'Unwritten Histories of Conceptual Art',
*Oehlen Williams 95*, Wexner Center for the Arts, Ohio
State University, Columbus
Imdahl, Georg, 'Wenn die zombies leuchten: Die
Rätselbilder des Kanadiers Jeff Wall', *Frankfurter*

## Selected exhibitions and projects
## 1995-96

### 1996

'Jeff Wall: Landscapes and Other Pictures',
**Kunstmuseum**, Wolfsburg (solo)
Cat. *Jeff Wall: Landscapes and Other Pictures*, Cantz,
Stuttgart, text Camiel van Winkel

'Jeff Wall: Space and Vision',
**Städtische Galerie im Lenbachhaus**, Munich (solo)
Cat. *Jeff Wall: Space and Vision*, Schirmer/Mosel,
Munich, texts Jean-François Chevrier and Helmut
Friedel

'Face à l'Histoire 1933-1996: L'artiste moderne face à
lévénement historique',
**Musée nationale d'art moderne**, Centre Georges
Pompidou, Paris (group)
Cat. *Face à l'Histoire 1933-1996: L'artiste moderne face
à lévénement historique*, Musée nationale d'art
moderne, Centre Georges Pompidou, Paris;
Flammarion, Paris, texts Jean-Paul Ameline, Harry
Bellet, et al.

'a/drift: Scenes from Penetrable Culture',
**Center for Curatorial Studies**, Bard College,
Annandale-on-Hudson, New York (group)
Cat. *a/drift: Scenes from Penetrable Culture*, Center for
Curatorial Studies, Bard College, Annandale-on-
Hudson, New York, texts Joshua Decter, Jeff Wall, et al.

'Matthew Barney, Tony Oursler, Jeff Wall',
**Sammlung Goetz**, Munich (group)
Cat. *Matthew Barney, Tony Oursler, Jeff Wall*, Goetz
Collection, Munich, texts Hans Dickel, Dirk Snauwaert,
Jeff Wall, et al.

'Hall of Mirrors: Art & Film Since 1945',
**Museum of Contemporary Art**, Los Angeles; toured to
**Wexner Center for the Arts**, Columbus, Ohio; **Palazzo
elle Esposizioni**, Rome; **Museum of Contemporary
Art**, Chicago (group)
Cat. *Hall of Mirrors: Art & Film Since 1945*, Monacelli
Press Inc., New York; Museum of Contemporary Art, Los
Angeles, texts Kerry Brougher, Russell Ferguson, et al.

'Prospect 96: Photographie in der Gegenwartskunst',
**Frankfurter Kunstverein**, Frankfurt; **Schirn
Kunsthalle**, Frankfurt (group)
Cat. *Prospect 96: Photographie in der Gegenwartskunst*,
Edition Stemmle, Frankfurt, text Peter Weiermair

## Selected articles and interviews
## 1995-96

*Allgemeine Zeitung*, 22 April, 1995
Newman, Michael, 'Jeff Wall's Pictures', *Flash Art*,
Milan, March/April

### 1996

Gardner, Belinda, 'Lakonie der Landschaft. Jeff Wall in
Gespräch mit Belinda Gardner', *neue bildende kunst*,
Berlin, No 4, August/September

Freedman, Adele, 'Vancouver to Paris', *Canadian Art*,
Toronto, Spring

Albig, Jörg-Uwe, 'Wahrheit ist kein Werk von
Sekunden', *art: Das Kunstmagazin*, No 6, Hamburg,
June
Brayshaw, Christopher, 'Jeff Wall: Critical
Transparencies: a Defense, an Exegesis', *Artichoke*, Vol
8, No 1, Calgary, Spring
Dickel, Hans, 'Im Licht der Bilder: Der Platz des
Betrachters im Werk von Jeff Wall', in Wolfgang Kemp,
*Zeitgenössische Kunst und ihre Betrachter*, Jahresring
43, Jahrbuch für moderne Kunst, Oktagon Verlag,
Cologne
Kaila, Jan, 'Jeff Wall', *Valokuva: Finnish Photography*,
No 3, Helsinki
Wagner, Anselm, 'Jeff Wall: Photografie als "tableau

## Selected exhibitions and projects
### 1996-97

### 1997

Book, *Szenarien im Bildraum der Wirklichkeit, Essays
und Interviews*, ed. Gregor Stemmrich, Verlag der
Kunst, Fundus-Bücher, Berlin/Dresden

**Museum of Contemporary Art**, Los Angeles; toured to
**Hirshhorn Museum and Sculpture Garden**,
Washington, DC; **Art Tower Mito**, Japan (solo)
Cat. *Jeff Wall*, Museum of Contemporary Art, Los
Angeles; Scalo Verlag, Zurich, text Kerry Brougher

'20/20',
**Marian Goodman Gallery**, New York, (group)

'Deslocaçãs/From Here to There',
**Fundação Calouste Gulbenkian**, Lisbon (group)
Cat. *Deslocaçãs/From Here to There*, Centro de Arte
Moderna José de Azeredo Perdigão, Fundação Calouste
Gulbenkian Lisbon; Centro Português de Fotografia,
Ministério da Cultura, Porto, text Michael Tarantino

documenta X,
Kassel, Germany (group)
Cat. *documenta X*, Cantz Verlag, texts Catherine David,
Jean-François Chevrier, et al.

'Framed Area: Site-Specific Works in Haalemmermeer,
Hoofdorp, and Schiphol Airport, Amsterdam',
organized by Framed Area Foundation, Amsterdam
(group)
Cat. *Framed Area: Site-Specific Works in
Haalemmermeer, Hoofdorp, and Schiphol Airport,
Amsterdam*, Framed Area Foundation, Amsterdam,
texts Ellen de Bruijne, Paul Kamp, et al.

'Opening Exhibition/Soweit der Erdkreis Reicht/Ein
Museum für Zeitgenössische Kunst',
**Museums Kurhaus**, Kleve, Germany, (group)

'Veronica's Revenge: Contemporary Perspectives on
Photography',
**Centre d'Art Contemporain**, Geneva, and tour (group)
Cat. *Veronica's Revenge: Contemporary Perspectives on
Photography*, Scalo, New York and Zurich, texts
Elizabeth Janus, Marion Lambert

'Contemporary Photography 1: "Absolute Landscape:
Between Illusion and Reality"',
**Yokohama Museum of Art**, Japan (group)
Cat. *Contemporary Photography 1: 'Absolute Landscape:
Between Illusion and Reality'*, Yokohama Museum of
Art, Japan, texts Amano Taro, Kuraishi Shino and
Catherine Grout

## Selected articles and interviews
### 1996-97

vivant"', *Noëma*, No 42, Vienna, August/September/
October
Welzer, Harald, 'Über Jeff Wall', *artist Kunstmagazin*,
Bremen, Heft 28, No 3

### 1997

Corrin, Lisa, 'Jeff Wall: Review of Hirshhorn Exhibit',
*Parachute*, Montreal, October/November/December
Muchnic, Suzanne, 'Jeff Wall's Aim? To Improve Your
Vision', *Los Angeles Times*, 13 July
Jones, Bill, 'The Truth Is Out There: Jeff Wall and Late-
century Pictorialism', *On Paper*, July/August

Goldberg, Vicky, 'Photos That Lie and Tell the Truth',
*New York Times*, 16 March

Noever, Peter, ed., *Kunst im abseits?/Art in the Center:
Two discussions on documenta X*, MAK Center for Art
and Architecture, Los Angeles; Cantz Verlag, Stuttgart

Carels, Edwin, 'Meditaties over het alledaagse:
Sokurov, Horsfield, Wall', *Metropolis M*, No 1, Utrecht,
February
Lütticken, Sven, 'Het geheugen van de hedendaagse
kunst: Over Gerhard Richter, Jeff Wall en Mat
Collishaw', *De Witte Raaf*, No 65, Ghent, January/
February

Miyatake, Miki, 'Take Photos, Add Paintings and Stir',
*Japan Times*, Tokyo, 17 January

Balkema, Annette W.; Slager, Henk, 'Transformational
Aesthetics: A Fax Interview with Jeff Wall', The
Photographic Paradigm, *Lier en Boog, Series of
Philosophy of Art and Art Theory*, Vol 12, Amsterdam
Birnbaum, Daniel, 'Iron Still', *Artforum*, New York, May
Bryson, Norman, 'Jeff Wall: Enlightenment Boxes', *Art
& Text*, No 56, Sydney, February/April

## Selected exhibitions and projects
### 1997-98

## 1998

'Here and Now II: Jeff Wall',
**Henry Moore Institute**, Leeds (solo)
Brochure, *Here and Now II: Jeff Wall*, Henry Moore
Institute, Leeds, text Jeff Wall

'Jeff Wall: Photographs of Modern Life. Works from
1978 to 1997 in the Basel Public Art Collection and the
Emanuel-Hoffmann-Foundation',
**Museum für Gegenwartskunst**, Basel (solo)

**Marian Goodman Gallery**, New York (solo)

**Galerie Rüdiger Schöttle**, Munich (solo)

**Galerie Johnen & Schöttle**, Cologne (solo)

'Auf der Spur: Kunst der 90er Jahre im Spiegel von
Schweizer Sammlungen';
**Kunsthalle**, Zurich (group)

'Breaking Ground',
**Marian Goodman Gallery**, New York (group)

'Roteiros, Roteiros, Roteiros, Roteiros, Roteiros,
Roteiros, Roteiros',
XXIV Bienal de São Paulo (group)
Cat. *Roteiros, Roteiros, Roteiros, Roteiros, Roteiros,
Roteiros, Roteiros*, Fundação Bienal de São Paulo, texts
Paulo Herkenhoff, Ivo Mesquita, et al.

'Odradek',
**Center for Curatorial Studies**, Bard College,
Annandale-on-Hudson, New York (group)
Cat. *Odradek*, Center for Curatorial Studies, Bard
College, Annandale-on-Hudson, New York, text
Thomas Mulcaire

## Selected articles and interviews
### 1997-98

Bryson, Norman, 'Too Near, Too Far', *Parkett,* No 49,
Zurich, May
Pontbriand, Chantal, 'The Non-Sites of Jeff Wall',
*Parkett*, No 49, Zurich, May
Schorr, Collier, 'The Pine on the Corner and Other
Possibilities', *Parkett*, No 49, Zurich, May
Stemmrich, Gregor, 'Vorwart', *Jeff Wall, Szenarien in
Bildraum der Wirklichkeit: Essays und Interviews*, Verlag
der Kunst, Fundus Books
Stigter, Bianca, 'Voor de nieuwe landverhuizers is
Europa en America. Gesprek met fotograf Jeff Wall',
*NRC Handelsblad*, Rotterdam, 20 June
Woods, Alan, ed., 'Jeff Wall interview/lecture',
*transcript: a journal of visual culture*, Vol 2, No 3,
Dundee
van Gelder, Hilde, 'Photography: From Modus to
Picture', *Lier en Boog, Series of Philosophy of Art and Art
Theory*, Vol 12, Amsterdam

## 1998

Schmerler, Sarah, 'Jeff Wall: Exhibit Review', *ARTnews*,
New York, May
Stevens, Mark, 'Nowhere Man', *New York Magazine*, 2
March
Smith, Roberta, 'The Focus Narrows, As Stark Images
Herald a Time for Seriousness', *New York Times*, 6
February

Reindl, Uta M., 'Jeff Wall', *Kunstforum International*,
Cologne, April/June

Groys, Boris, 'Die Photographie und die Strategien der
Avantgarde: Jeff Wall im Gespräch mit Boris Groys',
*Paradex*, Cologne, November

JEFF WALL

JANUARY 30 – MARCH 14, 1998
RECEPTION FOR THE ARTIST
FRIDAY, JANUARY 30, FROM 6–8 PM

MARIAN GOODMAN GALLERY
24 WEST 57TH STREET, NEW YORK, NY 10019 212 977-7160

## Selected exhibitions and projects
### 1998-99

'Extenuating Circumstances: Wall Hangings in the
Palais van Justitie in 's-Hertogenbosch',
**Museum Boijmans Van Beuningen**, Rotterdam
(group)
Book, *Palais van Justitie in 's-Hertogenbosch*,
Rijksgebouwen 010, Rotterdam, texts Ludger Gerdes,
Jan Ritsema, Charles Vandenhove, Bart Verschaffel,
Jeff Wall

### 1999
**Galerie Johnen & Schöttle**, Cologne (solo)

'Odradek',
**Mies van der Rohe Foundation**, Barcelona (solo)

'Jeff Wall, Pepe Espaliu: Tiempo Suspendido',
**EAC**, Castellon, Spain (solo)
Cat. *Jeff Wall, Pepe Espaliu: Tiempo Suspendido*,
Generalitat Valenciana, Valencia, texts Jose Miguel G.
Cortes, et al.

'Jeff Wall: Oeuvres 1990-1998',
**Musée d'art contemporain de Montréal** (solo)
Cat. *Jeff Wall: Oeuvres 1990-1998*, Musée d'art
contemporain de Montréal, texts Réal Lussier, Marcel
Brisebois and Nicole Gingras

'am Horizont',
**Kaiser Wilhelm Museum**, Krefeld (group)
Cat. *am Horizont*, Kaiser Wilhelm Museum, Krefeld, text
Julian Heynen

'Carnegie International 1999/2000',
**Carnegie Museum of Art**, Pittsburgh (group)
Cat. *Carnegie International 1999/2000*, Carnegie
Museum of Art, Pittsburgh, texts Madeleine
Grynsztejn, Jeff Wall, et al.

'The Museum as Muse: Artists Reflect',
**The Museum of Modern Art**, New York (group)
Cat. *The Museum as Muse: Artists Reflect*, The Museum
of Modern Art, New York, texts Kynaston McShine, et
al.

'August Sander: Landschaftsphotograhien/Jeff Wall:
Bilder von Landschaften',
**Die Photografische Sammlung/SK Stiftung Kultur**,
Cologne; toured to **Nederlands Foto Instituut**,
Rotterdam (group)
Cat. *August Sander: Landschaftsphotograhien/Jeff*

## Selected articles and interviews
### 1998-99

Lewis, Mark, 'Mark Lewis in Conversation with Jeff
Wall', *transcript*, Vol 3, No 3, Dundee
Rimanelli, David, 'The Best of 1998', *Artforum*, New
York, December
Roberts, John, 'Jeff Wall: The Social Pathology of
Everyday Life', *The Art of Interruption: Realism,
Photography and the Everyday*, Manchester University
Press, Manchester and New York
Smolik, Noemi, 'Der Spiegel bleibt: Die Präsenz der
Malerei im Zeitalter technisch reproduzierbarer
Abbilder', *Im Augenblick der Gegenwart.
Zeitgenössische Kunst in den Deichtorhallen Hamburg*,
ed. Belinda Grace Gardner, Helmut Metz Verlag,
Hamburg

### 1999

Badía, Montse, 'Perfección de la imagen: Entrevista
con Jeff Wall', *Lapiz*, No 157, Madrid, November

Pepe, Ed, 'Jeff Wall: Pictures 1990-1998/Review of
Montreal Exhibit', *Art New England*, Newtonville,
October/November
Whyte, Murray, 'Jeff Wall', *National Post*, Ontario, 11
February
Gopnik, Blake, 'A Wall Big Enough To Hang Art On', *The
Globe and Mail*, Toronto, 11 February

## Selected exhibitions and projects
## 1999-2001

*Wall: Bilder von Landschaften*, Die Photografische
Sammlung/SK Stiftung Kultur, Cologne, texts Anne
Gantefüher, Suzanne Lange and Michael Wiesemhofer

**2000**
**Galeria Helga de Alvear**, Madrid (solo)

'Hypermental: Rampant Reality 1950-2000, from
Salvador Dali to Jeff Koons',
**Kunsthaus Zurich**; toured to **Hamburger Kunsthalle**,
Hamburg (group)
Cat. *Hypermental: Rampant Reality 1950-2000, from
Salvador Dali to Jeff Koons*, Kunsthaus Zurich, texts
Bice Curiger, et al.

'Encounters: New Art from Old',
**National Gallery**, London (group)
Cat. *Encounters: New Art from Old*, National Gallery,
London, texts Robert Rosenblum, et al.

Biennale of Sydney (group)
Cat. *Biennale of Sydney*, texts Hetti Perkins, Harald
Szeemann, Robert Storr, Nicholas Serota, et al.

'Around 1984: A Look at Art in the Eighties',
**P.S. 1 Contemporary Art Center**, New York (group)
Cat. *Around 1984: A Look at Art in the Eighties*, P.S. 1
Contemporary Art Center, New York, text Carolyn
Christov-Bakargiev

'Architecture without Shadow',
**Centro Andaluz de Arte Contemporaneo**, Seville;
toured to **Centre de Cultura Contemporania de
Barcelona** (group)
Cat. *Architecture without Shadow*, Ediciones Poligrafa,
texts Abalos & Enguita, Joerg Bader, Catherine
Hurzeler, Hans Irrek, Gloria Moure, Barry Schwabsky,
Jeff Wall and Martin Tschanz and Terence Riley

**2001**
**Marian Goodman Gallery**, New York (solo)

## Selected articles and interviews
## 1999-2001

Arden, Roy; Wall, Jeff, 'La photographie d'art,
expression parfaite du reportage', *art press*, No 251,
Paris, November
Enright, Robert, 'The Consolation of Plausibility: An
Interview with Jeff Wall', *Border Crossings*, Vol 19, No
1, Winnipeg
Jocks, Heinz-Norbert, 'Jeff Wall: 'Judd plus Flavin plus
ein Foto: Ein Gespräch mit Heinz-Norbert Jocks',
*Kunstforum*, No 144, Cologne, March/April

**2000**

Lowry, Joanna, 'History, Allegory, Technologies of
Vision', *History Painting Reassessed*, ed. David Green
and Peter Seddon, Manchester University Press,
London and New York
Reeve, Charles, 'If Computers Could Paint: Charles
Reeve Speaks with Jeff Wall', *Books in Canada*, Vol 28,
Nos 8/9, Winter. Reprinted in *Documents*, Los Angeles,
entitled, 'A Conversation with Jeff Wall', No 17,
Winter/Spring
Shapiro, David, 'A Conversation with Jeff Wall', *Museo*,
Vol 3, Columbia University, New York, Spring

**2001**
Morgan, Robert C., 'Jeff Wall', *Tema Celeste*, Milan,
May/June
'Jeff Wall: Review of Marian Goodman Exhibit', *Village
Voice*, New York, 20 March

JEFF WALL

FEBRUARY 21 — MARCH 17, 2001
MARCH 21 — APRIL 14, 2001
RECEPTION WEDNESDAY FEBRUARY 21, 6–8 PM

MARIAN GOODMAN GALLERY
24 WEST 57TH STREET NEW YORK 10019 212 977-7160

## Selected exhibitions and projects
## 2001

**Galerie Rüdiger Schöttle**, Munich (solo)

'Jeff Wall: Still Lifes and Interiors',
**La Baloise**, Basel (solo)

**Galerie Johnen & Schöttle**, Cologne (solo)

'Jeff Wall: Figures and Places',
**Museum für Moderne Kunst**, Frankfurt (solo)
Cat. *Jeff Wall*, Museum für Moderne Kunst, Frankfurt,
texts Rolf Louter, Berndt Reiss, Hans Dickel, Jeremy
Gaines, Boris Groys, Jan Tumlir, Jean-François
Chevrier, Jean-Christophe Ammann, et al.

Receives The Paul de Hueck and Norman Walford Career
Achievement Award for Art Photography

'Roy Arden, Scott McFarland, Howard Ursuliak,
Stephen Waddell, Jeff Wall',
**Monte Clark Gallery**, Toronto (group)

'en pleine terre: Eine Wanderung zwischen Landschaft
und Kunst, Spiral Jetty und Potsdamer
Schrebergärten',
**Museum für Gegenwartskunst**, Basel (group)

'Antagonismes: casos d'estudi',
**Museu d'Art Contemporani de Barcelona** (group)

'En el Cielo',
**TRANS>arts.cultures.media**, Venice (group)

'Platform of Humanity',
Venice Biennale (group)
Cat. *Platform of Humanity*,Electa, Milan, texts Harald
Szeemann, Pier Luigi Tazzi, et al.

'Open City: Street Photographs Since 1950',
**Museum of Modern Art**, Oxford (group)
Cat. *Open City: Street Photographs Since 1950*, Museum
of Modern Art, Oxford, texts Kerry Brougher and
Russell Ferguson

'How You Look At It: Photographs of the 20th Century',
**Sprengel Museum**, Hannover (group)

'The Whitechapel Centenary Exhibition',
**Whitechapel Art Gallery**, London (group)
Cat. *The Whitechapel Centenary Exhibition*, Whitechapel
Art Gallery, London, text Catherine Lampert, et al.

'Collaborations with Parkett, 1984 to Now',.
**The Museum of Modern Art**, New York (group)

'Uniform: Order and Disorder',
**Stazione Leopolda**, Florence; toured to **P.S. 1
Contemporary Art Center**, New York. (group)

## Selected articles and interviews
## 2001

Invitation cards, Galerie Johnen & Schöttle, Cologne

Jeff Wall
Figures & Places

Tumlir, Jan, 'The Hole Truth: Jeff Wall About The
Flooded Grave, *Artforum* International, March
Dercon, Chris, 'De beeldende kunst imiteert de film: De
ontbeweeglijkheid van stilstaande beelden is anders
geworden', in *Ik zou een museum willen maken waar de
dingen elkaar overlappen*, Nai Uitgevers, Rotterdam,
2000. English translation in *Boijmans Bulletin*, Vol 1,
No 2, Museum Boijmans Van Beuningen, Rotterdam,
February

Albig, Jörg-Uwe, 'Wahrheit ist kein Werk von Sekunden', *art: Das Kunstmagazin*, No 6, Hamburg, June, 1996

Ammann, Jean Christophe, *Jeff Wall Transparencies*, Schirmer/Mosel, Munich, 1986; Rizzoli, New York, 1987

Arden, Roy: Wall, Jeff, 'La photographie d'art, expression parfaite du reportage', *art press*, No 251, Paris, November, 1999

Atkinson, Terry, *Jeff Wall. Dead Troops Talk*, Kunstmuseum, Luzern; The Irish Museum of Modern Art, Dublin; Deichtorhallen, Hamburg, 1993

Avgikos, Jan, *Artforum*, New York, September, 1992

Auffermann, Verena and Linsley, Robert, monograph, *Jeff Wall The Storyteller*, Museum für Moderne Kunst, Frankfurt, 1992

Badía, Montse, 'Perfección de la imagen: Entrevista con Jeff Wall', *Lapiz*, No 157, Madrid, November, 1999

Balkema, Annette W.; Slager, Henk, 'Transformational Aesthetics: A Fax Interview with Jeff Wall', The Photographic Paradigm, *Lier en Boog, Series of Philosophy of Art and Art Theory*, Vol 12, Amsterdam, 1997

Bangma, Anke, 'Rotterdam and the Children's Pavilion by Dan Graham and Jeff Wall', *Witte de With Cahier 3*, Witte de With Center for Contemporary Art, Rotterdam, February, 1995

Barents, Els, *Jeff Wall en Günther Förg: Fotowerken*, Stedelijk Museum, Amsterdam, 1985

Barents, Els, interview in *Jeff Wall Transparencies*, Schirmer/Mosel, Munich, 1986; Rizzoli, New York, 1987

Bickers, Patricia, 'Wall Pieces: Jeff Wall Interviewed', *Art Monthly*, No 179, London, September, 1994

Birnbaum, Daniel, 'Iron Still', *Artforum*, New York, May, 1997

Brayshaw, Christopher, 'Jeff Wall: Critical Transparencies: a Defense, an Exegesis', *Artichoke*, Vol 8, No 1, Calgary, Spring, 1996

Brisebois, Marcel, *Jeff Wall: Oeuvres 1990-1998*, Musée d'art contemporain de Montréal, 1999

Brougher, Kerry, *Jeff Wall*, Museum of Contemporary Art, Los Angeles; Scalo Verlag, Zurich, 1997

Bryson, Norman, 'Jeff Wall: Enlightenment Boxes', *Art & Text*, No 56, Sydney, February/April, 1997

Bryson, Norman, 'Too Near, Too Far', *Parkett*, No 49, Zurich, May, 1997

Carels, Edwin, 'Meditaties over het alledaagse: Sokurov, Horsfield, Wall', *Metropolis M*, No 1, Utrecht, February, 1997

Chevrier, Jean-François, 'Les Peintres de la Vie Moderne', *Galeries*, No 24, Paris, April/May, 1988

Chevrier, Jean-François, *Une autre objectivité/Another Objectivity*, Idea Books, Lyon, France, 1989

Chevrier, Jean-François, 'Une Exigence de Réalisme', *Symposium: Die Photographie in der Zeitgenössischen Kunst: Eine Veranstaltung der Akademie Schloss Solitude, 6/7*, December 1989, Edition Cantz, Stuttgart, 1990

Chevrier, Jean-François and David, Catherine, 'Actualité de l'image', *Passages de l'Image*, Musée nationale d'art moderne, Centre Georges Pompidou, Paris, 1990

Chevrier, Jean-François, 'Jeff Wall, The Story Teller', *Forum International 7*, Antwerp, March/April, 1991

Chevrier, Jean-François, *Jeff Wall*, Museum of Contemporary Art, Chicago; Whitechapel Art Gallery, London, 1995

Chevrier, Jean-François, *Jeff Wall: Space and Vision*, Schirmer/Mosel, Munich, 1996

Clark, T. J., Guilbaut, Serge, and Wagner, Anne, interview with Jeff Wall, 'Representations, Suspicions and Critical Transparency', *Parachute*, No 59, Montreal, July/August/September, 1990

Corrin, Lisa, 'Jeff Wall: Review of Hirshhorn Exhibit', *Parachute*, Montreal, October/November/December, 1997

Cortes, Jose Miguel G., *Jeff Wall*, *Pepe Espaliu: Tiempo Suspendido*, Generalitat Valenciana, Valencia, 1999

Couderc, Sylvie, 'Distance et Possesion: Les photographies de Jeff Wall et de Clegg & Guttmann', *Artefactum*, Vol 5, No 25, Antwerp, September/October, 1988

Crow, Thomas, 'Profane Illuminations, Social History and the Art of Jeff Wall', *Artforum*, New York, February, 1993

Crow, Thomas, 'Unwritten Histories of Conceptual Art', *Oehlen Williams 95*, Wexner Center for the Arts, Ohio State University, Columbus, 1995

David, Catherine, 'Picture for Women', *Cahiers du Musée d'Art Moderne*, Paris, Spring, 1988

David, Catherine and Chevrier, Jean-François, 'Actualité de l'Image', *Passages de l'Image*, Musée nationale d'art moderne, Centre Georges Pompidou, Paris, 1990

Decter, Joshua, *Flash Art*, Milan, November, 1989

Dercon, Chris, 'De beeldende kunst imiteert de film: De ontbeweeglijkheid van stilstaande beelden is anders geworden', in *Ik zou een museum willen maken waar de dingen elkaar overlappen*, Nai Uitgevers, Rotterdam, 2000. English translation in *Boijmans Bulletin*, Vol 1, No 2, Museum Boijmans Van Beuningen, Rotterdam, February, 2001

Dickel, Hans, 'Im Licht der Bilder: Der Platz des Betrachters im Werk von Jeff Wall', in Wolfgang Kemp, *Zeitgenössische Kunst und ihre Betrachter*, Jahresring 43, Jahrbuch für moderne Kunst, Oktagon Verlag, Cologne, 1996

Dickel, Hans, *Jeff Wall*, Museum für Moderne Kunst, Frankfurt, 2001

Dufour, Gary, *Jeff Wall 1990*, Vancouver Art Gallery, 1990

Enright, Robert, 'The Consolation of Plausibility: An Interview with Jeff Wall', *Border Crossings*, Vol 19, No 1, Winnipeg, 1999

Fer, Briony, *Jeff Wall*, Museum of Contemporary Art, Chicago, 1995

Francblin, Catherine, *Jeff Wall*, Marian Goodman Gallery, New York, 1989

Freedman, Adele, 'Vancouver to Paris', *Canadian Art*, Toronto, Spring, 1996

Friedel, Helmut, *Jeff Wall: Space and Vision*, Schirmer/Mosel, Munich, 1996

Gardner, Belinda, 'Lakonie der Landschaft. Jeff Wall in Gespräch mit Belinda Gardner', *neue bildende kunst*, Berlin, No 4, August/September, 1996

Gardner, Colin, *Artforum*, New York, February, 1991

Gingras, Nicole, *Jeff Wall: Oeuvres 1990-1998*, Musée d'art contemporain de Montréal, 1999

Goldberg, Vicky, 'Photos That Lie and Tell the Truth', *New York Times*, 16 March, 1997

Gopnik, Blake, 'A Wall Big Enough To Hang Art On', *The Globe and Mail*, Toronto, 11 February, 1999

Groys, Boris, 'Die Photographie und die Strategien der Avantgarde: Jeff Wall im Gespräch mit Boris Groys', *Paradex*, Cologne, November, 1998

Graham, Dan, 'The Destroyed Room of Jeff Wall', *Real Life Magazine*, New York, March, 1980

Graham, Dan, *Children's Pavilion*, Galerie Roger Pailhas, Marseille, 1989

Guilbaut, Serge, Clark, T. J., and Wagner, Anne, interview with Jeff Wall, 'Representations, Suspicions and Critical Transparency', *Parachute*, No 59, Montreal, July/August/September, 1990

Honnef, Klaus, 'Jeff Wall', *Kunstforum*, No 84, Cologne, August/September, 1986

James, Geoffrey, 'Pictures from an Explosive World', *Maclean's*, Toronto, 11 January, 1988

Jocks, Heinz-Norbert, 'Jeff Wall: 'Judd plus Flavin plus ein Foto': Ein Gespräch mit Heinz-Norbert Jocks, *Kunstforum*, No 144, Cologne, March/April, 1999

Jones, Bill, 'The Truth Is Out There: Jeff Wall and Late-century Pictorialism', *On Paper*, July/August, 1997

Jongé, Ingrid Fischer, *Jeff Wall*, Louisiana Museum, Humlebaek, 1992

Joselit, David, *Art in America*, New York, January, 1989

Kaila, Jan, 'Jeff Wall', *Valokuva: Finnish Photography*, No 3, Helsinki, 1996. Republished in Norwegian, as 'Jeff Walls hybride bilder', *Hyperfoto*, Oslo, Nos. 3/4, 1996

Kuspit, Donald B., 'Looking Up Jeff Wall's Modern "Appassionamento"', *Artforum*, New York, March, 1982

Ledes, Richard C, 'Dan Graham and Jeff Wall at Marian Goodman', *Artscribe*, New York, May, 1990

Lewis, Mark, 'An Interview with Jeff Wall', *Public 9*, Toronto, 1994

Lewis, Mark, 'Mark Lewis in Conversation with Jeff Wall', *transcript*, Vol 3, No 3, Dundee, 1998

Lingwood, James, *Une autre objectivité/Another Objectivity*, Idea Books, Lyon, 1989

Lingwood, James, *The Epic and the Everyday*, Hayward Gallery, London, 1994

Linsley, Robert, and Auffermann, Verena, monograph, *Jeff Wall The Storyteller*, Museum für Moderne Kunst, Frankfurt, 1992

Lowry, Joanna, 'History, Allegory, Technologies of Vision', *History Painting Reassessed*, ed. David Green and Peter Seddon, Manchester University Press, London and New York, 2000

Lussiev, Réal, *Jeff Wall: Oeuvres 1990-1998*, Musée d'art contemporain de Montréal, 1999

Lütticken, Sven, 'Het geheugen van de hedendaagse kunst: Over Gerhard Richter, Jeff Wall en Mat Collishaw', *De Witte Raaf*, No 65, Ghent, January/February, 1997

Migayrou, Frédéric, 'Transfiguration des types', *Jeff Wall*, Nouveau Musée, Villeurbanne, 1988

Migayrou, Frédéric, *Children's Pavilion*, Galerie Roger Pailhas, Marseille, 1989

Migayrou, Frédéric, *Jeff Wall*, Simple indication, *la lettre volée*, Singularités, ed. Marie-Angre Brayer, Brussels, 1995

Miyatake, Miki, 'Take Photos, Add Paintings and Stir', *Japan Times*, Tokyo, 17 January, 1997

Morgan, Robert C., 'Jeff Wall', *Tema Celeste*, Milan, May/June, 2001

Muchnic, Suzanne, 'Jeff Wall's Aim? To Improve Your Vision', *Los Angeles Times*, 13 July, 1997

Newman, Michael, *Jeff Wall*, De Pont Foundation, Tilburg, 1994

Newman, Michael, 'Jeff Wall's Pictures', *Flash Art*, Milan, March/April, 1995

Noever, Peter, ed., *Kunst im abseits?/Art in the Center: Two discussions on documenta X*, MAK Center for Art and Architecture, Los Angeles; Cantz Verlag, Stuttgart, 1997

Parent, Beatrice, 'Light and Shadow: Christian Boltanski and Jeff Wall', *Parkett 22*, Zurich, 1989

Pélenc, Arielle, 'Jeff Wall. Excavation of the Image', *Parkett* No 22, Zurich, 1989

Pélenc, Arielle, 'The Uncanny', *Jeff Wall Restoration*, Kunstmuseum, Luzern; Kunsthalle, Dusseldorf, 1994

Pepe, Ed, 'Jeff Wall: Pictures 1990-1998/Review of Montreal Exhibit', *Art New England*, Newtonville, October/November, 1999

Pontbriand, Chantal, 'The Non-Sites of Jeff Wall', *Parkett*, No 49, Zurich, May, 1997

Reeve, Charles, 'If Computers Could Paint: Charles Reeve speaks with Jeff Wall', *Books in Canada*, Vol 28, Nos 8/9, Winter. Reprinted in *Documents*, Los Angeles, entitled, 'A Conversation with Jeff Wall', No 17, Winter/Spring, 2000

Reid, Calvin, 'Jeff Wall', *Arts Magazine*, New York, December, 1989

Reindl, Uta M., 'Jeff Wall', *Kunstforum International*, Cologne, April/June, 1998

Rimanelli, David, 'The Best of 1998', *Artforum*, New York, December, 1998

Roberts, John, 'Jeff Wall: The Social Pathology of Everyday Life', *The Art of Interruption: Realism, Photography and the Everyday*, Manchester University Press, Manchester and New York, 1998

Russell, John, 'Dan Graham and Jeff Wall: The Children's Pavilion', *New York Times*, 12 January, 1990

Schmerler, Sarah, 'Jeff Wall: Exhibit Review', *ARTnews*, New York, May, 1998

Schorr, Collier, 'The Pine on the Corner and Other Possibilities', *Parkett*, No 49, Zurich, May, 1997

Schwander, Martin, *Jeff Wall Restoration*, Kunstmuseum, Luzern, et al., 1994

Seamon, Roger, 'The Uneasy Sublime: Defiance and Melancholy in Jeff Wall's Documentary Spectacle', *Parachute*, Montreal, April/May/June, 1992

Shapiro, David, 'A Conversation with Jeff Wall', *Museo*, Vol 3, Columbia University, New York, Spring, 2000

Shottenkirk, Dena, *Artforum*, New York, March, 1989

Slager, Henk; Balkema, Annette W., 'Transformational Aesthetics: A Fax Interview with Jeff Wall', The Photographic Paradigm, *Lier en Boog, Series of Philosophy of Art and Art Theory*, Vol 12, Amsterdam, 1997

Smith, Roberta, 'The Focus Narrows, as Stark Images Herald a Time for Seriousness', *New York Times*, 6 February, 1998

Smolik, Noemi, 'Der Spiegel bleibt: Die Präsenz der Malerei im Zeitalter technisch reproduzierbarer Abbilder', *Im Augenblick der Gegenwart. Zeitgenössische Kunst in den Deichtorhallen Hamburg*, ed. Belinda Grace Gardner, Helmut Metz Verlag, Hamburg, 1998

Snauwaert, Dirk, 'Written Interview with Jeff Wall', in catalogue for the exhibition *Matthew Barney, Tony Oursler, Jeff Wall*, Goetz Collection Munich, 1996

Spector, Nancy, 'The Children's Pavilion', *Canadian Art*, Toronto, Summer, 1990

Stals, José Lebrero *Jeff Wall*, Museo Nacional Centro d'Arte Reina Sofia, Madrid, 1994

Stemmrich, Gregor, 'Vorwart', *Jeff Wall, Szenarien in Bildraum der Wirklichkeit: Essays und Interviews*, Verlag der Kunst, Fundus Books, 1997

Stevens, Mark, 'Nowhere Man', *New York Magazine*, 2 March, 1998

Stigter, Bianca, 'Voor de nieuwe landverhuizers is Europa en America. Gesprek met fotograf Jeff Wall', *NRC Handelsblad*, Rotterdam, 20 June, 1997

Stockebrand, Marianne, *Jeff Wall*, Westfälischer Kunstverein, Münster, 1988

Thielman, Andreas, *Jeff Wall*, Westfälischer Kunstverein, Münster, 1988

Tumlir, Jan, 'The Hole Truth: Jeff Wall About The Flooded Grave, *Artforum* International, March, 2001

Wagner, Anne, and Clark, T. J., Guilbaut, Serge, interview with Jeff Wall, 'Representations, Suspicions and Critical Transparency', *Parachute*, No 59, Montreal, July/August/September, 1990

Wagner, Anselm, 'Jeff Wall: Photografie als "tableau vivant"', *Noëma*, No 42, Vienna, August/September/October, 1996

Wagner, Frank, *Jeff Wall*, Neue Gesellschaft für Bildende Kunst, Berlin, 1994

Wall, Jeff, 'Meaningness', *Free Media Bulletin*, No 1, with Duane Lunden and Ian Wallace, Intermedia Press, Vancouver, 1969

Wall, Jeff, *Landscape Manual*, Fine Arts Gallery, University of British Columbia, Vancouver, 1969

Wall, Jeff, 'Cine-Text (Excerpts) 1971', ed. Lucy Lippard, *Six Years: The Dematerialization of the Art Object, 1966-72*, Praeger, New York, 1973

Wall, Jeff, 'To the Spectator', *Jeff Wall*, Art Gallery of Greater Victoria, Victoria, 1979

Wall, Jeff, 'Stereo, 1980', *Parachute*, No 22, Montreal, 1980

Wall, Jeff, 'The Site of Culture: Contradiction, Totality and the Avantgarde', *Vanguard*, Vancouver, May, 1983

Wall, Jeff, 'Unity and Fragmentation in Manet', *Parachute*, No 35, Montreal, Summer, 1984

Wall, Jeff, 'A Note on Movie Audience', *Jeff Wall Transparencies*, Schirmer/Mosel, Munich, 1986; Rizzoli, New York, 1987

Wall, Jeff, 'Gestus', *Ein anderes klima/A Different Climate: Aspects of Beauty in Contemporary Art*, Stadtische Kunsthalle, Dusseldorf, 1984

Wall, Jeff, 'Dan Graham's Kammerspiel' in *Dan Graham*, The Art Gallery of Western Australia, 1984

Wall, Jeff, 'La Melancolie de la rue: Idyll and Monochrome in the work of Ian Wallace', *Ian Wallace: Selected Works 1970-87*, The Vancouver Art Gallery, 1988

Wall, Jeff, 'Into the Forest: Two Sketches for Studies of Rodney Graham's Work', in *Rodney Graham: Works 1976–88*, Vancouver Art Gallery, Vancouver, 1988

Wall, Jeff, 'Bezugspunkte im Werk von Stephan Balkenhol', in *Stephan Balkenhol*, Kunsthalle Basel, 1988

Wall, Jeff, 'Boy on TV (aus Eviction Struggle)', *Parkett* 22, Zurich, 1989

Wall, Jeff, *A Guide to the Children's Pavilion* (co-authored with Dan Graham), Contemporary Art Forum, Santa Barbara, California, 1990

Wall, Jeff, 'My Photographic Production', *Symposium: Die Photographie in der Zeitgenössischen Kunst: Eine Veranstaltung der Akademie Schloss Solitude, 6/7*, December 1989, Edition Cantz, Stuttgart, 1990

Wall, Jeff, 'Tradition and Counter-Tradition in Vancouver Art: A Deeper Background to Ken Lum's Work', *The Lectures 1991*, Witte de With Center for Contemporary Art, Rotterdam, 1991

Wall, Jeff, 'An Artist and his Models', *Roy Arden*, Contemporary Art Gallery, Vancouver, 1993, reprinted in *Parachute*, No 74, April/June, Montreal, 1994

Wall, Jeff, 'Some Sources for Warhol in Duchamp and Others', *Andy Warhol: Paintings 1960-1986*, Kunstmuseum Lucerne, 1995

Wall, Jeff, 'Marks of Indifference: aspects of photography in, or as, conceptual art', *Questioning the Object of Art: 1965-1975*, Museum of Contemporary Art, Los Angeles, 1995

Wall, Jeff; Gardner, Belinda, 'Lakonie der Landschaft. Jeff Wall in Gespräch mit Belinda Gardner', *neue bildende kunst*, Berlin, No 4, August/September, 1996

Wall, Jeff; Snauwaert, Dirk, 'Written Interview with Jeff Wall', in catalogue for the exhibition *Matthew Barney, Tony Oursler, Jeff Wall*, Goetz Collection Munich, 1996

Wall, Jeff, 'The Guitarist', *a/drift: Scenes from Penetrable Culture*, Center for Curatorial Studies, Bard College, Annandale-on-Hudson, New York, 1996

Wall, Jeff, *Szenarien im Bildraum der Wirklichkeit*, Essays und Interviews, ed. Gregor Stemmrich, Verlag der Kunst, Fundus-Bücher, Berlin/Dresden, 1997

Wall, Jeff; Balkema, Annette W.; Slager, Henk, 'Transformational Aesthetics: A Fax Interview with Jeff Wall', The Photographic Paradigm, *Lier en Boog, Series of Philosophy of Art and Art Theory*, Vol 12, Amsterdam, 1997

Wall, Jeff, 'Jeff Wall interview/lecture', ed. Alan Woods, *transcript: a journal of visual culture*, Vol 2, No 3, Dundee, 1997

Wall, Jeff, *Here and Now II: Jeff Wall*, Henry Moore Institute, Leeds, 1998

Wall, Jeff; Groys, Boris, 'Die Photographie und die Strategien der Avantgarde: Jeff Wall im Gespräch mit Boris Groys', *Paradex*, Cologne, November, 1998

Wall, Jeff; Arden, Roy, 'La photographie d'art, expression parfaite du reportage', *art press*, No 251, Paris, November, 1999

Wall, Jeff; Badía, Montse, 'Perfección de la imagen: Entrevista con Jeff Wall', *Lapiz*, No 157, Madrid, November, 1999

Wall, Jeff; Enright, Robert, 'The Consolation of Plausibility: An Interview with Jeff Wall', *Border Crossings*, Vol 19, No 1, Winnipeg, 1999

Wall, Jeff; Reeve, Charles, 'If Computers Could Paint: Charles Reeve speaks with Jeff Wall', *Books in Canada*, Vol 28, Nos 8/9, Winter. Reprinted in *Documents*, Los Angeles, entitled, 'A Conversation with Jeff Wall', No 17, Winter/Spring, 2000

Wall, Jeff; Shapiro, David, 'A Conversation with Jeff Wall', *Museo*, Vol 3, Columbia University, New York, Spring, 2000

Wall, Jeff; Dercon, Chris, 'De beeldende kunst imiteert de film: De ontbeweeglijkheid van stilstaande beelden is anders geworden', in *Ik zou een museum willen maken waar de dingen elkaar overlappen*, Naï Uitgevers, Rotterdam, 2000. English translation in *Boijmans Bulletin*, Vol 1, No 2, Museum Boijmans Van Beuningen, Rotterdam, February, 2001

Wallace, Ian, 'Revisionism and its Discontents: Westkunst', *Vanguard*, Vancouver, September, 1981

Wallace, Ian, *Jeff Wall. Selected Works*, The Renaissance Society, University of Chicago, 1983

Wallace, Ian, *Jeff Wall Transparencies*, Schirmer/Mosel, Munich, 1986; Rizzoli, New York, 1987

Watson, Scott, *Jeff Wall*, Neue Gesellschaft für Bildende Kunst, Berlin, 1994

Welzer, Harald, 'Über Jeff Wall', *artist Kunstmagazin*, Bremen, Heft 28, No 3, 1996

Wheeler, Dennis, 'The Limits of the Defeatured Landscape: A Review of Four Artists', *Arts Canada*, Toronto, June, 1969

Whyte, Murray, 'Jeff Wall', *National Post*, Ontario, 11 February, 1999

Wood, William, 'Three Theses on Jeff Wall', *C Magazine*, No 3, Toronto, Fall, 1984

Wood, William, 'Jeff Wall', No 13, *C Magazine*, Toronto, Spring, 1987

Woods, Alan, ed., 'Jeff Wall interview/lecture', *transcript: a journal of visual culture*, Vol 2, No 3, Dundee, 1997

van Gelder, Hilde, 'Photography: From Modus to Picture', *Lier en Boog, Series of Philosophy of Art and Art Theory*, Vol 12, Amsterdam, 1997

van Winkel, Camiel, 'Figure goes to ground', *Jeff Wall: Landscapes and Other Pictures*, Kunstmuseum Wolfsburg, Wolfsburg, Germany, 1996. Reprinted in English, in *Visual Arts and Culture: An International Journal of Contemporary Art*, Sydney, Vol 2, Part 1, 2000

Zaslove, Jerry, *Jeff Wall 1990*, Vancouver Art Gallery, 1990

## Public Collections

FRAC, Ajaccio, Corsica
FRAC, Aquitaine, Bordeaux
Fondation Caixa de Pensiones, Barcelona
Museum der Gegenwartskunst, Basel
FRAC, Champagne-Ardenne
Museum für Moderne Kunst, Frankfurt
Kunsthalle Hamburg
American Friends of the Israel Museum, Jerusalem
Kaiser-Wilhelm Museum, Krefeld
Tate Gallery, London
Kunstmuseum Lucerne
Musée d'Art Contemporain Montreal
Bayerische Staatsgemälde-sammlungen, Munich
The Art Gallery of Ontario, Ontario
The National Gallery of Canada, Ottawa
Centre Pompidou, Paris
Fonds Nationale d'Art Contemporain, Paris
Andy Warhol Museum, Pittsburgh
The Carnegie Museum of Art, Pittsburgh
Mackenzie Gallery, Regina, Saskatchewan
Foundation for Contemporary Art, Tilburg
The Ydessa Hendeles Art Foundation, Toronto
The Vancouver Art Gallery
Kunstmuseum Wolfsburg

## Comparative Images

page 94, **Stephan Balkenhol**
Big Man with Green Shirt

page 97, **Stephan Balkenhol**
Big Head (Man)

page 11, **Robert Bresson**
Mouchette

page 36, **Caravaggio**
The Flagellation of Christ
Musée des Beaux-Arts et de la Ceramique, Rouen

page 34, **Paul Cézanne**
The Bridge at Maincy, near Melun
Musée d'Orsay, Paris

page 40, **Paul Cézanne**
La Montagne Sainte-Victoire
Barnes Foundation, Merion

page 40, **Paul Cézanne**
Turn in the Road
Museum of Fine Arts, Boston

page 14, **Eugène Delacroix**
The Death of Sardanapalus
Louvre, Paris

page 177, **Eugène Delacroix**
Hamlet and Horatio in the Graveyard
Musée National du Louvre, Paris

page 117, **Albrecht Dürer**
Peasant's Column

page 161, **Ralph Ellison**
Invisible Man

page 11, **Jean Eustache**
La Maman et La Putain

page 41, **Théodore Géricault**
The Raft of Medusa
Louvre, Paris

page 104, **Francisco de Goya**
Yo lo vi (I saw it), from 'Los Desastres de la Guerra'

page 122, **Hokusai**
A High Wind in Yeijiri, from 'Thirty-six views of the Fuji'

page 131, **Jean-Auguste-Dominique Ingres**
The Odalisque with the Slave
Fogg Art Museum, Cambridge, Massachusetts

page 28, **Edouard Manet**
The Old Musician
National Gallery of Art, Washington DC, Chester Dale Collection

page 52, **Edouard Manet**
Le Déjeuner sur l'herbe
Musée d'Orsay, Paris

page 79, **Edouard Manet**
Olympia
Musée d'Orsay, Paris

page 89, **Edouard Manet**
In the Conservatory
Staatliche Muséen Preussischer Kulturbesitz, Nationalgalerie, Berlin

page 30, **Edouard Manet**
A Bar at the Folies-Bergère
Courtauld Institute Galleries, London

page 42, **Nicolas Poussin**
Landscape with Diogenes
Louvre, Paris

page 169, **Georges Seurat**
Sunday Afternoon on the Island of the Grande Jatte
Art Institute, Chicago

## List of Illustrated Works

page 83, **Abundance**, 1985
page 127, **Adrian Walker, artist, drawing from a specimen in a laboratory in the Department of Anatomy at the University of British Columbia, Vancouver**, 1992
pages 160-161, **After** Invisible Man **by Ralph Ellison, the Preface**, 1999-2001
pages 114-115, **The Agreement**, 1987
page 37, **The Arrest**, 1989
page 97, **Backpack**, 1981-82
pages 84-85, **Bad Goods**, 1984
page 183, **Blind Window No. 1**, 2000
page 183, **Blind Window No. 2**, 2000
page 143, **The Bridge**, 1980
page 175, **Citizen**, 1996
page 182, **Clipped Branches, East Cordova St., Vancouver**, 1999
pages 56, 68-69, **Coastal Motifs**, 1989
page 45, **The Crooked Path**, 1991
page 189, **Cuttings**, 2001
page 174, **Cyclist**, 1996
pages 24, 38-39, **Dead Troops Talk (A Vision After an Ambush of a Red Army Patrol Near Moqor, Afghanistan, Winter 1986)**, 1992
pages 6, 14-15, **The Destroyed Room**, 1978
page 167, **Diagonal Composition No. 2**, 1998
page 167, **Diagonal Composition No. 3**, 2000
page 93, **Diagonal Composition**, 1993
pages 42-43, **Diatribe**, 1985
page 177, **A Donkey in Blackpool**, 1999
page 125, **Doorpusher**, 1984
page 13, **Double Self-Portrait**, 1979
page 35, **The Drain**, 1989
page 164, **8056, Beverly Blvd., Los Angeles, 9 a.m., 24 September 1996**, 1996
page 111, **An Encounter in the Calle Valentin Gomez Farias, Tijuana**, 1991
pages 62-63, **Eviction Struggle**, 1988
pages 64-65, **Eviction Struggle, video installation**, 1988
page 105, **A Fight on the Sidewalk**, 1994
pages 162, 178-179, **The Flooded Grave**, 1998-2000
pages 22-23, **The Giant**, 1992
page 108, **The Goat**, 1989
page 176, **Green Rectangle**, 1998
pages 130-131, **The Guitarist**, 1987
pages 146-147, **The Holocaust Memorial in the Jewish Cemetery**, 1987
page 172, **Housekeeping**, 1996
pages 138-139, **A Hunting Scene**, 1994
page 10, **In the Public Garden**, 1993
page 66, **Insomnia**, 1994
page 58, **Jello**, 1995
pages 140-141, **The Jewish Cemetery**, 1980
page 166, **Just Washed**, 1997
page 103, **Little Children (I - IX)**, 1988
page 128, **Man in Street**, 1995
page 181, **Man with a Rifle**, 2000
pages 90-91, **Milk**, 1984
page 77, **Mimic**, 1982
pages 170-171, **Morning Cleaning, Mies van der Rohe Foundation, Barcelona**, 1999
pages 98-99, **Movie Audience**, 1979
page 12, **No**, 1983
page 86, **An Octopus**, 1990
pages 70, 73, **Odradek, Taboritska 8, Prague, 18 July 1994**, 1994
page 164, **Office Hallway, Spring St., Los Angeles**, 1997
pages 142-143, **The Old Prison**, 1987
pages 106-107, **Outburst**, 1989
page 55, **Park Drive**, 1994
page 150, **Passerby**, 1996
pages 154, 155, **A Partial Account (of events taking place between the hours of 9.35 a.m. and 3.22 p.m., Tuesday 21 January 1997)**, 1997
page 166, **Peas and Sauce**, 1999
page 165, **Picture for** Parkett, 1997
pages 32-33, **Picture for Women**, 1979
page 145, **The Pine on the Corner**, 1990
page 82, **Pleading**, 1988
page 156, **Polishing**, 1998
page 109, **The Quarrel**, 1988
page 189, **Rainfilled Suitcase**, 2001
page 149, **Rear, 304 East 25th Ave., Vancouver, 9 May 1997, 1.14 & 1.17 p.m.**, 1997
pages 134-135, 192, **Restoration**, 1993
page 158, **River Road**, 1997
page 182, **A Sapling Supported by a Post**, 2000
page 165, **Shapes on a Tree**, 1998
page 96, **The Smoker**, 1986
page 87, **Some Beans**, 1990
pages 80-81, **Stereo**, 1980
pages 46-47, **Steve's Farm, Steveston**, 1980
pages 50-51, **The Storyteller**, 1986
page 20, **The Stumbling Block**, 1991
pages 120-121, **A Sudden Gust of Wind (after Hokusai)**, 1993
page 148, **A Sunflower**, 1995
page 153, **Sunken Area**, 1996
page 157, **Swept**, 1995
page 168, **Tattoos and Shadows**, 2000
page 116, **The Thinker**, 1986
page 165, **Torso**, 1997
page 95, **Trân Dúc Ván**, 1988
pages 4, 113, **Untangling**, 1994
pages 184-185, **Untitled (Dawn)**, 2001
page 186, **Untitled (Forest)**, 2001
pages 190-191, **Untitled (Night)**, 2001
page 187, **Untitled (Overpass)**, 2001
pages 18-19, **The Vampires' Picnic**, 1991
pages 8-9, **A Ventriloquist at a Birthday Party in October, 1947**, 1990
page 159, **A Villager from Aricaköyü Arriving in Mahmutbey - Istanbul, September, 1997**, 1997
page 151, **Volunteer**, 1996
page 92, **The Well**, 1989
pages 88-89, **Woman and her Doctor**, 1980-81
page 100, **Young Workers**, 1978-83